AESTHETIC AUTONOMY: PROBLEMS AND PERSPECTIVES

GRONINGEN STUDIES IN CULTURAL CHANGE

GENERAL EDITOR

M. Gosman

EDITORIAL BOARD

J.N. Bremmer, G.J. Dorleijn, A.A. MacDonald,
B.H. Stolte, A.J. Vanderjagt

Volume XV

AESTHETIC AUTONOMY:
PROBLEMS AND PERSPECTIVES

EDITED BY

Barend van Heusden and Liesbeth Korthals Altes

PEETERS

LEUVEN - PARIS - DUDLEY, MA

2004

Illustration on cover: JUSTAR, Amsterdam, © 2004.

Library of Congress Cataloging-in-Publication Data

Aesthetic autonomy: problems and perspectives / Barend van Heusden & Liesbeth Korthals Altes (ed.).
 p. cm. -- (Groningen studies in cultural change; v. 15)
 Includes bibliographical references and index.
 ISBN 90-429-1579-X (alk. paper)
 1. Aesthetics, Modern--Social aspects--Congresses. 2. Arts, Modern--Social aspects--Congresses. 3. Autonomy (Philosophy)--Congresses. I. Heusden, Barend van. II. Korthals Altes, Liesbeth. III. Series

BH151.A27 2004
700'.1--dc22 2004061676

D. 2004/0602/157
ISBN 90-429-7-1579-X
© Peeters, Bondgenotenlaan 153, 3000 Leuven

CONTENTS

PREFACE AND ACKNOWLEDGEMENTS

In 1999, the local Groningen Research School for the Study of the Humanities, and the Groningen members of the national Netherlands Research School for Medieval Studies succeeded in obtaining a grant for an innovative, large-scale, collective research programme entitled *Cultural Change: Dynamics and Diagnosis*. Supported by the faculties of Arts, Philosophy and Theology and financed by the Board of the University of Groningen, the *Cultural Change* programme constitutes an excellent opportunity to promote multidisciplinary approaches to phenomena characteristic of transformation processes in the fields of politics, literature and history, philosophy and theology. In order to enhance programmatic cohesion, three crucial 'moments' in European history were selected: 1) Late Antiquity to Early Middle Ages (c.200-c.600), 2) Late Medieval to Early Modern (c. 1450-c.1650) and the 'Long Nineteenth Century' (1789-c.1918). In 2000 and 2002 further grants were obtained for *Cultural Change: Impact and Integration* and *Cultural Change: Perception and Representation* respectively. Several international conferences and workshops have already been organised; more are planned before the end of 2007.

This volume contains a selection of essays presented at the international conference on Cultural Crises in Art and Literature, held in Groningen in November 2002, in a special session on the question of the autonomy of the arts. Do we witness, in western culture, the end of the autonomy of the arts as it has been conceptualized and institutionalized since the eighteenth century? Indeed, developments of quite a different nature seem to have contributed to a blurring of boundaries between art and non-art, art and the market, art and politics or ethics, as well as between the arts themselves, and between 'high' and 'low' art. Although this volume does not pretend to map this complex process in its entirety – partly because it is impossible to step out of one's own history – it is meant as a contribution to the elucidation of the process itself, offering some challenging explanations as to the heat of the current debate.

We thank the Board of the University of Groningen for the financial support given to the *Cultural Change* programmes.

The editors are particularly grateful to Marijke Wubbolts for helping to organise the workshop and to Nella Gosman-Scholtens for preparing the texts for publication.

Martin Gosman, General Editor

INTRODUCTION

Liesbeth Korthals Altes and Barend van Heusden

Has the autonomy of art, so strongly defended since Kant, and so well insti- *quote* tutionalized, become a thing of the past? Art has once again, so it seems, become a means to an end. A means to many ends, in fact, as the aesthetic is ubiquitous in contemporary culture. It has made its appearance in the news, in politics, in publicity, in sports, in our constructed environment, in our clothing and furniture, as well as in ethics. We live in a highly designed world, we are exhorted to stylise our selves. The representation of reality in the news media draws even political, military and social conflicts, such as the manifestations against globalisation, the Gulf wars or the events of 11 September 2001, within the circle of the aesthetic.

What consequences does this expansion of the aesthetic have for art as an autonomous realm? What does it mean when the sometimes unsettling qualities of art, its openness and ambiguity, invade realms of life to which the aesthetic before seemed irrelevant? One wonders what can be the consequences for the definition of art, and for the artist's self-image. Do contemporary artists still perceive their art as 'autonomous' and what does that *why the* mean to them? And considering that artistic autonomy had become in mod- *question* ernity the paradigm for individual autonomy, does the current de-autonomi- *is important* sation entail that the freedom of the individual is in danger? Finally, the institutions of art (museums, art-education, government support and private sponsoring of the arts, art criticism) can hardly be expected to remain immune to these developments.

The autonomy of art can obviously be understood in a number of ways. *definitions* As *semantic* or *referential autonomy*, that is: involving a certain liberty with respect to the representation of historical reality; as *ethical autonomy* with respect to social norms and values (as in *l'art pour l'art*) or as *institutional autonomy* within the broader domain of culture. These three perspectives are strongly related to each other, as well as to a modern – and modernist – worldview. The autonomy of art can also, however, be understood as a *functional* or *semiotic autonomy*. Thus the German philosopher of culture Ernst Cassirer argued that art, as a symbolic form, represents reality in a specific way, which differs from other semiotic forms. Intriguingly, the specific *function* of the artistic perspective seems to be valued more than ever.

This raises questions both about art's symbolic function and its institutional place in contemporary society.

Lately, however, the autonomy of the arts has been challenged from various sides. The aim of the contributors to this book has been to investigate the contemporary questioning of the concept of artistic autonomy by reflecting upon its different aspects, its historical development, its function and consequences in contemporary global culture. What we would like to achieve – in a very modest way – in this volume on aesthetic autonomy, is an increasing insight in processes of change that are at work in contemporary culture, as these affect our daily lives as well as our profession. Apparently, the expansion of the aesthetic within culture also called for a new ethical commitment. In the light of urgent social-political and ethical questions, art has been challenged to relate more directly to 'the world', and artists themselves feel the need, nowadays, for an 'engagement' with reality, often rejecting established conventions of aesthetic expression and representation – and inventing new ones. Manifestations of this new ethical turn are, for instance the booming of *factional*, *authentic* 'literature' and art, as well as the apparent desire of the public to identify with the author as a real person, rooted in real life.

From a historical perspective, one may wonder how current trends and discussions relate to the history of the debate about the autonomy of the arts. How do the investigated contemporary developments relate to modernity, understood in its broadest sense as a culture in which rational thinking and theoretical and empirical knowledge have been dominant? Why was Kant's 'solution' – art's autonomy – so widely accepted, and does the current trend re-enact earlier attempts at aesthetization of life and culture, such as romanticism or decadentism, or even pre-modern aesthetic modes?

Interestingly, recent cognitive research has challenged the belief in the specificity of the aesthetic. The autonomy of art has been questioned on account of the continuity of human cognitive capacities. Devices that were presumed to be typically 'aesthetic' were found outside art as well, and apparently relate to general cognitive devices. This research asks for a more integrated investigation of the semiotic functions involved in aesthetic representation and communication, as well as for a comparative approach, involving both works of art and non-aesthetic objects and processes.

Questioning autonomy means: questioning the roots of modernity. The history of aesthetic autonomy is in fact the history of modernity. It is certainly not an unambiguous history, but the intricacies reflect the complexity of modern culture, with its tensions between realism and idealism, between romanticism and rationalism, and between form and meaning. The debate on aesthetic autonomy leads us to philosophy, poetics, anthropology and sociology, history and economics. The theoretical void we faced after the

demise of structuralism has not yet been filled. Maybe it cannot be filled, but in that case, we need to build something that allows us to sail the void without falling prey to vertigo.

Finally, the concept of aesthetic autonomy has been one of the pillars of the humanities. The semiotics that underlies post-structuralism in a sense corroborated the fashionable opinion that art – or science, or politics – is, in the end, just a matter of conventions, and has not, therefore, any intrinsic or autonomous value. As the concept of artistic autonomy (and its crisis) affects our ideas about the artistic canon, contemporary theories of art and literature will have to face the challenge: once art's autonomy is no longer self-evident, it may become far less easy to identify canonical works.

The discussion about aesthetic autonomy has a wide reach, as it tackles questions pertinent to the basis of our culture and to the humanities as a critical reflection on culture. In a sense, analysis is now turning upon itself, as it discovers – or rather, as it is forced to acknowledge – the limitations of its own approach. How to deal with an art that is no longer autonomous, from within a science that was founded upon that same autonomy, and helped to define its foundations?

CONTRIBUTORS

René Boomkens is Professor of Philosophy, University of Groningen, the Netherlands.

Rainer Grübel is Professor of Slavic Literature, University of Oldenburg, Germany.

Arnold Heumakers is a literary critic and Lecturer in Cultural History of the Netherlands at the University of Amsterdam, the Netherlands.

Barend van Heusden is Senior Lecturer in Film Studies and Semiotics of Culture, University of Groningen.

Liesbeth Korthals Altes is Professor of Comparative and Modern French Literature, University of Groningen.

Margriet van der Waal is PhD-student in Comparative Literature, University of Groningen.

Peter V. Zima is Professor of Comparative Literature, University of Klagenfurt, Austria.

SOME REFLECTIONS ON LITERATURE, AUTONOMY, AND CRISIS

Liesbeth Korthals Altes

Has the autonomy of literature come to an end? If so, why would that be problematic, or indicative of a crisis? Before attempting an analysis, I should like to reflect on what autonomy could mean here. The heatedness of the debates on literature, as on art in general, suggests that these debates touch upon issues perceived as vital, although perhaps by an ever-declining group. In many respects, this 'crisis' of literature is a part of a more general disorientation concerning the arts and culture in late-capitalist, multicultural democracies. However, as Yves Michaud argues in his challenging work, *La Crise de l'Art Contemporain*, rather than labelling this as the end of art or of literature, one should speak of the end of a certain representation of the arts.[1] It should be kept in mind, indeed, that the whole history of the notions of literature and art consists of border wars and redefinitions. In this perspective, the post-modern de-differentiation of literature may appear as merely the next fluctuation in the mapping of cultural practices. And rather reassuringly, literary production itself is booming. However, this does not mean that there are no significant changes taking place.

This essay will focus on some of the current 'threats' to the autonomy of literature: first, briefly, on the de-autonomisation of literary studies themselves; second, on the democratisation of culture and its consequences for the definition of literature; third, on some challenges to 'literariness' and generic borders in contemporary literature; and finally, on literature's relation to ethics, one of its 'significant others', from which it was meant to cut itself loose. Needless to say, the discussion of this kind of change or crisis cannot but be coloured by one's own conception of culture and values.

Just to remind us that crisis in literature is nothing new – this may even be its natural state – here is a short extract from Mallarmé. In 1886, he sent to the *National Observer* an essay entitled *Crise de Vers*, which was to become famous:

[1] 'La prétendue crise de l'art contemporain est donc une crise de la représentation de l'art et une crise de la représentation de sa fonction' (Michaud, *La Crise de l'Art Contemporain*, p. 253).

> Notre phase, récente, sinon se ferme, prend arrêt et peut-être conscience … La littérature ici subit une exquise crise, fondamentale.[2]

What is described in this rather Hegelian way – as a growing awareness and *Aufhebung* at the same time – is the crisis in the definition of poetry induced by the practice of free verse. Mallarmé first seems to embrace this subversion of an age-old convention; but in a typical turnaround, he ends up praising verse, with its constraints, which allows poetic language to overcome the arbitrariness of language, brings poetry – of all other arts – closest to music, and secures its autonomy from referential language. Interestingly, interwoven through Mallarmé's always intricate formulations are references to Victor Hugo, the literary giant who bridged the gap between poetry and reality by making poetry swallow all referential discourse: history as well as politics or ethics, all were turned into Hugolian verse. But, as Mallarmé finely remarks, verse cannot but loosen the sentence from its referentiality: it plays with rhythm, sounds, and thus disperses in musicality any precise semantic content, any moral or social intent.

Not surprisingly, Mallarmé became the founding father of a triple autonomy: that of the artwork, autotelic and self-contained, 'aboli bibelot d'inanité sonore'; that of the poet, cast as sovereign subject, devoted to universal values and free from 'partial' moral or political bonds; and that of the realm of literature, essentially distinct from 'l'universel reportage', freed from direct referentiality and social or moral functions. An important correlate of this autonomy was, and still is, the 'impunité esthétique' claimed by Baudelaire, which grants writers the freedom to transgress moral or political norms. From a sociological perspective, according to the well-known analyses of Bourdieu (1992) or Schmidt (1989), this cluster constituting the autonomy of the literary field progressively established itself in the second half of the eighteenth century, when a certain kind of writing came into its own *as an art*. Writers, poets, artists in general, acquired progressive practical, financial and moral independence, emancipating themselves from the influence of church and state. Institutions such as universities, secondary schools, associations of literary critics, publishers, etc. took control of defining literature (object) and literary quality (value). This institutional autonomy is obviously relative, as is the moral and political independence of the arts and the artist, or the blocking of referentiality. *Pace* Mallarmé, Hugo's ideal of the poet as the spokesman of the people and the prophet of a new humanity, held and still holds a strong appeal for many writers and

[2] 'Our recent stage, if it does not reach a close, [at least] comes to a halt and perhaps to consciousness … Literature here undergoes an exquisite, fundamental crisis' (my somewhat explicitating translation, LKA).

readers, just as Sartre's call for *engagement* in fiction was only partly and temporarily silenced by the *Nouveau Roman*'s or post-modern literary self-reflexiveness. Literature owns no evident and uncontested functional autonomy, there are only historically specific negotiations between transitive or intransitive conceptions of the art of language, and of the degree of directness in literature's commitment.[3]

What kind of changes concerning these various facets of literature's autonomy could be said to characterise contemporary Western culture? And what values and implications are at stake? The four aspects that will be discussed in this paper are just a few among the many relevant recent developments. One could also have focused on changes concerning the literary object, such as experiments with internet publishing and the possibilities it offers for readers to become co-authors: this problematises the notion of text as a materially finite and autonomous 'object', and stresses the active participation of the reader in producing the literary experience. Or one could discuss the increasing impact of the author figure, challenging the notion of the artwork as an object independent of its maker (challenging at the same time literary theories which dispense with the author figure altogether). Literature comes to us not just through a text severed from its origin, which we privately and silently appropriate: writers present and perform their work – and themselves – live, in public and private places, in a striking revival of the literary 'salon', or through radio, television, internet, newspapers, and magazines, following a careful media strategy. The extra-textual ethos of the author tends to interfere strongly in the reception and interpretation of works. In all these changes, the media and new technologies play an important role, creating alternative production modes and presentation circuits.

But let us return to the four factors in question: the crisis of the object of literary studies, the consequences for literature of the democratisation of culture, the downplaying of literariness, and the ethical demand on literature.

What is the object of literary study?

Literary studies themselves have witnessed a striking explosion of their object. After the strongly autonomist approaches to literature common in the nineteen-sixties (New Criticism, Structuralism, or the German *werkimmanente Interpretation*), the claim for contextualisation has broadened the perspective on literary works and practices, as part of a more general movement. As Hal Foster argues, after Modernism's tendency to foster discipli-

[3] See for instance Diaz, *L'Autonomisation*.

narity, specialisation, and the autonomy of the different arts, we now encounter

> a scepticism regarding autonomous 'spheres' of culture, or separate 'fields' of
> experts ... The very notion of the aesthetic ... is in question here: the idea that
> aesthetic experience exists apart, without 'purpose', all but beyond history.[4]

The blooming of contextualisation, from New Historicism to cultural studies, has certainly left the academic study of literature in a crisis regarding its 'autonomy': literary studies are in search of their object, their theories, and methods. They have enlarged their domain to all texts, written or not, fictional or not, literary or not, professing a sometimes vehement disinterest in any autonomy of the literary, which is a notion under suspicion of elitism. Literature is approached as one cultural practice among others, just another manifestation of 'discourse' in a Foucauldian sense. Its grounding in history and ideology, at all the stages of the literary process – of production, distribution and reception – has been amply demonstrated. The 'pure' approach of the 'autonomous' artwork has been unmasked as a suspicious attempt to avoid political self-reflection (see for instance Sun-Mi Tak, who analyses Staiger's or Kaiser's *werkimmanente Interpretation* in post-war Germany as an effective way to allow painful questions to remain unasked).[5] We all appropriate the text into (semi-) private, different objects, according to the interpretive communities we belong to, as Stanley Fish has argued; the 'well-wrought urn' has been taken to pieces. Literary studies have embraced, with good arguments, many neighbouring or less close disciplines: sociology, cultural history, philosophy of culture, ethics, to name only the most important ones. But then the invited disciplines invade the house. Which professionality, which precise competence can be demanded from a literary scholar nowadays? However relevant and justifiable most of this contextualisation may be, it would seem to be rash to dismiss the question of literary specificity as irrelevant. Literature can obviously be studied from many angles, as a document for historical, ideological, or moral development, for instance. But at some point, the question has to be addressed as to which forms and functions, which specific verbal practices are involved when distinct texts receive or claim the label 'literary' in a specific culture. These questions need to be asked, not in defence of a self-evident status of literature, but as an investigation of the significance of specific writing and reading practice, and how it functions. If formal characteristics do not seem sufficient to define a category of texts as 'literature' – although in current west-

[4] Foster, *The Anti-Aesthetic*, p. xv.
[5] Tak, *Das Problem der Kunstautonomie*, pp. 117-119.

western culture, features such as ambivalence, density of information, and attention to form are good candidates – their function and use, and the kind of framing they involve, deserve more research. It is significant that, among all cultural practices, anthropologists as well as speech-act theorists, philosophers as well as sociologists, observe the existence of texts that frame human experience and display it for emotional and cognitive reflection and re-enactment, while calling attention to their textual constitution. Reflection on the pragmatic conditions defining 'literature' may bring more unity and focus in the broad range currently implied in literary studies, which amounts to a plea for a relative autonomy of literary studies and for a more reflective recourse to (the indispensable) interdisciplinarity.

Democratisation and literature

In contemporary Western societies, new social groups and minorities have gained access to cultural means of representation. In addition, the advent of the leisure society offers more people time for reading, writing, and other artistic activities. The democratisation of culture has led to a differentiation of communities and tastes and of forms and functions of literature. This certainly has had consequences, and denotes a 'threat' to certain representations of the autonomy of literature.

First, it is no longer a small group of highly educated professionals who determine what (good) literature is. Does this mean, as has been argued, that the laws of the marketplace are tending to take over that determining role, and that democratisation is to be equated with massification, commercialisation, and banalisation? In fact, one of the characteristics of post-modern culture is precisely the problematisation of the values attached to notions such as mass-culture and commercialisation. I do not want to minimise the effects of commercialisation, but no simple opposition can be construed between market and mass taste on one hand, and (high) art on the other. Literary works such as those produced by Houellebecq, Dave Eggers, Umberto Eco, and films like *American Beauty*, *Amélie Poulain* are bestsellers, appreciated by a very diversified public. Is their commercial success enough reason to discard them as non-art? These works bridge the former gaps between high and low, and find a new and varied public; their intertextuality includes references to all levels of culture. From a perspective on the definition of 'art' with respect to social class and the education of taste, these interloping works, which leave the researcher puzzled as to the interpretive community, the particular taste to which they address themselves, are most interesting indeed. In *Les Particules Elémentaires*, Houellebecq happily switches from Proust to Bill Gates in one sentence; this novel can be read for sex-and-sensation, but also as a highly sophisticated play with literary

and extra-literary conventions and expectations, which justifies his status as a cult author cherished by established literary critics (such as Josyane Savigneau in France [*Le Monde*] or Arnold Heumakers in The Netherlands).[6]

The diversification of publics and conceptions of literature is not in itself new. But whereas Bourdieu (1979 and 1992) could analyse the developing literary field as a setting in which the clash between artistic criteria reflected social struggle, contemporary culture no longer fits easily into this picture with sharply defined dominants and minors. In most Western societies, the more highly educated public shows a happy eclecticism in taste, though it would be risky to generalise this to all participants in culture. Indeed, democratisation also means the flourishing of local, partial, and sometimes exclusivist interests and values, which challenge the competence of the traditional arbiters. It certainly is an interesting development that legitimacy can now be claimed for values that are explicitly and proudly local (for instance 'feminist', or 'gay', or even 'regional') instead of 'universal'.[7]

Whereas individuals can benefit from this diversification, difficulties arise for the institutions that select, transmit and judge, and organise access to literary competence: what is good literature? Which literature is to be taught, subsidised, consecrated; what kind of literary competence should be trained at school or university, according to which and whose values? If everybody is an artist, if everything is art, this means that there is no specific skill, no tradition to teach and cherish. The criteria for distinction have become hazy, and immediately refer back to the underlying ideology and norms of the categorising person. The fear of being normative in a politically incorrect direction paralyses many players in the field, while it is evident that every decision has to be value-laden. For educational institutions, one possible escape could be to avoid clinging to one kind of function, one kind of literature ('high' literature, or, in contrast, reading-for-identification). Instead, they could introduce young readers to the different kinds of experiences and functions reading and writing can provide, and to the historical and cultural variety which can be observed.

An important issue, of course, concerns the manner in which different (sub)cultures co-exist: in a hierarchy, in concurrence, or in juxtaposition without contact, as 'incommensurable' entities, to use Lyotard's fashionable expression. At certain moments, Michaud comes to a gloomy conclusion (which seems to be shared by Zima, see elsewhere in this volume): if there is no longer any generally accepted norm, no consensus, if literature and art

[6] The cultural magazine *Inrockuptibles*, which played an instrumental role in discovering and publishing Houellebecq, functions more generally in the French cultural field as a bridge between (formerly) high and low culture.

[7] See also Michaud, *La Crise de l'Art Contemporain*, p. 129.

in general lose autonomy as their regulating ideal, they will fall prey to the laws of the marketplace and massification. Moreover, if partial interests gain unchecked power of legitimisation and expression, the risk of segregation and sectarianism looms large, Michaud argues: culture splinters into a myriad of autonomous subcultures, each with its own rules, artistic forms and values. Thus, he concludes, the democratisation of culture entails the threat of the 'disparition pure et simple de la communauté de goût' ('the downright disappearance of the commonality of taste'); *de-differentiation* slides into *non-differentiation* and then into *indifference*.[8] It is not difficult, however, to reply that the 'common taste' which is often nostalgically presupposed, could only exist as forcefully imposed on a more diversified practice.[9]

It is also important to realise that this notion of the commonality of taste has its roots in the philosophy of the Enlightenment, which so fundamentally contributed to the reflection on the function of the arts. The notion of the autonomy of the aesthetic developed by Kant was inseparable from the idea (or ideal) of a shared rationalism and of the commonality of pursuits, which had democracy as their political goal. Far from clearing the way for unbridled individualism, Kant's reflection on autonomy, both of the ethical and of the aesthetic, relied upon the conviction that a rational human being could not fail to want to act morally: the autonomy of the beautiful actually meant affranchisement from individualism. In this respect, Kant ultimately shares with Schiller the dream of art's contribution to the common good and to a just society, even if he would not agree with the latter's conviction that literature and art have a clear didactic and moralising function (as expressed in Schiller's notion of 'ästhetische Erziehung'). Art gives the subject an ideal image of his absolute autonomy and shows him the way of responsible freedom. Only one century later, with industrialisation and capitalism flourishing, the idyll of society and art or the artist acting in harmony had turned sour, and Mallarmé's retreat into art as an ivory tower expresses the end of this dream. It had been exchanged for another: the realm of art as essentially distinct – and at a utopian-critical distance – from the realm of politics, economy, and morality. This ideal finds its radicalisation

[8] *Ibidem*, pp. 57-63. This view is also strongly presented by Baudrillard, see Zima's discussion of his views in this volume.

[9] Which does not always mean that it was resented: there are enough testimonies to the liberating effects of the idea of a 'universal literature', a *République des lettres*, compared to sometimes stifling, very local interests; see, for instance, Chamoiseau, *Ecrire*, or Pierre Bergounioux, on the pleasure of discovering broader horizons through the 'imposed' culture. For a well-documented analysis of the tension between a centrally defined taste and literary norm, and the regional periphery, cf. Thiesse, *Ecrire la France*.

in Adorno's utopian-critical concept of the *Ästhetik der Negativität*, where art holds the role of the 'Statthalter unbeschädigten Lebens mitten im beschädigten'.[10] The cynical turn of history is that precisely the advent of democratisation has shattered this dream of commonality, is Michaud's dismal conclusion.[11]

But it is this interweave of the independence of art and that of the individual that makes the idea of the autonomy of art so precious to its defenders. It represents a refuge of individualism, the dream of escaping the laws of the marketplace. It is worthwhile meditating upon Isobel Armstrong's harsh judgement that the category of the aesthetic is 'the last bastion of the private self hubristically conceived as omnipotent creator ... the ultimate aggrandisement of the transcendent subject as master of its world'.[12]

Beyond the threat to individuality, one of the underlying but persisting anxieties of those who question the development of contemporary culture is that the utopian-critical function of art and literature, which was protected exactly by their autonomy, has come to an end. Indeed, if the arts become more closely tied to commerce, how can they hold their sting? In any case, belief in the social and political effectiveness of literature and art had already come under strong suspicion of naivety, because of the insight that no place is free from ideology, and because late capitalism so easily absorbs all critique, which gets safely stored away in the 'autonomous' and thus harmless realm of art. And whenever literature and arts did devote themselves to 'local' political agendas – socialist, Maoist, and so on – this led to disastrous artistic and social results, as the last century amply demonstrated. But as Hal Foster observes, 'it is this last moment (figured brilliantly in the writings of Theodor Adorno) that is hard to relinquish: the notion of the aesthetic as subversive, a critical interstice in an otherwise instrumental world'.[13] And why should we? The insight that literature does not display universal values, in complete autonomy, does not mean that, to individuals as well as communities, literature cannot be an important tool to explore the problematic experience of reality.

A similar dispirited reaction expresses itself in the conclusion that, in a pluralist society, literature – and art in general – can no longer contribute to collective memory; a view, again, defended by Michaud.[14] On the contrary, I would argue that the fact that memory has been diversified can be consid-

[10] 'The heeder of undamaged life in the midst of all the damaged' (Adorno, *Ästhetische Theorie*, p. 179).
[11] Michaud, *La Crise de l'Art Contemporain*, p. 240.
[12] Armstrong, 'Writing for the Broken Middle, The Post-Aesthetic', p. 63.
[13] Foster, *The Anti-Aesthetic*, p. xv.
[14] Michaud, *La Crise de l'Art Contemporain*, p. 129 and *passim*.

ered as one of the gains of democratisation of culture. Indeed, there is perhaps no common memory in the sense that history is lived and represented differently, according to whether one sides with the powerful or the marginalised, those who write history or those who undergo it. Accepting that a multiplicity of perspectives is inevitable seems to be the only way out. One should not absolutise one of them, but rather examine how the different perspectives complement and contradict each other. Take the example of South Africa: how can one expect literature to contribute to collective memory if not by offering precisely a host of conflicting perspectives on the experience of history (see the contribution of Margriet van der Waal in this volume)?

Thus, the democratisation of literature means a loss of autonomy in the sense that the arbitration of what (good) literature is has been pluralised – up to a certain degree, because the impact of the traditional professionals must not be under-estimated. Room has been made for different criteria, among which 'heteronomous' ones have acquired respectability. This plurality is certainly a serious challenge to contemporary culture, in as much as it requires new conceptions to regulate institutionalised access to literary culture and competence. But it can also be considered a positive achievement that different functions of literature are now more evenly acknowledged. In fact, people have written just as much for values considered 'heteronomous' or 'lower taste' – historical and social testimony, identity-constitution, consolation – as for 'autonomous' and 'highly literary' values such as critical reflection, or pleasure in the power of imagination and language. Critics and educational institutions only have to be more explicit as to which interpretive communities and which criteria form their frame of reference – which does not imply that no judgement can be formulated. To educational institutions, this means teaching literature not as an established value for the distinction it grants, as Bourdieu would call it, but to show how it can fulfil different functions. If one takes seriously the parallel between democracy in culture and democracy in politics, then the simple juxtaposition of incommensurable appreciations must be turned into a debate about values, conceptions, desired functions of literature and art.

Border wars or the end of literature?

Besides the changes in literary culture discussed above, there are also changes in the conception of the aesthetic and the literary that question literature's autonomy. Are we witnessing the end of aesthetic autonomy? In the case of literature, some developments seem to support this view.

Consider fictionality, for instance, a feature which has come to play a crucial role in defining (a part of) literature for two centuries, and which

currently seems much less evident. In its place, much contemporary litera-
ture seems to be fascinated by the real. There is a growing popularity of
works that hover as close as possible to real experience, either by merging
or associating with non-artistic discourses on reality, or by downplaying the
category of literariness. And, strikingly, the aesthetic-as-linked-to-the-
fictional seems to have emigrated from literature to everyday life. Indeed,
according to a fashionable analysis, post-capitalist society has been de-
scribed as a 'société du spectacle' (Debord), or stronger, as the reign of the
'simulacre' (Baudrillard). The pervasive media duplicate the representation
of life experience up to the point of evacuating precisely the coveted 'real-
experience' value, aided by the widespread practice of simulation games
which threaten the perception of the distinction between real and fictional.
Moreover, characteristic aesthetic categories such as ambiguity, fictionality,
artificiality, or at least 'constructedness', have been transferred to real life:
one is exhorted to shape one's personal life and identity as an autonomous
art work, and to organise valuable 'experiences' and 'moments of intensity'
deliberately, whether the exhortation comes from a Foucauldian 'esthétique
de l'existence' or from advertisements, magazines, or soaps.

 Thus, while one observes in everyday life an increasing fascination
with the virtual, the artificial and the aesthetic, literature – traditionally the
domain where these categories are placed in the foreground – seems to be
obsessed by the 'un-mediated real' and, as such, is prepared to risk its liter-
ariness. There is a strong tendency to cultivate documentary truth value, au-
thenticity, rejecting aestheticism and artistic conventions. Two manifesta-
tions of this phenomenon will be briefly discussed here: the blurring of
boundaries between literature and non-literary discourses; and the 'anti-
aesthetic', which means, in the case of literature, the tendency to subvert or
bypass conventional literariness. However, as I shall argue, this does not
necessarily mean that the idea of literature's distinctiveness as a cultural
practice has become obsolete.

 Throughout the history of its autonomisation, literature has been set off,
as an art, against non-artistic discourses with which it competed in the effort
to understand (historical, social, personal, religious) reality and experience.
It is mainly the novel which, as a proteic genre, has shown an impressive
capacity to incorporate other discursive (sub)genres, usually with the claim
of an increase in 'veracity': the letter, journalistic report, historical analysis,
scientific theory and methods of investigation, have found their way into
fiction. In this perspective, the invasion of contemporary literature by the
non-fictional is nothing new (but the question why this kind of writing still
desires the blessing of the 'literature' label, and how it at the same time
changes the value and meaning of literariness, deserves further investiga-
tion). There is a growing amount and popularity of works on the border be-

tween literature, understood as fiction, and ethnography, historiography, sociology, journalism, philosophy, and so on. Symmetrically, in these non-fictional disciplines, there is a wide-spread recognition that they share narrativity with literature, and literary techniques have gained acceptance, especially narrative techniques such as multiple perspective, psycho-narration, games with chronology, and characterisation.[15] Does this mean that the frontiers between the literary and the non-literary are actually disappearing?

In a sense, the domain of literature has been broadened to include genres in which the aesthetic – understood as attracting attention to the perception of form and to the representation itself through complexity, ambiguity, style etc. – is not placed in the foreground. In these genres, 'heteronomous' values – such as informativeness, and human, historical, sociological, ethnographic, moral or ideological interests – tend to dominate. But many writers of these intermediate genres are inclined to accentuate and exploit the hesitation about the kind of generic frame involved: is it fictional or factual? That which is ethically and ontologically acceptable within one generic frame can be unacceptable within the other. Part of the fascination that current practices of faction and autofiction exert may have to do with the evocation of simultaneous contradictory reading attitudes, and the play with expectations and evaluations, also with respect to an aesthetic categorisation in 'high' and 'low' literature. This hesitation itself draws attention to the formal and ideological aspects of the chosen conventions and genres, and thus invites aesthetic attention.

A popular border genre, for example, is ethnographic faction, successfully articulated by John Berger. Thus, a recognised writer like Pierre Bergounioux (France) claims not to invent any of his narrative material. His work *Miette* (1995) can hardly be called a novel, according to established standards. It is rather an ethnographic reconstruction of the life of a peasant family in the remote Limousin plateau in mid-France, during the whole span of the last century, which witnessed the end of an almost 'pre-historical' way of life. Descriptions of the utensils these peasants handled and of their material traces in the house and on the land, or the occasional sociological analysis of their condition, alternate with memories of the narrator's discovery of and relationship with these people. The author is very conscious of transgressing expectations concerning 'literature', and especially 'fiction'. In an interview he states:

[15] The work of new journalists like Tom Wolfe or of historicists like Hayden White or Frank Ankersmit are well-known examples.

> I don't consider myself as a novelist. I don't believe I have enough real capacity for invention ... I hardly ever veer from what I have been able to see with my own eyes.[16]

His *parti-pris* for reality-bound writing seems to spring from the desire to establish a kind of moral continuity between himself as an author, now member of the intellectual-artistic class, and the sober habitus of the peasant community by whose standards he appears to judge himself. But Pierre Bergounioux's style is almost provocatively sophisticated, including frequent literary and philosophical allusions, as if he aims at conveying upon his object the class distinction and dignity traditionally attached to high literature: his peasants are carried flamboyantly into the realm of the aesthetic.

At the same time, this brilliant style is mixed – and occasionally clashes – with features that mimetically represent the peasant's view of life and mode of speech, such as the idiosyncratic use of a *passe-partout* word like 'choses' (things), used with a striking frequency, sometimes more than seven times on one page. So the difference between straightforward ethnography and this kind of intermediate writing is the self-conscious use of language and devices for representation, which has a complex effect. It elicits an ethnographical, information-oriented, reading: a philosophical and sociological reflection on the representation of the life experience of those who do not have the words to do so themselves, and a reflection on the social and ideological factors affecting the (access to) aesthetic means of representation. Ultimately, it is a highly poetic exploration of the gap between things and words, and of the traces in time and space of human presence.

As for the blurring of boundaries between fiction and faction: the historical novel as well as autobiographic fiction are, of course, genres in which much experimentation with conflicting reading frames occurs. In historiography itself, there is a growing awareness of the role of narrativity and of the partiality of represented perspectives, in addition to suspicion of the claim to generality. This has led to renewed attention being paid to writings based on oral history, personal testimony, resulting in a certain literarisation of historiography, with Hayden White's work as a seminal influence. Literature, symmetrically, takes its pretensions to write an alternative history seriously. This has led to interesting intermediary genres that have become very popular, not surprisingly, in postcolonial literature and in literature produced by emancipating minorities who consider the re-writing of history as an imperative. But the perception of the boundaries between factual and fictional reading frames have all but disappeared, I would argue. This is primarily due to the fact that the expectations of factual accuracy and moral

[16] In Kéchichian, 'La Mémoire' (my translation, LKA).

integrity differ in both frames. This is clearly attested by a row like that about Helen Demidenko's allegedly autobiographical fiction, *The Hand that Signed the Paper*, as Ann Rigney showed.[17] In what was presented as authentic faction, to a certain degree, this young Australian writer claimed to reproduce the history of her Ukrainian father and his kin, accused of war crimes in the Second World War. As it turned out, neither her name nor the evoked characters were authentic, and her representation of historical facts appeared dubiously biased. Critics and readers reacted strongly to what was experienced not as the writer's creative liberty but as a breach of trust, which shows how strong the norms regulating the intermingling of fact and fiction, and the expectations relating to the author's ethos, actually are. By breaking the authenticity contract, many readers felt that this kind of work does not become simply fiction, but a lie.[18] Furthermore, just like ethnographic faction, historiographical and autobiographical faction can be called – and work as – literary faction in as much as they direct attention to their constituent features as representations of experience. When the Algerian novelist Assia Djebar, also a trained historian, uses French archive material to rewrite the colonisation of Algeria in *L'Amour, la Fantasia* (1985), she certainly means to offer a corrective and complementary view on official French historiography, which could be considered as a heteronomous interest. But her 'montage' and exhibition of archives is integrated in the whole novelistic composition in such a way that attention is drawn *at the same time* to the aesthetic and to the ideological dimensions of language and representation.

Another kind of literature that challenges 'literariness' or the 'aesthetic' – when understood as attention to artistic conventions and form – consists of works recognised as literary but which paradoxically aspire to the anti-aesthetic. In this domain, several issues can be at stake.

The conscious rejection of literariness in the sense of fictionality and conventionality can come from the attempt to capture in words the immediacy of raw experience and sensation, the 'morsure du réel', through the avoidance of conventional means of expression. Paradoxically, this can only mean the invention of new conventions. The longing for the real as the always-elusive referent seems only to have increased in our over-mediatised everyday life. The aesthetic, in the defined sense, is readily equated with inauthenticity, and becomes a superfluous and annoying intermediary. Direct, 'visceral' experience and sensation are appreciated, rather than literary craftsmanship and tradition. It is tempting to draw a parallel with cultural/economic analyses such as Pine and Gilmore's, who distinguish new

[17] Rigney, 'What's in a Name?'.
[18] See on this point also Cohn, *The Distinction*.

strategies in contemporary society to sell products by stressing their 'experience' potential: to sell means to organise experiences; the ethics of capitalism is replaced by the cultivation of sensation and direct emotion, cognitive distance has to be abolished.[19]

This anti-aesthetic position is frequently linked to the rejection and even 'subversion' of elite culture, with which conventional literariness is associated, especially in literature representing the experiences of the marginalised and the excluded. There is a significant revival of the social novel, with writers themselves originating from the marginalised world that is depicted. Such works also come from established authors who interestingly combine solidarity with the 'excluded' and a highly conscious rejection of conventionally aesthetic means of representation.[20] This search leads to new experiments that draw attention to language and representation, and thus paradoxically to a new anti-aesthetic aesthetics.

The same happens in contemporary autobiographical writing, perhaps the most flourishing of contemporary genres. It covers the whole spectrum, from straightforward 'journal' to the most sophisticated self-reflexive writing. Again, this leads to interesting borderline cases that play with conflicting expectations and thus emphasise the representation as such. Such reflexivity is especially rewarding in this kind of writing claiming 'authenticity'. Take the French cult author Christine Angot or the American Dave Eggers, for example, who publish 'auto-fiction' in which the authenticity of the voice, with all its effects of pathos, plays a central role: they seem to epitomise our culture of narcissism, indulging freely in the lack of all aestheticising distance. Eggers admonishes his public in clear words:

> People, friends, please:
> TRUST YOUR EYES, TRUST YOUR EARS, TRUST YOUR ART![21]

Angot's ex-husband, who is the narrator in her indirect auto-portrait *Sujet Angot*, conjures her to use just real, authentic material:

> Mets les mots de Léonore. Prends des phrases de moi … La seule chose que j'aime vraiment c'est tout ce qu'on a vécu … C'est d'une émotion.[22]

[19] Pine and Gilmore, *The Experience Economy*.

[20] As in the 'dirty realism' of writers such as Irving Welsh (*Trainspotting*) or Virginie Despentes (*Baise-moi*).

[21] Eggers, *A Heartbreaking Work*, p. 34.

[22] 'Take Léonore's [their daughter] words. Take my sentences … The only thing I really like is all we lived … It has such emotional value' (Angot, *Sujet Angot*, p. 93).

But to the attentive reader, these claims of immediacy and authentic expression become suspect precisely because of their hyperbolic insistence, and tricky *mises en abyme*: Eggers stages his alter ego in an interview with the director of a real-life TV show, and shows him prepared to take any guise she thinks 'sellable': authenticity thus appears to be easy to fabricate. Angot turns her *autoportrait by proxy* into an ironic representation of the impossibility to get any hold on the self. The interesting thing is that both works can actually be read, and have been read, straightforwardly as a deeply emotional self-pursuit, *and* ironically as a reflection on that kind of self-representation.

A last example I shall indulge in here is the 'literary' work of Catherine Millet, a well-known French art critic. As a critic, she firmly rejects the merging of art and reality and defends the specificity of the art object, opposing modern art's tendency towards de-differentiation with the necessity of aesthetic 'distance': 'écran qui évite que les gestes de l'artiste ne se dispersent dans la totalité du réel'.[23] Her criterion for real art, in good Adorno tradition, is its resisting alterity. In her own 'literary' work, however, Millet does everything to challenge this credo: *La Vie Sexuelle de Catherine M.*, published by the famous literary editor Seuil in a collection named 'Fiction et cie.', is a seemingly non-fictionalised account of the writer's own intensive sex life, featuring quite openly an incredible amount of easily recognised public personalities. There is very little aesthetic distance here, it seems, and much food for thought about the ethical and aesthetic borders between real life and art.

The invasion of literature by adjacent discursive genres indeed means an opening up of literature to functions other than the strictly aesthetic. If one takes a descriptive perspective on literature, however, there is no need to deplore this development. The collusion of traditional literary writing with competing discursive genres and media, especially television and film, creates new artistic challenges. It can be argued that, just like earlier annexations of extra-literary genres by the novel, these contemporary mixtures produce their own artistic effects, although this does not mean that the notion of literature remains unchanged. It is also interesting to observe that writing – in whatever genre, but still with a pretension to being 'literature' – apparently still fulfils a crucial function, as emancipating individuals and collectives massively take to the literary narrative to impose and expose their own stories and their own versions of history.

[23] 'Screen that prevents that the artists' gestures get dispersed into the totality of the real' (Millet, *L'Art Contemporain*, p. 105).

Literature between ethics and aesthetics

This last section focuses on a motif that runs through the preceding pages: ethics' claims on literature, contesting its autonomy. During the twentieth century, the development of literary studies into an autonomous academic discipline went hand in hand with the evacuation of the traditionally prominent concern for ethical issues within the study of literature. Especially in structuralist and semiotic approaches, the pursuit of scientific objectivity required a separation between the subject and the object of research, making an ethical approach to narrative fiction inappropriate for epistemological reasons and also obsolete; interest in the ethical 'matter' or workings of literature tended to follow suit. Ironically, while literary scholars carefully avoided the question of ethics, moral philosophers, dissatisfied with Kantian deontology as well as with utilitarian ethics, suddenly rediscovered literature, especially the novel. Even those thinkers who had criticised 'humanism' most fiercely, such as Foucault, Derrida and Lyotard, started to reflect explicitly on their own post-modern ethics, and their reflections have been 'applied' (by themselves and others) to literature. Interestingly, they transfer to ethics some crucial characteristics of the aesthetic: ambivalence, plurality, and the idea of the constructedness of personal existence, as in Michel Foucault's 'aesthetics of existence' or Richard Rorty's proposal for ironical ethics based on the playful acceptance of the multiplicity of 'vocabularies'. This has been interpreted as a takeover of ethics by aesthetics, as if aesthetic openness and flexibility offered a model for ethics more adequate for postmodern times. But the reverse can be argued as well, and perhaps a taboo on the ethical dimension of art and literature has been lifted, as will be discussed in this last section.

The relationship between morality and literature is both intimate and conflictive, as we have known since Plato. In the middle of the eighteenth century, Kant formulated his thesis of the autonomy of the aesthetic – which is not the same as the arts –, free of interest. To Kant, as mentioned earlier, this did not mean that the aesthetic divorced itself completely from the ethical. But later generations have tended to interpret this autonomy of the aesthetic as the independence of art from morality, as in the well-known provocative formulations of Théophile Gautier or Oscar Wilde. Writers and poets claimed and obtained room for transgression and the right to explore freely the dark side of human being and society. This kind of autonomy is deeply linked to liberal democracy, to freedom of thought, of invention, and of expression. This moral auto-nomy or 'self-rule' finds its limits defined

by the law, the overarching rule.[24] Nonetheless, it is a very vulnerable achievement, which comes under pressure as soon as political, social or military circumstances legitimate the moral or political enrolment of the arts. Not surprisingly, public exhortation to art and literature to be more explicitly committed increased after '9/11'; but since the beginning of autonomisation, there have been intense debates about literature's vocation, oscillating between autonomy and engagement, and even attempting to combine the two.[25]

Has the 'ethical turn', which arose in the groves of Academe in the eighties, offered a direct threat to the autonomy of literature? In fact, the wide spectrum it shows does not allow an easy answer. The scale ranges from the requirement of a clear moral commitment from writers and critics alike, to Deconstructivist ethics precisely undermining any intention of moral closure. In some approaches, literature hardly retains any aesthetic autonomy, as moral judgement prevails. Martha Nussbaum, for instance, although claiming a flexible approach to ethics and attentiveness to the complexities of literary form, ultimately judges literary works according to their contribution to 'a consistent and sharable answer to the "how to live" question ... To this extent its flexibility is qualified by a deep commitment to getting somewhere'.[26] She values literature's potential for moral elevation, and considers aesthetic and/or ethical complexity or ambiguity as instrumental to an ultimately moral experience. Literature's ethical effectiveness shows itself in the strengthening of the moral autonomy of the subject, not in aesthetic autonomy.

At the other end of the spectrum, Derrida also argues that literature has no real autonomy, but applies very different arguments: literature parasites upon other discourses; it is no thing in itself, and is better described as an attitude, a way of framing texts. Literature is an approach to discourse where discourse turns upon itself, questions itself, comes into crisis.[27] Though it needs free play, its effects target the 'real world'. In the wake of Derrida, Levinas and Blanchot, Andrew Gibson argues that the novel's

[24] The legal contours of the freedom of expression and of transgression, which is such an important component of autonomy, form an important, often neglected aspect. Even in contemporary Western countries, there are more cases of direct and indirect censorship than many realise, with interesting cultural differences. See, for instance, the recent work by Edelman and Heinich, *L'Art en Conflits*, which, from a sociological and legal point of view, discusses the challenges brought by new transgressive practices of art and the (legal) sanctions they incur.

[25] See Heumakers's contribution to this volume.

[26] Nussbaum, *Love's Knowledge*, p. 28.

[27] See on this point Derek Attridge's interview with Derrida, in Jacques Derrida, *Acts*, pp. 33-75 *passim*).

ethical function lies in its 'form which ... dissolves any given set of cogni-
tive horizons'.[28] Literature is the place where morality, understood as deonto-
logical, is exposed in its rigidity and partiality, and set off against the disrup-
tive power of imagination and ambivalence. The ethics offered by literature,
in a post-modern reading, is 'a kind of play within morality, [which] holds it
open, hopes to restrain it from violence or the will to dominate, subjects it
to a kind of auto-deconstruction'.[29]

Though concerned with a very different kind of ethics, both Nuss-
baum's 'Aristotelian' and Derrida's deconstructive reading agree that the
critic has a (social, moral) responsibility.[30] To Derrida and his kindred spir-
its, however, much more than to Nussbaum, it is clearly the aesthetic 'turn-
ing-upon-itself' of the text that allows ethical reflection to work. It is pre-
cisely the autonomy of the literary, appearing in a specific reading attitude,
which guarantees its ethical impact by keeping open the moment of 'unde-
cidability' triggered by the text, thus creating space for alternatives. This
conception of ethical reading as the suspension of judgement has been criti-
cised as 'just free play', but need not stand in opposition to the demand of
moral engagement on the part of the reader. Ethical reflection on literature,
on art in general, requires a *va-et-vient* relationship between this kind of
suspension of judgement, which allows a temporary adoption of value posi-
tions other than one's familiar value positions, and a reaction of the type
'here I am', 'here I stand', which is demanded of us in everyday life.[31] This
is precisely the ethical work that reading can force us to perform.

Here again, at the junction between aesthetic autonomy and reflective
ethics, lies an important role for literary education, as this kind of reading
attitude is not a given but the result of training. In this respect, it can be ar-
gued that aesthetic education is a pre-condition of ethical reflection.

Conclusion

Crisis marks a moment of change. Something comes to an end. In our case,
the self-evident value of literature and its presumed 'autonomy' are extinct.

[28] Gibson, *Postmodernity*, p. 91.
[29] *Ibidem*, p. 15.
[30] Derrida writes: 'What is sometimes hastily called deconstruction is ... at the very
least, a way of taking position, in its work of analysis, concerning the political and
institutional structures that make possible and govern our practice ... Precisely be-
cause it is never concerned only with signified content, deconstruction ... should
seek a new investigation of responsibility' (quoted in Bernstein, *The New Constella-
tion*, p. 187).
[31] On this topic, see Ricoeur's careful reflection on the ethical dimension of (read-
ing) literature and on 'narrative identity', in *Soi-même comme un Autre*.

In fact, its 'functional' autonomy seems historically very relative, more an effect of perspective, a representation, or even just wishful thinking, than an established fact. With the democratisation of literature, new participants, new forms and 'heteronomous' functions are claiming explicit recognition and legitimacy. This indeed entails an intense renegotiation of definitions and frontiers between literature and non-literature, between literature and the adjacent arts, media and discourses, which, in turn, create new artistic opportunities. But literature does appear to have various, quite distinct functions, and it can also be considered an enrichment to see these acknowledged. The history of literature, especially of the novel, does not really invite pessimism regarding literature's capacity to absorb such developments.

However, the crisis in institutions dealing with literary education must be taken seriously. In our pluralistic, multicultural society, there is more need than ever for education in the arts and literature: not – or not just – as cultural heritage, although that function is important enough, but as vital and varying ways of configuring the perplexities of experience. Training in aesthetic attitude – paying attention to ways of perception and representation, and the suspension of judgement – fulfils some functions that seem crucial to democracy: it opens up space for imagination, and evokes alternatives to the existing state of the world; it upholds what is perhaps a necessary illusion, that of the autonomy of the individual, against the lucid recognition of far-reaching economic, sociological and biological determinisms. (Reading) literature explores the area where instinctive preferences and social mechanisms become value and choice.

AESTHETIC AUTONOMY AND LITERARY COMMITMENT

A PATTERN IN NINETEENTH-CENTURY LITERATURE

Arnold Heumakers

The poet, novelist, and critic Théophile Gautier is known as one of the first public defenders in France of the idea of *l'art pour l'art* or 'art for art's sake'. In the provocative and witty preface to his first novel *Mademoiselle de Maupin* (1835), he attacks both the bourgeois moralists who complain about the lack of ethics in modern literature and the Saint-Simonians and Fourierists who try to instrumentalise art and literature for their own humanitarian goals. According to Gautier, they are absolutely wrong in demanding that art and literature obey the laws of morality and social progress. Art and literature have their own laws, which can by no means be measured by ethical or utilitarian standards. Beauty, and nothing else, is the goal of all art, and, as Gautier makes perfectly clear:

> Il n'y a que de vraiment beau que ce qui ne peut servir à rien; tout ce qui est utile est laid, car c'est l'expression de quelque besoin, et ceux de l'homme sont ignobles et dégoûtants, comme sa pauvre et infirme nature. L'endroit le plus utile d'une maison, ce sont les latrines.[1]

Elsewhere in the preface, Gautier defends pleasure as the only goal in life, denies the existence of progress (asking if one single new cardinal sin has been invented since the beginning of time), and confesses that he would gladly renounce his political rights in exchange for seeing an authentic painting by Raphael or a beautiful woman in the nude. All this is fun to read and, despite the obvious irony, it seems impossible to misunderstand Gautier's position: in his view, art and literature constitute an autonomous kingdom, in which beauty rules supreme.

[1] 'Only that which is of no use can be truly beautiful; what is useful is ugly, as it is the expression of some need, and the needs of man are unworthy and disgusting, as is his poor and handicapped nature. The most useful place in the house is the latrine' (Théophile Gautier, *Mademoiselle de Maupin*, p. 54). N.B. All translations of the citations from the French and German, given in the footnotes, are by the editors.

Less well known, however, are several articles that the same Théophile Gautier wrote and published in 1848, the year in which a republican revolution put an end to the reign of the *roi-citoyen* Louis Philippe d'Orléans. Gautier cordially accepted the new Republic on condition that it would not bring back the spectres of 1793, such as the guillotine and the Jacobin Terror. This time he admitted his faith in progress. First there had been slaves, then serfs, and today there are proletarians – but they too will soon be able to liberate themselves, according to Gautier, as machines assume the toils of labour.

The most revealing passage is the one in which Gautier speaks about the limits of equality. He opposes what he calls 'l'égalité des envieux' ['the equality of the envious'] who cannot accept that people are not identical. A certain inequality is therefore inevitable, as well as the existence of an aristocracy: 'Il y aura toujours parmi les hommes une aristocratie que nulle république ne supprimera, celle des poètes'.[2] It comes as no big surprise: the poets are the inevitable aristocracy, even in a republic. But wait and see what Gautier means by a poet:

> Par poète nous n'entendons pas seulement ceux qui assemblent des rimes, mais nous ramenons ce nom à son beau sens grec – ceux qui font ou qui créent – le conquérant, l'artiste, le législateur, le savant sont des poètes, lorsqu'ils ont trouvé une idée, une forme, une vérité, un fait; autour de ces centres lumineux le reste de l'humanité s'équilibre et gravite avec le même plaisir impérieux que le satellite autour de sa planète.[3]

Here is reason for surprise indeed, because this generous definition of the poet seems, to say the least, very hard to reconcile with any conception of a non-utilitarian *l'art pour l'art*. If even the conqueror, the legislator, and the scholar are considered poets, poetry must necessarily be of some, not to say great, public use. In another article written in 1848, Gautier underlines the use of art in a more traditional way. Art has a function in modern civilisation, precisely because this civilisation is dominated by 'the useful' (*l'utile*); utilitarianism makes everything look horrible, resembling human

[2] 'There will always be found among men an aristocracy that no republic can abolish, that of the poets'.
[3] 'By poet we do not only intend those who assemble rhymes, but we refer this name to its beautiful Greek meaning – those who make or create – the conqueror, the artist, the legislator, the scholar are poets when they have found an idea, a form, a truth, a fact; around these sources of light the rest of humanity finds its equilibrium and gravitates with the same necessary pleasure as the satellite around its planet'. (Théophile Gautier, *Fusains et Eaux-Fortes*, p. 234). My attention to this and similar articles was drawn by Bénichou, *L'Ecole du Désenchantement*, pp. 566-573.

beings who walk around with their skin turned inside out and with bones, veins, and organs visible.

What is lacking is beauty, and this is where art comes in: 'Il faut que l'art donne l'épiderme à la civilisation, que le peintre et le sculpteur achèvent l'œuvre du mécanicien', writes Gautier, who makes it clear that he is fully prepared to accept civilisation as it stands, including railways, steamboats and machinery.[4] In yet another article dating from 1848, he even gets seriously excited about modern balloons. If only one would be able to steer them properly, balloons would 'immediately change the face of the earth', according to Gautier; and he finds it hard to understand why every inventor, scientist, mechanic, chemist, and also every poet, is not occupying himself day and night with this vital issue.[5]

Again, there is no mention at all of *l'art pour l'art*. Tasks that can only be referred to as 'useful' are assigned to the artist as well as to the poet. Why is all this attention being devoted to the inconsistencies – for that is what they appear to be – in Théophile Gautier's aesthetic convictions?

In a long essay on the 'parfait magicien ès lettres françaises' to whom he dedicated his *Les Fleurs du Mal*, Baudelaire regrets Gautier's 'quelques paroles laudatives à monsieur Progrès et à très puissante dame Industrie'. Baudelaire tries to explain the weakness of his friend and master by arguing that contempt can occasionally make one's soul too benign, that is to say: Gautier had not meant a word of what he had said, but preferred to live in peace even with industry and progress – 'ces despotiques ennemies de toute poésie'.[6]

Baudelaire might be right – it would not have been the first time Gautier had displayed opportunistic behaviour. During the July Monarchy he had written at least one official poem honouring the martyrs of the Revolution of 1830 as well as the Orléans-dynasty.[7] Rather than attempt to explain Gautier's particular convictions, however, it may be more

[4] 'Art should provide civilisation with a skin, the painter and the sculptor must complete the work begun by the mechanic' (Gautier, *Souvenirs*, pp. 202-203).

[5] Gautier, *Fusains et Eaux-Fortes*, pp. 262 and 259.

[6] '... the great magician of French literature ... the few laudatory words dedicated to sir Progress and to the very powerful lady Industry ... these despotic enemies of all poetry'. (Charles Baudelaire, *Œuvres complètes*, vol. II, p. 128).

[7] Bénichou, *L'École du désenchantement*, p. 503. The poem concerned is *Le 28 Juillet* (Gautier, *Poésies Complètes*, vol III (ed. Jasinski), pp. 229-236). As Bénichou points out, Gautier showed similar opportunistic behaviour during the Second Empire when he profited from his friendship with the Emperor's niece Princess Mathilde, while at the same time defending the idea of *l'art pour l'art*; of course, this is not necessarily a contradiction.

interesting to examine another approach that draws attention to a pattern in
which his paradoxical convictions might find a proper place.

First we have to realise that Gautier was by no means the only defender
of *l'art pour l'art* who exchanged this conviction for a more socially and
politically committed point of view, at least temporarily. Baudelaire himself
is another example. Never an unconditional supporter of *l'art pour l'art*, he
nonetheless considered 'l'idée de l'utile' to be the most hostile opponent of
'l'idée de beauté'. The same Baudelaire, who, in his *Salon* of 1846,
confessed to his readers how much he enjoyed the sight of a policeman
beating up a republican, collaborated with a journal called *Le Salut du
Peuple* in 1848, in which republican artists and the beauty of 'le peuple'
were highly praised. Three years later, in an article on the revolutionary
poet Pierre Dupont, Baudelaire wrote about 'la puérile utopie de l'école de
l'art pour l'art'.[8]

One wonders whether this really is the same poet as the one who will
soon regret Gautier's praise of progress and industry and who, in 1862, will
be defended by Gautier against the accusation of immorality with the
following argument: 'En art, il n'y a rien de moral ni d'immoral, il y a le
beau et le laid, des choses bien faites et des choses mal faites'.[9] The same
argument is made, almost literally, in Oscar Wilde's famous preface to *The
Picture of Dorian Gray* (1891): 'There is no such thing as a moral or an
immoral book. Books are well written, or badly written. That is all'.[10]

It is no coincidence that I mention Oscar Wilde at this point, as he can
serve as the third and, for this occasion, last example of unstable *l'art pour
l'art* aestheticists. Wilde, of course, wrote *The Soul of Man under Socia-
lism*, in which socialism (although a rather peculiar, highly individualistic
brand) was not at all presented as a danger to the soul – on the contrary. A
few years earlier, having established that 'the people are suffering, and are
likely to suffer more', he ended an article entitled *The Poets and the People*
with the burning question: 'Where is the poet who is the one man needful to
rouse the nation to a sense of duty and inspire the people with hope'?[11] A
truly amazing question, coming from Oscar Wilde.

The least we can say by now is that most enthusiasm for *l'art pour l'art*
apparently has an antipole with which it cannot easily be reconciled, at least
at first sight. There seems to be a clear contradiction between, on one hand,

[8] '... the childish utopia of the school of art for art's sake'. (Baudelaire, *Œuvres
Complètes*, vol. II, p. 26).
[9] 'In art, there is nothing moral or immoral, there is the beautiful and the ugly, well-
made things and things badly made' (Gautier, *Fusains et Eaux-Fortes*, p. 308).
[10] Oscar Wilde. *The Artist as Critic* (ed. Ellmann), p. 235.
[11] *Ibidem*, p. 45.

the extreme confirmation of aesthetic autonomy (obvious in any statement that makes art and literature its proper goal) and, on the other, expressions of faith in a more or less socially and politically committed art and literature. Yet both positions are present in the same poets and writers, although generally not at the same time. Are they simply at odds with themselves, or is there some sort of connection that can illuminate the juxtaposition of these seemingly contradictory points of view?

Here, the pattern I suggested can come to our aid. Let us examine its components. I propose to begin with the idea of aesthetic autonomy, of which the notion of *l'art pour l'art* must be considered the paroxysm.[12] As far as we know, the concept appeared for the first time in the diary of Benjamin Constant, in an entry of 10 February 1804 , when he and his lover Madame de Staël were visiting Weimar. Constant mentions a visit by Schiller and a conversation with a young Englishman, Henry Crabb Robinson, a pupil of Schelling's, who had written a study on Kant's aesthetics in which Constant finds 'des idées très énergiques'. And then he remarks: 'L'art pour l'art, sans but, car tout but dénature l'art'.[13]

It is not my intention to reconstruct, as far as this would be possible, the manner in which Constant's private slogan found its way via the liberal philosopher Victor Cousin and others into the literary polemics of the July Monarchy, where Théophile Gautier must have picked it up. The main reason for quoting Constant is to draw attention to the German origin of the concept, although it would be a serious mistake to identify the extreme, sometimes even amoral positions of Gautier, Baudelaire, or Wilde with the painstaking earnestness of Kant's philosophical aesthetics.

Common ground, nevertheless, is found in the idea of aesthetic autonomy, which, in his *Kritik der Urteilskraft* (1790), Kant defined in relation to the judgement of taste as 'reinen uninteressierten Wohl-gefallen'[14] and which, before Kant, had already been defined by Goethe's friend Karl Philipp Moritz – now in relation to the beautiful work of art – as the 'in sich selbst Vollendeten'.[15] That is to say: the really beautiful must always be understood in opposition to the useful, which will never be

[12] On *l'art pour l'art* in France, see Cassagne, *La Théorie*. On the German origins of the idea, see Wilcox, 'The beginnings'. Of interest is also Bell-Villada's *Art for Art's Sake*, and Egan's 'The Genesis'. Surprisingly, there is no separate study on the invention of aesthetic autonomy in the eighteenth century. Most helpful have been Abrams's, 'Art as Such' and 'From Addison to Kant'.

[13] '... very powerful ideas ... Art for art's sake, without goal, as all goals bereave art of its nature' (Benjamin Constant, *Journal Intime*, p. 159).

[14] '... pure disinterested well-being' (*Kritik der Urteilskraft*, p. 41).

[15] '... in itself perfected' (Moritz, *Schriften*, pp. 3-9).

perfect in itself. I do not think that Gautier, Baudelaire or Wilde would have disagreed.

Neither did the early German Romantics, the brothers Friedrich and August Wilhelm Schlegel, Novalis, and Schelling, who made this idea of aesthetic autonomy their article of faith. In one of his *Athenäums-Fragmente*, Friedrich Schlegel writes:

> Eine Philosophie der Poesie überhaupt würde mit der Selbständigkeit des Schönen beginnen, mit dem Satz, dass es vom Wahren und Sittlichen getrennt sei und getrennt sein solle, und dass es mit diesen gleiche Rechte habe.[16]

His brother August Wilhelm resists, in his *Kunstlehre*, the idea of the useful in relation to art and considers it desirable that any serious poetics should start with the confirmation of the 'Autonomie der Kunst'.[17] In the same Kantian spirit, Schelling relates, in his *System des transzendentalen Idealismus* (1800), the 'Heiligkeit und Reinheit der Kunst' directly to a total 'Unabhängigkeit von äussern Zwecken'.[18] Although rarely explicit on the subject of aesthetic autonomy, Novalis describes poetry in one of his fascinating notebooks as 'ein gebildeter Überfluss – ein sich selbst bildendes Wesen' that should not try to have any 'effects'.[19]

These ideas can be seen as the outcome of a long process, which was initiated in the Renaissance, of the emancipation or liberation of the arts from the traditional religious, political, and moral constraints. In the eighteenth century, the century in which the arts were finally united in one 'system'[20] – and thanks to Baumgarten's invention of 'aesthetics', they acquired their own philosophical discipline – this process found its theoretical justification in Moritz's and Kant's proclamation of aesthetic autonomy.

Yet neither Kant nor Moritz would have denied the moral significance of art, despite their clear demarcation of the difference between art and literature, on one side, and the traditional ethical, political, and religious demands, on the other. To Moritz, contemplation of a beautiful work of art,

[16] 'A philosophy of poetry would in general have to start with the independence of the beautiful, with the proposition that it is, and should be, separated from the true and the moral, and that it has equal rights to these'. Cf. Schlegel (Friedrich), *Schriften*, p. 53.

[17] Schlegel (August Wilhelm), *Die Kunstlehre*, pp. 13 and 15.

[18] '... holiness and purity of art ... independence of external goals' (Schelling, *Texte*, p. 115).

[19] '... a created (cultivated) wealth – a self-creating being' (Novalis, *Schriften, II.*, p. 757).

[20] Kristeller, 'The Modern System of the Arts'.

perfect in itself, could regenerate the human being who had been distorted by the modern division of labour, whereas Kant considered the beautiful to be an idea of the good, and art and its enjoyment a non-negligible incentive for social life. The early Romantics put even more trust in the possibilities of art, or rather 'poetry', since they maintained that poetry was the real essence of every form of art.[21]

To them, the autonomy, independence, and freedom of the aesthetic functioned as the necessary condition that enabled them to decide, from a sovereign position, the relationship between art or poetry and the world of politics, religion, and morality. There can hardly be any doubt about the importance they were willing to allocate to art and poetry in the modern reconstruction of the world of politics, religion, and morality. Confronted with the confusion of Enlightenment criticism and the political disaster of the French Revolution, only an 'aesthetic education of mankind' (to quote Schiller's famous *Briefe* on this subject) could offer a salutary solution.

In the so-called *Älteste Systemprogramm des deutschen Idealismus*, written by Schelling, Hegel or Hölderlin in 1796-1797, the anonymous author puts all his trust in aesthetics and expresses the hope that, in the near future, poetry will again become what it had been in the beginning: 'Lehrerin der Menschheit'. After that had been accomplished, all other arts and sciences would dissolve into poetry, and the end result would be an 'allgemeine Freiheit und Gleichheit der Geister'.[22] Poetry would supposedly be able to perform this miracle by means of a 'new mythology', an idea that must have haunted the minds of nearly all early German Romantics. Dreams about this kind of 'new mythology' keep recurring in their texts, most prominently in Friedrich Schlegel's *Gespräch über die Poesie* (1800), where it is advanced as the privileged way to a complete regeneration of humankind.[23]

[21] See, for instance, Friedrich Schlegel's *Gespräch über die Poesie*. As an answer to the question 'Ist denn alles Poesie?', this little exchange follows: 'LOTHARIO: Jede Kunst und jede Wissenschaft, die durch die Rede wirkt, wenn sie als Kunst um ihrer selbst willen geübt wird, und wenn sie den höchsten Gipfel erreicht, erscheint als Poesie. LUDOVIKO: Und jede, die auch nicht in den Worten der Sprache ihr Wesen treibt, hat einen unsichtbaren Geist, und der ist Poesie' ['But is everything poetry, then?' LOTHARIO: all art and all science that works through language, when, as art, it is done for its own sake, and when it reaches the highest peaks, takes on the appearance of poetry. LUDOVIKO: And even when it is not done in the words of language, it has an invisible spirit, and that is poetry'] (*Schriften*, p. 296).

[22] 'the teacher of mankind ... the overall (general) freedom and equality of minds (spirits, souls)' (Jamme and Schneider, *Mythologie*, pp. 11-14).

[23] See the 'Rede über die Mythologie' in Schlegel's *Gespräch* (*Schriften*, pp. 301-307). On the Romantic notion of a 'new mythology', see Frank, *Der kommende Gott*, and some of the contributions to Bohrer, *Mythos und Moderne*.

When one sees how Schlegel and Novalis tend to enlarge the field of poetry to include everyone and everything, the question inevitably arises as to how all this can be considered as partaking of the autonomy of the aesthetic. If everything is art or poetry, what remains of the meaning of autonomy? A possible answer is that, in this case, aesthetic autonomy also enlarges itself to cover all of reality, so that the difference between art and reality eventually disappears. Indeed, Novalis and Friedrich Schlegel describe the world as a work of art that continually produces itself.[24] To them poets and artists are the ones who take charge, so to speak, of the human part of this cosmic creativity. Poets and artists are the seers, the prophets, and the priests, who, on account of their inner genius, are able to understand what is going on. Their creative activity presents them with a symbolic image of the whole and allows them to perform, for the rest of humankind, or just for the nation, the role of spiritual and political guide.[25]

[24] In his *Gespräch über die Poesie*, Friedrich Schlegel calls the world an 'ewig sich selbst bildendes Kunstwerk' ['a work of art forever creating itself'] (*Schriften*, p. 308). Novalis denies that nature and art are different: 'Die Natur hat Kunstinstinkt - daher ist es Geschwätz, wenn man Natur und Kunst unterschieden will ['Nature has an instinct for art – which is why it is nonsense, these attempts to separate nature from art'] (*Schriften*, vol. II, p. 810.)

[25] Discussing the primary condition of poetry in his *Gespräch über die Poesie*, Friedrich Schlegel writes: 'Ja, wir alle, die wir Menschen sind, haben immer und ewig keinen andern Gegenstand und keinen andern Stoff aller Tätigkeit und aller Freude, als das eine Gedicht der Gottheit, dessen Teil und Blüte auch wir sind – die Erde. Die Musik des unendlichen Spielwerks zu vernehmen, die Schönheit des Gedichts zu verstehen, sind wir fähig, weil auch ein Teil des Dichters, ein Funke seines schaffenden Geistes in uns lebt und tief unter der Asche der selbstgemachten Unvernunft mit heimlicher Gewalt zu glühen niemals aufhört' ['Yes, we all, as humans, will forever have no other object or subject of activity and enjoyment but that one poem of the deity, of which we are both part and blossoming – the earth. We can hear the music of the infinite instrument, we can grasp the beauty of the poem, because part of the poet, a spark of his creating spirit, lives in us and never stops glowing with a secret ardor, deep under the ashes of our self-made unreason'] (*Schriften*, pp. 279-280). And Novalis about the prophetic quality of poetry: 'Nichts ist poetischer, als Erinnerung und Ahndung oder Vorstellung der Zukunft' ['Nothing is more poetic than remembrance, and conjecture or imagination of the future'] or 'Der Sinn für Poesie hat nahe Verwandtschaft mit dem Sinn der Weissagung und dem religiösen, dem Sehersinn überhaupt' ['The sense of poetry is strongly related to the sense of prediction and to the religious, to the sense of prophecy as such'] (*Schriften*, vol. II, pp. 283 and 840). Moreover, the connection between poetry and prophecy is one of the main issues in Novalis's unfinished novel *Heinrich von Ofterdingen*. There one can read about the ancient Greek poets: 'Sie sollen zugleich Wahrsager und Priester, Gesetzgeber und Ärzte gewesen seyn ...'. ['They are said to have been at the same time prophets and priests, legislators and medical doctors']

I refer to this position, which I can only roughly sketch here, as 'the totalisation of art'. Its counterpart would be the position of which the French *l'art pour l'art* doctrine is the most extreme example. There, art does not coincide with the world, but forms a separate and absolute domain, an autonomous world with its own rules and laws. It may seem that only this last position is really in accordance with the idea of aesthetic autonomy. However, we should keep in mind that the first position, the one I have called 'the totalisation of art', is no less conditional on aesthetic autonomy. Without it, there simply would be no space for artists and poets to assume their role of spiritual and political guides of humankind. In a way, the Romantic poets see themselves as a reincarnation of the first legislators and creators of civilisation, who, according to ancient tradition, are supposed to have been the first poets as well.

No one performed the role of spiritual and political guide better than Victor Hugo, who, in his youth, was the inspired defender of the Catholic faith and the Bourbon monarchy, and subsequently the 'Olympic' supporter of a liberal romanticism, and then the personification of the resistance against Napoleon III while in exile on Jersey and Guernsey during the Second Empire (by some scholars considered to be one of the high tides of *l'art pour l'art*).[26] In his book on William Shakespeare (1864), Hugo explicitly compares the modern visionary poet with his distant ancestors and defines their common task:

> Le poète arrive au milieu de ces allants et venants qu'on nomme les vivants, pour apprivoiser, comme l'Orphée antique, les mauvais instincts, les tigres qui sont dans l'homme, et, comme l'Amphion légendiaire, pour remuer toutes les pierres, les préjugés et les superstitions, mettre en mouvement les blocs nouveaux, refaire les assises et les bases, et rebâtir la ville, c'est-à-dire la société.[27]

In the same book Hugo attacks the doctrine of *l'art pour l'art*, championing instead a concept of art that promotes and supports progress and justice. But simultaneously, Hugo does not deny the idea of aesthetic autonomy: 'Rester fidèle à toutes les lois de l'art en les combinant avec la loi du progrès, tel est

(*Schriften*, vol. I, p. 257); the task of the modern poet (in the novel: the medieval poet) is to recover these qualities lost since Antiquity.

[26] See, for instance, Cassagne, *La Théorie*.

[27] 'The poet arrives among these comers and goers that we call the living, to tame, as in the ancient Orpheus, the bad instincts, the tigers that live in man, and, as the legendary Amphyon, to shake the stones, the prejudices and the superstitions, setting in motion the new blocks, reconstruct the basements and the foundations, and re-build the city, that is to say, society' (Hugo, *Œuvres Complètes. Critique*, p. 411).

le problème, victorieusement résolu par tant de nobles et fiers esprits', he declares.[28] That it is not a recently acquired conviction becomes clear when we look back at an article from 1834. There, Hugo firmly resists 'l'utilité directe de l'art' that was demanded of poets and artists by the socialist sects that aroused the anger of Théophile Gautier about the same time. Hugo finally comes to the following synthesis:

> Il faut, après tout, que l'art soit son propre but à lui-même, et qu'il enseigne, qu'il moralise, qu'il civilise et qu'il édifie chemin faisant.[29]

This underlines the point I wish to make. What Victor Hugo presents here as a synthesis is actually a combination of possibilities which also could have been chosen separately. On the basis of the recently-invented aesthetic autonomy, a pattern becomes visible within which these two possibilities, the totalisation of art and the idea of art as an absolute on its own, resemble two divergent yet occasionally intersecting paths. I suggest that there can be no absolute mutual contradiction since they share the same origin, which, in a way, is also the origin of the modern (or Romantic) idea of art.

If I am right, it must be this pattern that we see at work in the amazing inconsistency of aesthetic conviction in the minds of Théophile Gautier, Charles Baudelaire, and Oscar Wilde. Even for these generally staunch defenders of *l'art pour l'art*, the promise of a totalisation of art and the ensuing social and political commitment always remained a serious temptation.

In order to understand why this was the case, it is useful to take a closer look at Hegel. We ought to ignore the young and ambitious Romantic and possible author of the *Älteste Systemprogramm des deutschen Idealismus* (the text is in his handwriting) and investigate the systematic philosopher who presented his lucid *Vorlesungen über die Ästhetik* many years later. Hegel obviously had lost all of his earlier Romantic aspirations by then. In these lectures, he developed a view of contemporary art that turns out to be the exact opposite of the high hopes for aesthetics, art, and poetry that he had expressed in the *Systemprogramm*. Scholars usually refer to this new view as Hegel's notorious thesis of the 'end of art'.

According to Hegel, all this means that, for modern man, art has lost its metaphysical necessity in relation to man's knowledge of truth and the

[28] 'To follow all the laws of art, combining them with the laws of progress, that is the problem that was victoriously solved by so many noble and proud spirits' (*ibidem*, p. 436).

[29] 'After all, art should be its own goal, teaching, moralizing, civilizing, and edifying along the way' (*ibidem*, p. 58).

Absolute. Art once possessed this necessity: in bygone times, knowledge and experience of God or the gods, for instance, could only be obtained through the medium of art. Religion, in those days, really was a 'Religion der Kunst', Hegel claims, although not implying that art as such was revered (as in the cult of *l'art pour l'art*), but rather that the gods and saints were worshipped in their artistic appearances.[30] However, as Hegel sternly declares, 'die schönen Tage der griechischen Kunst wie die goldene Zeit des späten Mittelalters sind vorüber'. Nowadays art is 'nach der Seite ihrer höchsten Bestimmung für uns ein Vergangenes'.[31] This erstwhile function of art has since been taken over by the subjective inner religion of Protestantism and, successively, by the free thinking of Hegel's own philosophy.

As a consequence, art, devoid of its highest calling, is confronted for the very first time by itself, by its own freedom or, to put it in a less rose-coloured way, its vacancy. And so is the artist: reduced to subjectivity, he can randomly choose any form and any content. In this situation of utter relativism, Hegel concluded, the need for a science of art is much more urgent than in the past. This kind of science would have been superfluous when art still fulfilled its task as a privileged medium of truth because at that time 'die Kunst für sich als Kunst schon volle Befriedigung gewährte'.[32] Art was taken for granted, and being the only medium of truth, Greek art was not under the rule of an external authority. Therefore Hegel can uphold with some justice that it was the artists and poets who 'created' the gods - simply because no one else did.[33]

But does this mean that Greek art was already an autonomous art? In some sections of his *Ästhetik*, Hegel seems to take this point of view, as when, for example, he argues that art always finds its final goals in itself, and that 'Belehrung, Reinigung, Besserung, Gelderwerb, Streben nach Ruhm und Ehre' have nothing to do with works of art as such.[34] Yet, the dependence of art on truth and the Absolute indicates its essentially heterogeneous nature. Art becomes autonomous, implying freedom as well as vacancy and relativism, only after it has lost its privileged revelatory function. That is to say, Hegel's 'end of art' actually coincides with the modern invention of aesthetic autonomy.

[30] Hegel, *Vorlesungen über die Ästhetik, I/II* (ed. Bubner), p. 171.
[31] '... the beautiful days of classic Greek art, like the Golden Age of the late middle ages, are gone ... in view of its highest destiny, art to us is something that belongs to the past' (*ibidem*, pp. 49-50).
[32] '... art in itself, as art, already guaranteed full satisfaction' (*ibidem*).
[33] *Ibidem*, pp. 168-169.
[34] '... instruction, purification, improvement, making money, striving after fame and glory' (*ibidem*, p. 108).

Until now, I have presented this autonomy in terms of liberation or
emancipation of art from traditional bonds of religion, morals, and politics.
Fully living up to his reputation as philosophical dialectician, Hegel
presents the same phenomenon in terms of an irrevocable loss.

The point is not to decide which presentation is correct, but rather to
pay attention to the tension between the paradoxical extremes of liberation
and loss. After all, the same tension can be detected in the ideas of the
Romantics, who did not reckon with something as drastic as the 'end of art'
in any way. All the same, they imagined themselves living in a time that
was not particularly well disposed towards poetry and art. According to
August Wilhelm Schlegel in 1803, all the arts were 'im tiefem Verfalle'
because the spirit of the times favoured the useful and the practical.[35] He
criticised the *Aufklärung* for its 'ökonomische Geist', its 'politische
Rechenkunst', and its educational ideals, sacrificing fantasy and play to a
form of 'Sittlichkeit' in which Schlegel could detect nothing else but 'öko-
nomische Brauchbarkeit', and nipping all poetry in the bud for the younger
generation.[36] No wonder he was forced to conclude 'dass jedes Zeitalter in
Rücksicht auf Poesie und Kunst vorzüglicher sei als das unsrige'.[37]

Considering this harsh judgement of the present, shared by many
Romantics, their nostalgia for the past comes as no surprise. When August
Wilhelm's brother Friedrich passed the Wartburg near Eisenau on his way
to France in that same year, 1803, he deeply mourned the times 'da die
Poesie hier in voller Blüte stand, und durch ganz Deutschland das
allgemeine Element des Lebens, der Liebe und der Freude war'.[38] In addi-
tion to the Middle Ages, Ancient Greece was another favourite object of
Romantic nostalgia, thanks to Winckelmann, who had pictured ancient
Greek life as immersed in art and poetry. But, unlike Hegel, who declared
the beautiful days of Greek art and the golden age of the late Middle Ages
to be gone forever, the Romantics were convinced of a future resurrection.
Their programme of a totalisation of art, as I have called it, was actually
meant to bring them back.

[35] '... in deep decline' (Schlegel, *Geschichte*, pp. 44-45). The title of the section
from which the quotation comes: 'Allgemeine Übersicht des gegenwärtigen Zu-
standes der deutschen Literatur'.
[36] 'economic spirit ... political calculation ... moral(ity) ... economical benefit' (*ibi-
dem*, pp. 60-62).
[37] '... that every age, with regard to its poetry and its art, is better than ours' (*ibidem*,
p. 77).
[38] '... the times when poetry fully flowered here, and when it was, throughout Ger-
many, the general element of life, love, and happiness' (Schlegel, *Reise nach Frank-
reich*, p. 2).

Contemporary hostility toward art and poetry did not discourage them. On the contrary, they believed as skill-ful dialecticians that the negative would produce the positive almost automatically. August Wilhelm Schlegel even defended the *Aufklärung* he had criticised so severely as something necessary in the *Bildungsgeschichte*. However, he continued,

> In der absoluten Schätzung bleibt dem ungeachtet das Negative, was es ist; wenn schon für mich, so wie zwei Verneinungen in der Sprache wieder bejahen, indem ich das Negative als negativ setze, wieder ein Positives daraus wird. Wie chemische Verwandtschaft durch Entgegensetzung bedingt ist, wie der negative Pol eines Magneten den positiven eines anderen anzieht, so ruft ein Extrem sein entgegengesetztes hervor.[39]

In his famous speech *Die Christenheit oder Europa* (written in 1799), Novalis spoke of 'eine Oszillation, ein Wechsel entgegengesetzter Bewegungen' that was 'wesentlich' of each time and period. Besides growth and decay, what could also be expected with certainty was 'eine Auferstehung, eine Verjüngung, in neuer, tüchtiger Gestalt'. Was it not true, after all, that 'fortschreitende, immer mehr sich vergrössernde Evolutionen' were the 'Stoff der Geschichte'?[40]

In spite of their bleak view of the present, these Romantic writers allowed themselves to be extremely optimistic about the future. They even announced the recovery of the lost Golden Age – with Novalis being one of the most persistent here. In the notes for his unfinished novel *Heinrich von Ofterdingen*, one reads simply: 'Das ganze Menschengeschlecht wird am Ende poetisch. Neue goldne Zeit'.[41] This would be the end result of the aesthetic revolution that he and his Romantic friends were preparing.

To put the perspective right, it is important to emphasise the novelty of this future Golden Age. It would not be simply a copy of the past. To Novalis and the Schlegels, history never literally repeated itself. History was progress, receiving direction from its final goal that, in a peculiar way, was also a return to the beginning. Or as Novalis expressed himself in one

[39] 'In an absolute estimate it [the Enlightenment] remains, no matter what, the negative, which it is; although to me, as when two negations in speech again affirm, if I put the negative negatively, it yields again a positive. Like chemical relationships that are determined by opposition, like the negative pole of a magnet that attracts the positive of another, an extreme evokes its opposite' (*Geschichte*, p. 81).

[40] 'An oscillation, a change of opposite movements ... typical/essential ... a resurrection, a regeneration, in a more excellent form ... progressing, constantly extending evolutions ... the substance of history' (*Die Christenheit oder Europa* in: *Schriften*, vol. II, p. 735).

[41] 'In the end, all mankind becomes poetic. New golden age' (*ibidem*, vol. I, p. 397).

of his notebooks: 'In der künftigen Welt ist alles, wie in der ehmaligen Welt - und doch alles ganz anders.'[42] In the eyes of these Romantics, the past, whether real or mythological, offered the model or paradigm for the future. They resembled the historian, whom Friedrich Schlegel in one of his *Athenäums-Fragmente* defined as 'ein rückwärts gekehrter Prophet'.[43]

Advocating a totalisation of art and presenting themselves as seers and prophets, as high priests of the coming reign of art and poetry, they announced (as Novalis did in *Die Christenheit oder Europa*) 'eine universelle Individualität, eine neue Geschichte, eine neue Menschheit' or, in so many words, 'eine neue goldne Zeit'[44] and put all their faith in the – revolutionary if necessary – course of history. The future, not the past, was their main concern. To them, modern aesthetic autonomy was indeed a liberation, an opportunity for art and poetry to recover their lost position in society as a holy source of meaning and cohesion.

By contrast, the French supporters of the idea of *l'art pour l'art*, who transformed art and poetry into an absolute of its own, separated from the rest of society, had apparently lost all faith in history. To them, the past was not a source of models or paradigms for the future, but rather a refuge from the deeply despised present. Rejecting any form of social or political commitment, they retreated into exotic dreams, creating an ancient, mediaeval or oriental world that suited their eccentric taste.

'Je suis un homme des temps homériques', says the protagonist of Théophile Gautier's novel *Mademoiselle de Maupin*, 'Le monde où je vis n'est pas le mien, et je ne comprends rien à la société qui m'entoure'.[45] In his *Histoire du Romantisme*, Gautier wrote about himself at the time of the famous 'bataille d'Hernani' in 1830. He considered himself not a 'dilettante de Saint-Just et de Maximilien de Robespierre', as did some of his more politically oriented friends, but 'plutôt moyen âge, vieux baron de fer, féodal, prêt à nous réfugier contre l'envahissement du siècle'.[46] To him, too, ancient Greece and the Middle Ages were the main points of historical reference, but their actual meaning was reversed.

In *Mademoiselle de Maupin*, Gautier gave a concrete image of the refuge from history he was dreaming of: a big, square building with no

[42] 'In the coming world everything is as in the world that was - and yet completely different' (*ibidem*, vol. II, p. 514).

[43] '... a prophet turned backwards' (*Schriften*, p. 33).

[44] '... a universal individuality, a new history, a new mankind, a new golden age (*Schriften*, vol. II, p. 745).

[45] 'I am a man from Homeric times ... the world in which I live is not mine, and I don't understand the society that surrounds me' (*Mademoiselle de Maupin*, p. 226).

[46] '... rather middle age, old baron of steel, feudal, ready to hide for the invading century' (Gautier, *Histoire du Romantisme*, p. 96).

windows on the outside, accommodating a large colonnaded inner court of white marble with a crystal fountain in the middle. An oriental atmosphere prevailed, as barefoot black people with golden rings around their legs and beautiful, slender white servants moved between the arcades from time to time. In the words of Gautier's hero D'Albert,

> Moi, je serais là, immobile, silencieux, sous un dais magnifique, entouré de piles de carreaux, un grand lion privé sous mon coude, la gorge nue d'une jeune esclave sous mon pied en manière d'escabeau, et fumant de l'opium dans une grande pipe de jade. [47]

This image of an exotic, secluded place, sealed off from the ugly present, and situated in a most paradoxical, timeless past, recurs almost literally in Baudelaire's famous poem *La Vie Antérieure*. It also left a significant stamp on Joris-Karl Huysmans's novel *À Rebours* (1884), the poisonous 'yellow book' in which Oscar Wilde's protagonist Dorian Gray reads 'the story of his life, written before he had lived it'.[48]

This image expresses an intrinsic disenchantment with modern, bourgeois life that is difficult to overlook. But it also expresses disappointment with the high hopes of the earlier Romantics, who had put their faith in history and in a Utopian totalisation of art. The aesthetes of *l'art pour l'art* clandestinely shared these high hopes, as their occasional inability to resist the temptation of poetical and artistic commitment unmistakably suggests. To them, aesthetic autonomy was simultaneously a liberation and an irrevocable loss. Unable to restore artistic religion as the expression of a society immersed in art and poetry, they finally made art into an exclusive and demanding religion for the happy few who shared their cult of beauty and their disappointment with a possible totalisation of art.

High expectations and bitter disappointment motivated the pattern that structured an important part of nineteenth-century art and literature. The question arises as to whether this pattern is limited to the nineteenth century. One can argue, for instance, that the pole of the totalisation of art has continued to attract many of the twentieth-century Avant-garde movements. Expressionists, Futurists, Surrealists, and others yielded to the temptation which Gautier, Baudelaire, and Wilde had not always been able to resist. They dreamed of a total aesthetic revolution that would create a new world

[47] 'I will be there, immobile, silent, under a magnificent canopy, surrounded by piles of pillows, a big private lion under my elbow, the naked breasts of a young slave under my foot as a footbench, smoking opium in a big pipe of jade' (*Mademoiselle de Maupin*, p. 235).
[48] Wilde, *The Picture of Dorian Gray*, p. 112.

and a new man, as an updated version of the new Golden Age predicted by
a visionary Romantic such as Novalis in the eighteenth century.

On the other hand, one can also argue that so-called 'modernist' writers
such as James Joyce, Samuel Beckett, Vladimir Nabokov, and many others,
stuck to one form or other of *l'art pour l'art*. Did Joyce's Stephen Dedalus
not exclaim in *Ulysses*: 'History is a nightmare from which I am trying to
awake'?[49] Beckett's tragicomical tramps, forever waiting for Godot, would
burst out in laughter at the mere thought that their minimal adventures could
possibly be connected to the hope of an aesthetic revolution. Confronted by
objections by moralists and advocates of political commitment, Nabokov
obstinately denied that literature was meant to offer anything else but
'aesthetic bliss'.[50]

Thus, the twentieth century witnessed the appearance of the same
elements that formed the pattern in the previous century. Whether the
pattern also repeats itself is, of course, a different question. To answer this
question, it would be necessary to elaborate more fully on the continuity
from visionary Romanticism to the Avant-garde movements and from *l'art
pour l'art* to Modernism. It would also be necessary to cover the tension
still felt between liberation and loss implied in Hegel's thesis of the 'end of
art', as a consequence of the modern invention of aesthetic autonomy. For
the moment, it suffices to have sketched the pattern itself of the intriguing
relationship between the totalisation of art and art as an absolute. We should
not overlook this relationship if we wish to discuss the contemporary status
– and even the possible withering away – of aesthetic autonomy, this auton-
omy being the necessary precondition of both the options that are involved
in the pattern.

[49] Joyce, *Ulysses*, p. 42.
[50] Nabokov, 'On a Book Entitled Lolita', p. 332.

FROM 'WORK OF ART' TO 'TEXT' AND 'THING'

THE CONTRA-FACTURE OF THE SYMBOLISTS' CONCEPT OF ARTISTIC CREATION IN THE ART AND LITERATURE OF RUSSIAN AVANT-GARDISM

Rainer Grübel

> The only works of art which count nowadays are those which are no works of art anymore.
> Theodor W. Adorno[1]

The problem of the work of art

This article investigates the functional transformation, or contra-facture,[2] of genres and works of art in the context of the development from 'the art of life' in Symbolism to 'the life of art' in Post-symbolism. It focuses on the reification of the work of art, its transformation into a 'thing' ('vešč") in Suprematism and in the verbal art of Russian Futurism, as well as on the invention of a new literary ('poetical') language.[3] This literary language ('Zaum'') should be free of conventional meaning, with the words functioning as proper names. With regard to the structure of the artefacts, this transformation is described as the step from *composition* to *construction* and, with regard to the change of aesthetic concepts, as the replacement of the 'work of art' by the 'text'. In the course of this process, the concept of the autonomous creation of objects, independent of their contexts, is replaced by the idea of constructing products that are related to their place in the universe and to the history of perception. With respect to the problem of reference, we shall trace the Utopian character, the project quality of the artistic construct, throughout the process. Finally, this essay

[1] Adorno, *Philosophie*, p. 33.
[2] In German: Kontrafaktur, from the Latin *contrafactura*. Related to the work of art or text as an institution, the notion 'contra-factura' is a terminological innovation. In German literary criticism the expression 'Kontrafaktur' is used with respect to the functional and value change of genres (cf. Verweyen/Witting, *Die Kontrafaktur*; Grübel, 'Chlebnikov's Zangezi').
[3] Cf. Grygar, 'Über die Auffassung'.

attempts to outline the conceptual character of art in the Avant-garde on the one hand, and in Socialist Realism and Post-modernism on the other.

The transition from the 'work of art' to the 'vešč' or 'text', was accompanied by a change from a more normative poetics to a more descriptive version (particularly in Russian Formalism). This process, which originated under the erstwhile special social and cultural conditions in Russia, was first spread to other European countries by artists (such as Kandinsky, Malevič, Gončarova), and then by critics and theoreticians of art and literature (Roman Jakobson, Karel Teige, Jan Mukařovský). It resulted in the widespread idea of the 'auto-poetic' function of works of art and literary texts.

The sudden change of nineteenth-century Russian culture, which had been strongly influenced by Positivism and Realism, to a Modernism shaped by Symbolism and Avant-gardism appears as a split, a radical switch, with regard to the conventions covering the concepts of 'work of art' and 'genre'. Modernism took a position contrary to the late eighteenth-century idea of 'work of art', contrasting the universality of literal communication with the regionality of oral communication. Modernism also rejected the Romantic notion of the work of art, which promoted aesthetics as a counterfoil to the instrumentalism of scholarship[4] and, in doing so, introduced an extended model of literariness.[5] Humboldt had already made it quite clear that all historiography has to use imagination, and Danto later demonstrated its narrative structure.[6] The fragmentation of reality in scholarship seemed to be overcome in pictorial and verbal artefacts, which, precisely because of their fragmentary character, once again claimed to be able to refer to an infinite world.

The Romantic concept of the 'work of art' was based both on the genetic principle of 'originality' and on a nature-and-culture-integrating element. In Russian, this power of a non-sublimated, untamed natural energy is called the 'element' ('ėlement'). However, the transcendent power of the volcano or the wild ocean was disciplined in the romantic work of art by the introduction of the sublime. The sublime, given in the content of the picture or the verbal text, is transferred in Modernism to the level of the expression. Now the surface of the picture, the sound or grapheme structure of the poem itself, represents the sublime. Thus in Mayakovsky's tragedy *Vladimir Mayakovsky* (1913), the traditional, sublime heaven with its stars is de-sublimated in favour of the sign structure of the word, which, on the basis of sound and letter similarity, constructs a close connection between

[4] Adorno, *Philosophie*, p. 33.
[5] Gossman, *Between History and Literature*.
[6] Danto, *Analytic Philosophy*.

the words 'if', 'to love', 'to kill', 'love', 'execution', 'to seduce', 'heaven', and 'milk': 'esli b', 'ljubit'', 'ubit'', 'lobnoe', 'rastlili b', 'nebo'. The traditional heaven, awe-inspiring because of its amazing dimensions, is seduced here by means of the iconicity of words, which form a special sound- and icon-structure in the poem. Thus, the power and sublimity of heaven and the promise of an innocent Paradise with milk (and probably honey) are presented through the words (here displayed in italics):

Если б вы так как я, *любили,*	*If* you, like me, would *love,*
вы *убили любовь*	You would *kill love*
или *лобное* место нашли	Or for *execution* find a place
и раст*лили б*	And would *seduce*
шершавое потное *небо*	The rough sweaty *heaven*
и мо*лочно*-невинные звезды.[7]	And *milky*-innocent stars.

In the poet's declaration of love to the universe, love as a *condition humaine* seduces the terror of the sublime, transforming it into the poetic form of sound and iconic hyperbola.

In the course of the nineteenth century, history itself had been invented as a generic principle. Tolstoy's novel *War and Peace* (resp. *War and World*) is the best Russian example of this idea. To Hegel and his followers, it was history (or more precisely: the history of the 'Weltgeist', the spirit of the world itself) that seemed to produce culture, and it was the philosopher who became the authoritative agent of world history and declared the end of art. Again, Tolstoy agreed with him, this time in his essay *What is art?* In spite of these changes, the 'work of art' was still declared – notwithstanding the tradition of the Enlightenment – to be a symbol of creative interpretation rather than of rational cognition.[8] The work of art had become an interpretative experience ('Erlebnis').[9] A common knowledge of works of art among reading society guaranteed the possibility of mutual understanding. Quotations from canonic works of art became signals of education, engendering membership of an interpreting civic community. It was for this reason that the German philologist Friedrich Gundolf could call his opus magnum *Der Geist der Goethezeit* ['*The Spirit of Goethe's Time*'].

Our main question is whether the discontinuity in the explicit and implicit habits of working with the notion 'work of art', as well as with the corresponding notion of 'genre', can or even should be regarded as a symptom and as a *movens*, i.e., a moving force, in the striking disruption of the

[7] Mayakovsky, 'Vladimir Mayakovsky', p. 162.

[8] Biti, *Literatur- und Kulturtheorie*, p. 832.

[9] Dilthey, *Das Erlebnis.*

historical progression in literature and culture, and whether it thus functions as a factor in a shift of paradigms. This change could be related to the search for compensation for the growing fragmentation of the world that was occurring in scholarship and technique, in society and economy. The autonomy of the creating subject and its product must somehow be involved in this process of replacing the work of art by texts or 'things' that, in extreme cases, are non-mimetic, abstract, and do not refer to a reality outside themselves. The author of a fictional world, the painter of a surface that presents a constellation of colours and figures similar to those in the world outside of art, has now been replaced by a constructor who assembles colours and forms, produces montages of sounds and letters in order to create an object that is not a secondary phenomenon because of its likeness to objects in the 'real' world, but a phenomenon with its own intrinsic value. Thus the autonomy of the artist creating *ex nihilo*, gifted with genius, has been replaced by the habit of a workman who uses given materials and invents possibilities to combine them.

Conditions underlying the changes in Russian culture at the fin-de-siècle

In his essay *The Crisis of Art*, read as a lecture in 1917 between the February and October revolutions, the influential Russian philosopher Nikolai Berdyaev observed that the art of his era seemed to be taking two different directions. One of them, exemplified by Stéphane Mallarmé's poetry and Richard Wagner's opera, strove for synthesis, whereas the other was characterised by an analytic tendency.[10] Like Wagner's 'Gesamtkunstwerk' ('sintezis iskusstv'), the pictures of Mykolas Čiurlionis displayed an inclination toward a disastrous 'synthesis of art', in Berdyaev's view. The philosopher conceived this art as a 'product of differentiation' ('produkt differenciacii')[11] and considered the aspiration to synthesis to be a kind of regression. The composer Aleksandr Skriabin himself, Berdyaev argues, traced this 'synthesis of art' back to mystery. He finds the most prominent theoretician of the *Gesamtkunstwerk* in Russian Symbolism in Vjačeslav Ivanov, who propagated a new type of theurgist art, unifying Christianity with the Old Greek Dionysian model of art.[12] Both Wagner's and Ivanov's aims are not a new step within art, but rather a catastrophic switch to the creation of life. Indeed, Ivanov tried to reinstate the chorus of the Greek tragedy as a collective representative of the (re-)unified people. Berdyaev

[10] Berdyaev, *Krizis iskusstva*, p. 16.

[11] *Ibidem*, p. 4.

[12] This idea of art originated in Nietzsche's differentiation between Dionysian and Apollonian art.

warns us that 'Ivanov is a remarkable poet, but in our time, which is not orientated toward conciliation,[13] his theoretical attempts could turn out to be a danger to the autonomy of art'.[14] His words appear indeed strikingly premonitory: we are reminded of the fact that, after the October Revolution, propagandists of proletarian art transformed Ivanov's 'theatre of conciliation' into a collective model of art that had to serve a political cause. Thus Ivanov's pseudo-religious theatre paved the way for the 'social commandment' ('social'nyj zakaz') in Socialist realism and for the 'Gesamtkunstwerk Stalin'.[15]

Cubism and Futurism, on the contrary, were seen by Berdyaev as the most prominent representatives of the analytic wing of modern culture. In his view, they divide the organic (which in itself is a romantic topos) into parts, leading to dematerialisation and de-crystallisation. The word becomes, as it were, separated from the 'Logos'.[16] The philosopher considered the crisis of art, which presented itself in both directions of modern culture, to constitute a break with the tradition of classicism, marking the end of Renaissance in Russian culture, while also being a symptom of a general crisis of life. He thus interpreted the barbarism of Russian Futurism as an 'industrial war',[17] in which the human being is replaced by the machine, and even as the herald of the Apocalypse.

Russian Symbolism and Russian Avant-gardism emancipated the work of art, which was now seen as nothing more than a text or a thing, from the constraints of authoritative interpretation, and vested the interpretive sovereignty in the reader or listener. In doing so, they replaced the symbolic concept of the work of art with an allegorical one. According to this allegorical concept, it became the function of the text or 'thing' to make new experiences possible and to request an explanation. On the level of the text itself, this change can be read as a contra-facture of the model of the work of art,[18] the production of a kind of 'anti-art', which, in the framework of the radicalised aesthetics of innovation in Russian Formalism,[19] repeatedly assigns new meaning to the text, finding new interpretations for one and the

[13] The Russian word 'sobornost'' designates conciliation, initially in a religious sense and later in a secular sense, in the late nineteenth century. It was a catchword of the philosophy of Vladimir Solov'ev and later served as a fundament in Bakhtin's philosophy of the dialogue.

[14] Berdyaev, *Krizis iskusstva*, p. 5.

[15] Groys, *Gesamtkunstwerk Stalin*.

[16] Berdyaev, *Krizis iskusstva*, p. 11. Logos, in this Johannine sense, is the incarnation of eternal meaning in the word.

[17] *Ibidem*, p. 22.

[18] Grübel, 'Zitate'.

[19] Hansen-Löve, *Der russische Formalismus*.

same text. Traditional points of reference, such as the intention of the author,[20] the genesis, genre, cycle of texts, and style, lose their previous function as a guarantee of meaning and sense, and the text relinquishes the synthetic function that shaped it as a complete whole[21] and typified it as an iconic picture of a totally integrated world in the sense of Hegel's *Encyclopaedia of the Spirit.*

In Postmodernism,[22] the dethronement of the text as a guarantee for the continuity of meaning in favour of an open notion of 'text', which dialogically[23] relates to its texture[24] in the form of quotations, answers, and reinterpretations, can be seen as having been induced by the literary practice of Russian Modernism. The contemporary claims for the openness of the system, as well as the endlessness of innovation, seem to have had their origin in the studios and studies, in the cafés and theatres, and in the institutes and debating clubs of Saint Petersburg and Moscow.[25] From the turn of the century onward, Russian Symbolism elaborated a net of motifs reaching far beyond the borders of a single work of art or even of an œuvre. Thus we find, during the second period of Symbolism, a system of motifs that organises a model of the world from cosmogony (chaos and cosmos), time and eternity, the fluidity and fugacity of time, to the music of the spheres, the opposition of sun and moon, the astral cosmos, light, including day and night, Mother Earth with her vegetation, and the symbols of water.[26] Even writers who did not join the Symbolist movement, like Vasily Rozanov (1856-1919), exploited this net of motifs and contributed to it. Rozanov interpreted the sun as heterosexual gravitation and the moon as homosexual gravitation, when he constructed his poetical texts as 'fallen leaves'.[27] The isolated text takes on the role of merely a partial statement that is integrated into the unified extensive text of all works of art in

[20] This creation of meaning manifests itself, for instance, in the standard question of schoolteachers up to the end of the twentieth century: 'What did the author mean to say?' If this method has any effect, it is grounded on the presumption that asking about the intention of the author opens the way to the meaning of the text. However, this meaning is constructed by the pupil, creating a picture of the author (in the Russian language of literary criticism: 'obraz avtora') to whom this meaning can be attributed. If the teacher has created a similar picture of the author, he will accept the meaning, which is attributed to the text by the pupil.

[21] Müller and Wegmann, 'Tools'.

[22] As argued by Barthes in *Sade, Fourier, Loyola*, and in *Le bruissement de la langue*, or by Foucault in *L'ordre*.

[23] Bachtin, *Problemy tvorčestva*.

[24] Greber, *Textile Texte*.

[25] Schlögel, *Petersburg 1909-1921*; Ingold, *Der grosse Bruch*.

[26] Hansen-Löve, *Der russische Symbolismus*, vols. 1 and 2.

[27] Grübel, *An den Grenzen der Moderne*.

Symbolism. With the autonomy of the text, the autonomy of the author is also affected by this process: whereas Tolstoy, writing *War and Peace* (1864-1869), created not only a whole world, but also its historical laws, the symbolist Aleksandr Blok gave a merely fragmentary sketch of the revolutions of 1917 when he wrote the poem 'The Twelve' (1918). And it was not he who found the interpretation of the historical event – the return of Jesus Christ as the leader of the twelve (!) revolutionaries – but the poem itself that, with its rhyme 'rose' – 'Christós', induced this interpretation.

Recent efforts to reconstitute the notion 'work of art' by basing it on a complex of intercommunicating texts on the one hand, and on the interpretive power of methods developed in universities[28] on the other, may be seen as a continuation of the development of concepts for the 'work of art' during the transition from the nineteenth to the twentieth centuries and during the subsequent two decades. The same applies to the conception of the 'work of art' as a collection of procedures of selection, which realise their literary form in the medium, conceived as a source of possibilities.[29]

Analogous to the radical break in the notion of text around 1900, we can observe a reinterpretation of the concept of genre. This process starts with the German Morphological School and with Russian Formalism. But the question is whether or not their reversion to Goethe's distinction of 'natural form' ('Naturform') and 'literary species' ('Dichtart') preserves the differentiation between the stable natural and the variable cultural (historical) dimensions of the phenomena beyond the range of the single text.[30] However, attention ought to be paid to the fact that the Formalists' distinction between 'poetical language' ('jazyk poėtičeskij') and the 'prose of everyday life' ('bytovoj jazyk') implies a differentiation that is as much trans-historical as Goethe's 'natural forms'. And it is no less interrelated to culturally developing genres that correspond to the 'literary species' of the German author. At any rate, Bakhtin's concept of genre memory[31] offers the possibility to base constancy and variability on cultural and intercultural foundations. His 'memory of genre' suggests a bridge from the historical moment to cultural synchrony, as well as from a single culture to a (dialogic) chorus of cultures.

Meyer's idea that an evolution of genre concepts parallels the evolution of genres and that the two parallel processes are mutually influential[32] also applies to the disruption of genres and the conceptualisation of completely

[28] Müller and Wegmann, 'Tools'.
[29] Plumpe, *Ästhetische Kommunikation*; Biti, *Literatur- und Kulturtheorie*, p. 835ff.
[30] Cf. Propp, *Morfologija*, and Tynjanov, 'O literaturnoj ėvoljucii'.
[31] Bachtin, *Problemy poėtiki*, and *Voprosy literatury i ėstetiki*.
[32] Meyer, 'Gattung'.

new genre notions. And it offers a possibility to confront the concrete and time-bound genre of a certain text in its historical moment not only with the history of this genre but also with the history of its concepts. Considering Gérard Genette's genre concepts,[33] the question arises as to whether the network of texts and kinds of texts[34] that he conceived might not require some external institution supporting this system, and whether the breaks in the configuration of the consciousness of genres might determine the manner in which the clusters of attribution are distributed and the kind of relevance they could possibly gain at all. In a way, this model of genres implies a detached observer who may even be outside of its synchronic validity.

Three theses are advanced here:

1. In the nineteenth century, we notice the dominance of notions of 'work of art' and 'genre' that conceive the creator of a work of art and the user of a genre as an institution, intentionally working on a natural ground and generating culture.
2. In the twentieth century, a 'textile' interactive notion of text increasingly replaces the hieratic concept of the work of art (implying the autonomy of the artist); and at the same time a concept of classes of texts, sensitive to the context as well as to the medium, takes the place of the autonomous notion of genre.
3. During the transition from the nineteenth to the twentieth century, the dethronement of the notion 'work of art' and the discontinuities in the theory of genre have their starting point in text practice as well as in aesthetic theory.

The radical nature of cultural change in Russian Modernism corresponds to a cultural self-understanding, which, due to the missing Renaissance cultural period, is dominated not by a culturological point of view, but by a culturosophical one. In an article written and published in conjunction with my colleague Igor' Smirnov five years ago, we differentiated the culturosophical way of thinking from the culturological one[35] on the basis of the fact that the former uses only two types, diametrically opposed to each other, whereas the latter uses more than two. The mediaeval dichotomy of the holy and the earthly world is conserved as a structure and remains valid in the opposition of the Western and the Slavophil positions. It is always characterised by a rigid opposition of values: one culture (always the bad

[33] Cf. Genette, 'Genre'; *idem, Introduction, Seuils* and *L'œuvre de l'art.*
[34] Cohen, 'Do Postmodern Genres Exist?'.
[35] Grübel and Smirnov, 'Geschichte'.

one) is present and another (the good, the ideal one, of course) is projected into the future.

Combining religion and philosophy, Solov'ev's 'all-embracing unity' project at the end of the nineteenth century created a secularised philosophy in the form of a 'theory of the beautiful in nature and culture', constituting, for the first time, a point of reference for Russian cultural self-recognition. It goes without saying that this project (as well as Fedorov's idea of the necessity to perfect God's creation of the universe) tries to compensate the threatened loss of meaning that results from an extremely fragmented 'world of life'. The invention of the German term 'Lebenswelt' and the corresponding Russian term 'byt' should also be seen as a symptom of this effort to overcome the disintegration of reality.

The investigation of the notion 'work of art' in aesthetics and literary scholarship at the beginning of the twentieth century should not, however, be separated from reflection on language. The crisis observed in the concept of literary language in particular and of language in general in Hugo von Hofmannsthal's 'The Chandos Letter' can be regarded as a paradigmatic example. We should take into consideration the possibility that the invention of the open text, and the transition from an context-independent and media-blind theory of genre to a context- and media-sensitive one, accompany the replacement of the dominance of a concept of literary communication, defined by the Enlightenment and based on prose, by a type of communication stimulated by the ideas and literary practice of Romanticism.[36] But the radicalisation of this romantic idea of language in Modernism was unprecedented.

This mode of literary communication, which is grounded on a language that is opposed to the prose of everyday life,[37] has been developed and used by Russian Futurists such as Velimir Chlebnikov and Aleksei Kručenych, and it has been theoretically sanctioned by Russian Formalists such as Yuri Tynjanov and Roman Jakobson. Certainly this concept of language had been prepared in the theoretical discourse of Russian Symbolist poets such as Vjačeslav Ivanov, Andrej Bely, and Aleksandr Blok. Their discussions led to the question concerning the way in which the radically new concept of 'work of art' correlates with the proposal of a literary language that is totally liberated from all of what Peirce called 'interpretation'. Our deliberation also involves a second problem, namely, how this concept of 'transmental' language ought to be related to the sound concepts of (Russian) Symbolism. Two aspects are quite clear: the 'Zaum'' (the Futurist's term for this new literary language) radicalises and 'literalises', i.e., transforms into

[36] Cf. the concept of Modernism as macro-period in Deppermann, *Dostoevsky.*
[37] Grübel, 'Die Krise'.

letters, the concept of the (poetical) literary sound language of Symbolism, which had been oriented toward sound and repetition. The latest result of this radicalisation is the concept of the 'auto-poetic' function of literary language in the theory of Roman Jakobson, a concept which was adopted by Post-modernism.

We must ask whether the networks of neo-mythical motives in Symbolism, which were also exploited by the proletarian writers after the second revolution in 1917, could be considered to constitute a 'super-work of art', which demotes single texts to individual elements within a super-text. And taking genre concepts into consideration: can Bakhtin's notion of the novel be said to function as an all-embracing reservoir of genres, rendering obsolete the traditional concepts of genre because the novel as a 'super-genre' adopts all previous genres? What factors effected the elimi-nation of the barriers between the authors, critics, and scholars of literature? For, at the same time, this suspension blurs the borders between literary, critical, and scientific language. A decisive role seems to have been played by the change in the relationship between art and life, as the idea of expan-ding art into life was replaced by a concept that suggested the extension of life into art. The Symbolists tried to organise life according to the model of art, whereas the Futurists demanded that art be modelled on life. These op-posing tendencies to transform everything into an aesthetic state of being, on the one hand, and to give everything a physical if not a physiological state of being, on the other, may be pictured as counter-rotations that never-theless had the same effect of eliminating the traditional gap between life and art. As art and life increasingly separated – Lomonosov (1711-1765) had been the last person who evidently integrated poetry and scholarship – the need felt to bring them together again also influenced the position of the author.[38]

Furthermore, in spite of all the basic claims to innovation in avant-garde culture, a need for the creation of continuity arose, which made it pos-sible for Socialist Realism and Post-modernism to participate in, and con-tribute to, the development of certain features of the Avant-garde model of culture. Mayakovsky called Chlebnikov a 'poets' poet', and thus created the first element of a new cultural canon. This canon, however, was not so much defined by exemplary works of art, which could be imitated, but rather by the Futurist language and genre-model concept that Chlebnikov called the 'super-story' ('sverchpovest'') and which, like Bakhtin's novel, but now in literary language, integrated all other genres as subtexts.

In 1986, from his post-structuralist point of view, Aleksandr Zholkovsky, the Russian emigrant and theoretician of literature, classified

[38] Grübel, *Der Wandel im Autorbild.*

Velimir Chlebnikov as a 'Russian graphomaniac'[39] who did not produce coherent texts because of this variety of genres. Four years later, Zholkovsky answered the question as to whether Sergej Ėjzenštejn followed totalitarian aesthetic theory or Bakhtinian dialogicity by saying that, in the work of the most prominent producer of films in Russian Avant-gardism, we find the 'tendency for a total control by rationality'.[40] So the question arises: did Chlebnikov lose or give up control over his writing and does this loss or abandonment of control make him a worthless writer? On the other hand, is the rationalism that was sacrificed by the Futurists restored to power in Ėjzenštejn's film-making? We meet yet another contradiction in the argumentation of Boris Groys who, in 1992, as an archivist of the 'new-ness of the new' and in the perspective of an 'economy of culture', denies even the possibility of 'the new'. In the implicit tradition of Nietzsche's thesis about the 'eternal repetition of the same', Groys sees the 'new' as nothing but the concealed repetition of the 'old'. However, Post-modernism and Deconstructivism themselves are under pressure to innovate if, obeying the imperatives of scientific discourse and its institutions, they claim to say something new. So Groys' thesis about the impossibility of the new is a paradox: if it is true, then it is not new; if it is new, then it is not true.

Cultural frameworks of the contra-facture of the work of art

At the end of the nineteenth century, the radical change in Russian art, music and literature, which became obvious with the appearance of the Avant-garde during the years before the First World War, was accompanied by remarkable peripheral conditions. After the emancipation of the serfs in 1861, society was freed from feudal structures, but there was no well-developed middle class or well-functioning market system, no separation of church and state or working constitutional and parliamentary system. More than 90% of the population in the country suffered from poor living con-ditions and there was no reliable and balanced system of citizens' rights. Time and again, acts of terror, sanctioned by anarchists and radical social-ists, shook the citizens' confidence in the load-bearing capacity of the social system and the state, and strengthened the desire for either a religious-heretical or social-romantic integration of the individual into a harmonic society, which would be moulded in accordance with the model of the archetype of 'conciliation' ('sobornost'') of the Byzantine church. In philos-ophy and in cultural criticism, we observe the prolongation of the above-mentioned 'culturosophia'. It had not yet succeeded in establishing the

[39] Zholkovsky, 'Grafomanstvo kak priëm'.
[40] Zholkovsky, 'Poètika Ėjzenštejna'.

differentiation of theory and practice that had been a fundamental demand of Karl Marx.

In the eighteenth and nineteenth centuries, the nobility was increasingly replaced as the dominant bearer of secular culture and civilisation by members of society who had no place in the codified corporate social order and who were therefore merely called 'raznočincy' – 'members of another rank'. They had a stereotypical education: they completed their studies in seminaries for priests. But, instead of serving in the church, they became literary critics. It was not until the second half of the twentieth century that they took over the professional fields of artists and composers, writers and producers.

At the end of the nineteenth century, the essay *What is Art? (Čto takoe iskusstvo?* 1897-98), by the novelist Leo Tolstoy, roused Russian writers, artists, musicians, and critics. This text is a manifesto of an aristocracy that is bursting at the seams. After Gogol', who, in his *Selected Passages from Correspondence with Friends*, still sketched an ideal picture of the noble-man, Tolstoy denied the economic basis of nobility, landowning, its style of life, and its canon of values. In the world of the court, the nobles had ordered serfs or employees to produce art for money. Alternatively, they took the pen or brush into their own hands, without being motivated by any economic interests. The impoverished poet and writer Aleksandr Puškin preferred to accept a low and demeaning position in the court of the Tsar, rather than bothering about the royalties for his books; translations were better paid than original works in the Russian language anyway. But it was the same Puškin who coined the concept of the 'not-made-by-hand' ('ne rukotvornyj') work of art in Russian culture. The poet is considered to be a prophet and his work is conceived as the creation of a god in a secular con-text.

As mentioned before, at the end of the nineteenth century, Tolstoy's missionary doctrine shook the field of Russian culture. Referring to Plato in his criticism of the goals of fiction, the novelist[41] articulated his fundamental doubts about art as a culture of the governing class. He rejected the aesthetic theory of his time as a product of the wealthy segments of society that had broken with Christianity. The goal, he declared, should be to create a religious art, as well as an art of the simple people, characterised by a naïve feeling of being alive. Tolstoy tried for the last time to overcome the Russian cultural 'dia-glossia', the presence of two relatively independent cultures, which was a result of the rather late industrialisation of the country. This cultural 'dia-glossia', which consisted in the juxtaposition of the oral culture of the village and the literary culture

[41] Tolstoy, *Čto takoe iskusstvo?*, p. 175.

of the towns and cities, remained dominant in Russia until the end of the 1930s.

During the last quarter of the nineteenth, and the first decade of the twentieth century, Tolstoy abandoned the basic assumptions of a realist concept of art, and constantly radicalised his point of view. He was deeply suspicious of Černyševsky's basic aesthetic category of 'interest' which the critic had borrowed from Friedrich Schlegel. The Count tried to replace all aesthetic principles with ethical ones. In keeping with the principles of the late Enlightenment (most of all, those expressed by Rousseau), that which was cognitively understandable seemed to be more acceptable to him than that which causes aesthetic pleasure. In as much as Tolstoy promoted aesthetic values, they were related to the category of 'the true', which was subordinate to 'the good', in his view.

In his essay *On Art* (*Ob iskusstve*) of 1889, Tolstoy declared:

> To be a perfect work of art, everything which the artist portrays has to be new and important for all people. It must be completely beautiful. The artist must speak from inner necessity and therefore be totally truthful.[42]

In accordance with the model of reflection, the form now has to correspond to the content[43] (the expression, the structure of the sign vehicle has to be motivated by reference and signification, that is to say: by the reference to the expressed reality and by the attribution of meaning). Tolstoy declares the 'unity of the authentic habit of the author towards his subject'[44] to be the binding force of the aspired work of art. He demands that the artist should see matters as they are and not as he would like to see them. His definition of talent as the capacity to tell the truth even against one's own will implies that, in a work of art, the phenomena of reality must have primacy. The most perfect author, then, is a writer who lets his heroes go their own way. Against the culture of his time, against Wagner, Maupassant, and the art of decadence, Tolstoy distinguishes an *anaesthetica*, which, unexpectedly, had much in common with the coming Avant-garde concept of art. Subordinating the work of art to its ethical function, Tolstoy undermined Puškin's notion of the aesthetically-determined work of art. This negation of beauty

[42] Tolstoy, *Čto takoe iskusstvo?*, p. 106. In addition to Tolstoy's suppression of aesthetics in favour of ethics and epistemology, we have to register Nietzsche's suppression of ethics in favour of aesthetics and epistemology. Both attempts to overcome the traditional triad of the Good, the True, and the Beautiful were, considering the ethics, rejected by the Russian-Jewish philosopher Lev Šestov (1900).

[43] Tolstoy, *Čto takoe iskusstvo?*, p. 116.

[44] *Ibidem*, p. 130.

as a leading value and its replacement by the good also challenged, of course, the concept of the autonomy of art.

The departure from the notion 'work of art', which was current in Russia in the eighteenth and nineteenth century, may also be observed in the declarations and manifestoes of the Russian Symbolists from the 1890s onward. Inspired by the concept of the work of art of the French Symbolists, by Nietzsche's literary philosophy, and by Wagner's concept of the total work of art, life itself was conceived as an aesthetic creation which, on the basis of an implied homology, should be the equivalent of a work of art. The Symbolist's way of living, shown by Aleksandr Blok, Andrej Bely or Vjačeslav Ivanov, demonstrated how being, as 'correspondence' to the work of art, had to be an audible echo of the eternal recurrence of 'the same'. In accordance with the aesthetic ideas of the Symbolists, the centre of creative activity in the semiotic triangle was placed neither on the side of the sign vehicle nor on that of the referent, but in the corner of the interpretant or meaning. The sign vehicles merely had to function as a means to make the abstract ideas concretely perceptible. The primary responsibility (for the determination of meaning) was assigned to the interpretant (in the terminology of Peirce), since only the connection between the sign vehicle and the referent could guarantee the perceptibility of the idea. This competence gave the poet as 'seer' a prominent role, which culminated in the picture of the secularised prophet, as already suggested by Puškin.

The simile, which in the view of the Symbolists governs the world and is carried out in the time-dimension as eternal repetition, came into view as the relationship of the artefact to the world of living ('Lebenswelt'), as a spatial relationship of correspondence and similarity. The writer surrounds his work, as it were, with a life similar to his work. This similarity promotes the mutual permeation of *art creating life* and the *life of the work of art*, thus weakening the barriers between art and life. In his autobiography, Andrej Bely portrayed himself as a work of art with a theme: '... I feel the Symbolists' theme growing in myself, as it was to be heard in my soul since early childhood'.[45]

From the 'art of life' in Symbolism to the 'life of art' in Avant-gardism

With the step from Symbolism to Avant-garde, the Symbolists' *art of life* was transformed into the Avant-gardists' *life of art*, or 'life creation' ('iznetvorčestvo'). In spite of the similarity of the close relationship of art and life in early and high Modernism, Post-symbolism inverted the relation between them. As for the Symbolists, life had to be equal to art, thus, to the

[45] Bely, 'Počemu ja stal simvolistom', p. 418.

Futurists, art had to be equal to life. Striving to achieve this aim, the physicality of the work of art became more prominent as well, i.e., it had to be just as firmly based on material grounds as life itself. The Formalists' thesis about the literary text's 'orientation to its expression' ('ustanovka na vyraženie'), which refers to the relation of the signifier to its own material, provides the theoretical concept for the concrete view of the text as a body, in accordance with the model of life in Russian Avant-gardism. In Mayakovsky's concept, the Symbolists' belief in the cultural immortality of the successful work of art was replaced by the belief in the biological immortality of the artist. This idea was inspired by the Russian thinker Fedorov, who had declared the abolition of death to be the cosmic task of mankind.

From the point of view of the Avant-garde, it is not the task (of the writer) to make the literary text similar to life, but rather to remind us of the fact that every effective artefact is, in principle, a part of life. Life itself is submitted to the aesthetic rule of innovation, which is grounded on a specific theory of perception. According to this theory, we no longer constantly perceive what surrounds us, but only what has changed or has become perceptible by a changed manner of perception. This condition of life is thought to be congruent with, and integrated into, a way of life based on innovation of the media we use, which confront us with their innovations or with innovations we have created ourselves.

As a consequence, the texts of Chlebnikov and Kručenych, which are written in the 'transmental language' ('zaum'') or the 'language of the stars' ('zvezdnyj jazyk')[46], implement the principles of media innovation and the so-called 'self-reflective' or 'autopoetic' orientation of the verbal artefact toward its own materiality. As a new language, this 'transmental' speech is also a medium for the future. It rejects conventional words because their meaning is determined by conventional semantics and therefore, rather than referring to the physical nature of the perceptible world, they stress the distance separating language from phenomena in the outside world. 'Zaum'' and the 'language of the stars' appear to be the things' 'own speech', the speech of cosmic phenomena that never age, since those things never grow old. However, the Avant-garde concept of language comes up against its own limits here, risking its claim to innovation with this new language .

The texts written in transmental language (with their renunciation of conventional meaning[47] and the resulting absence of a relationship to a

[46] Cf. Grübel, *Russischer Konstruktivismus*, pp. 63-69; Oraić, 'Die Sternensprache', pp. 448-455.
[47] Concerning Russian literature, we cannot agree with P. Bürger's thesis that in the Avant-garde text 'das Einzelzeichen ... auf die Wirklichkeit verweist' ['the single

reality outside language) provoked protests as harsh as those aroused by the paintings of Malevič. His famous picture 'Black Square' (1914-1915) is an absolute pictorial equivalent of the transmental poems of Chlebnikov. The concept of the 'Black Square' (which only selects the frame from the conventional elements of a picture, replacing the traditional mimetic content of the picture by black colour) can be traced back to the tradition of the religious icon in the Eastern Orthodox Church. This tradition of painting is characterised by the claim of the actual presence of the depicted object in the picture. The icon does not reproduce its subject, but 'participates' in it. It is precisely this trope of participation that is the basis of the power of attraction which the art of the icon exercised upon the Avant-gardists. However, in contrast to the religious icon, Malevič's 'Black Square' is a picture without content, an artefact without reference that, like a poem in the 'zaum'' language, has no subject in terms of conventional semantics.

Referring to the religious tradition of painting, while at the same time depriving it of its content and rejecting the mimetic function of the secularised tradition of painting, Malevič's picture breaks with the function and the semiotic practice of artistic tradition. By virtue of the desemiotisation (removing the semiotic content) of the picture (the painting does not show an object which is given outside the picture), the traditional basic function of the mimetic artefact is destroyed. It appears to be the contrafacture of a work of art, a kind of anti-art. This contra-facture is a radical innovation that guarantees the newness of the artefact, as long as the convention of mimetic representation, to which it reacts, is valid.

In a way, analogous to Malevič's visual artistic practice, Kručenych's poem, consisting of the vowels 'o e a/i e e i/a e e b' forms an estranged quotation from the Lord's Prayer, from which it extracts mainly the stressed vowels. In the English translation, the initial sounds would be: 'ou e a e' (from 'Ou-er Father …'). Though Kručenych's poem evokes the main text of the Lord's Prayer, it deprives it of its religious meaning by extreme reduction. The text quotes the vowels of the spoken ritual as 'sound tops', namely, that which can be heard when the prayer is said in unison, which makes it impossible to understand what has been said. At the same time, the poem attacks the sound practice of the Symbolists' poetry, the so-called 'instrumentation' of the vowels (the procedure of structuring by instrumentation.) The Symbolists used this principle of the correspondence of vowels to suggest the homologous structures of the world and the poem. The semantic power of the vowels, which the Symbolists utilised in order to show the capacity of the work of art to make the structure of the world audible through the use of vowel correspondences, was thus destroyed by

sign refers to reality'] (*Theorie der Avantgarde*, p. 126).

the Futurists. At the same time, in Avant-gardism, the work of art lost its referential function. This was the result of the procedure which I call 'the contra-facture of the work of art'. Like Malevič's 'Black Square', Kruče-nych's poem is no longer the contra-facture of a single artefact but the con-tra-facture of the 'work' of art as such. Both Malevič and Kručenych give the institution of the artefact a new function.

From composition to construction, from 'work of art' to 'thing' ('vešč'') or 'text'

Since 1920, the term 'composition', which, in accordance with the leading role of music in Russian Symbolism, also referred to the structuring activity of the poet, has been replaced in Russian Avant-gardism by the term 'construction'.[48] Borrowed from the language of engineering, terms such as 'procedure' ('priëm') and 'construction' ('konstrukcija'), which correspon-ded to the scholarly language of structuralism, find a late equivalent in Roland Barthes' notion 'bricolage'. The anthropologist Claude Lévi-Strauss introduced the term 'bricolage' in 1962, referring to how people use the ob-jects around them to develop and assimilate ideas, taking the amateur-brico-leur as a modern personification of mythical, 'cold', culture, and contrasting him with the rationally arguing and planning engineer in a 'hot' culture. Roland Barthes used this term as a metaphor for the work of the modern writer. Thus, the concept of 'writer' lost something of its planning ration-alism.

In the culture of the Russian Avant-garde, the work of art is conceived as a construction, an artefact, which contains an inherent, dominant visual arrangement. To this internal correspondence with the structural principles of the fine arts, a concept of surface arrangement is added, which is related to a term in fine art that is called the 'factura[49] of the artefact' by the Forma-lists and Futurists. This 'factura', which is formed by letters or sounds, expresses its orientation in the verbal artefact in terms of the structure of the medium. Therefore the artists and poets of the Avant-garde strove to make the surface of the picture or the poem 'rough', as it was precisely this roughness that made the work of the artist and writer perceptible. Concepts of montage and collage played an important role in this treatment of the sur-face. The term 'factura' finds its equivalent in the theory of the Russian Formalists, in the notion of 'text'. The text is considered to be built up by the so-called 'syn-function' of its elements, i.e., the correlation of letters,

[48] Grübel, *Russischer Konstruktivismus*, p. 12ff.
[49] 'Faktura' means a visible structure of the surface; cf. Hansen-Löve, 'Faktur, Ge-machtheit'.

sounds, words, motives, verses, stanzas, chapters, themes etc., whereas the auto-function relates this kind of phenomenon to phenomena within other systems, such as those of society, history, economics, or politics. So the words 'dveri te' ('those doors') und 'ver'te' ('believe!'),[50] constituting the end rhyme in Mayakovsky's poem *War and World*, are mutually correlated by the iconic relationship of their phonemes, and are also related to those of the other rhymes of the poem. The semantics of these words, designing the appeal of the poet to the readers/listeners to believe his words and the (metaphorical) 'doors' (of the lyric ego's eyes), through which the public/audience is encouraged to go, form a part of this 'syn-function' by means of their equivalence. And the function, combining internal parts of the text, also concerns the relation of 'seeing' (vs. 'feeling') and 'believing' (cf. 'doubting Thomas'), the evocation of Jesus Christ, who plays a game of droughts ('šaški')[51] with Cain, and the promise of the secularised Messiah, the futuristic Messiah poet. The relation of the text, written in 1916, to the First World War, is seen by the Formalists as an auto-function, because the war, with its political, economic, and social implications, exists independently of the poem in the line of historical events (economic conditions and social development), and goes back to the invasion of Russia by Napoleon and his troops. However, the narration about the war of 1812 in Tolstoy's novel *War and Peace* is again combined with Mayakovsky's poem by syn-function in the literary text; this is expressed by the title 'War and World', which differs not at all in spoken Russian but only in the written version, in the letter 'i' from Tolstoy's title.[52] Of course, nowadays we doubt the rigid differentiation of *internal* or poetic and *external*, or political, economic, social phenomena etc., but we should not forget that this division paved the way for the insight into the autopoetic function of the poetic text.

One of the text-building techniques in the art of the Russian Avant-garde, reaching far beyond the literary theories and aesthetics of their time, is the quotation. Thus the early Avant-garde text generates reference, in most cases, by means of the evocation of traditional examples, although this involves the genre of a single text rather than the single text itself. Mayakovsky's drama *Mysterium Buffo* is a contra-facture of German mystery plays.[53] The title of the early Futurist's anthology *The Sickly Moon*

[50] Mayakovsky, 'Vojna i mir', p. 266.

[51] *Ibidem*, p. 265.

[52] Tolstoy himself hesitated whether to write his title with an 'i' or an 'и', giving it either the meaning 'War and World' or 'War and Peace'.

[53] This is already indicated by the combination of the noun 'Mystery', referring to the Christian mediaeval mystery plays, as in Oberammergau, for instance, with the adjective 'buffo', usually combined with the noun 'Opera', and referring to the traditional Italian male singer of comic roles.

(*Dochlaja luna*) quotes and evokes the high Symbolist theme of 'the moon'. Kručenych's and Matyušin's opera *Victory Over the Sun* (*Pobeda nad solncem*) breaks the fixation with the sun of middle Symbolism, as well as the bourgeois multimedia genre of the opera. The 'super-story' ('sverch-povest'') *Zangezi* by Chlebnikov presents in one and the same text the contra-facture of the orthodox liturgy and of Wagner's total work of art.

We find demontage as the counterpart of montage in the texts of the late Avant-garde, such as in those of the so-called 'Obèriuty', for example. The name 'Obèriu' is an abbreviation, which ironically refers to the Soviet custom of designating institutions, and means 'Society of real art' (*Obščestvo real'nogo iskusstva*). The representatives of this 'society' took the Futurists' art and developed it into an absurd variant of Avant-gardism. In his late prose text *The Blue Exercise Book No. 10* (*Golubaja tetrad' Nr. 10*), dating from January 1937, Daniil Charms (1905-1942), the most prominent representative of Absurdism in Russian literature, showed the demontage of the hero, the main protagonist of classical Russian prose. By the procedure of emptying the traditional semantic units, the work of art not only loses its subject but is also deprived of all motivation for narration:

> There once was a red-haired man without eyes and without ears. He also had no hair, so that he was called Red Fox only conditionally ... There was nothing at all, so that one cannot understand, whom there is to talk about.
> We'd better not talk at all about him.

> Жил один рыжий человек, у которого не было глаз и ушей. У него не было и волос, так что рыжим называли условно, [...] Ничего не было, так что непонятен, о ком идет речь.
> Уж лучше мы о нем не будем больше говорить.[54]

Kazimir Malevič's manifesto *Suprematism*, dating from 1920, implicitly contains the transformation of a work of art into a thing that finds its place in the universe on an equal basis with all the other phenomena:

> One of the fundaments of Suprematism is the natural constitution as experience and practice, which offers the possibility to allow everything, after having replaced the book world by experience and action, to participate in the universal creation.

[54] Charms, *Gorlo bredit britvoju*, p. 21.

Одна из основ супрематизма природоестество как опыт и практика,
дающая возможность, книжный мир заменив его опытом, действием,
через что все приобщается к всетворчеству.[55]

Though in the Russian language of the late nineteenth century the noun
'thing' ('vešč'') could be used to refer to the artefact, the use of this term
was radicalised by many members of the Avant-garde even in the objective
sense that is suggested by the word 'thing'.[56] The expression 'thing' meant
the physical, a-semiotic presence of the artefact, and its similarity to the
stone, the tree, or the star. *The Thing* was the name of the Berlin journal
edited by Il'ya Erenburg and El Lisicki in 1923, whereas the German title
Gegenstand as well as the French name *Objet* offer different connotations.
Only the Russian title dares to suggest the contra-facture of the work of art.
Its producer, the constructor in art and literature, takes his place beside the
mechanical engineer, the constructor of machines. At the end of the Avant-
garde movement in Russia, the theoretician of Russian Constructivism,
Kornely Zelinsky, called the poem a 'machine of logics' ('mašina logiki').[57]

In his programmatic essay *How Verses Should Be Made* (*Kak delat'
stichi*), Vladimir Mayakovsky initially postulates the demand that the poet
should produce his text not in accordance with given rules (like the mathe-
matician), but in accordance with rules he has created himself. This may re-
mind us of the aesthetic ideas that were commonly held during the 'genius'
period in Pre-romanticism. The Russian poet departs from this model, how-
ever, when he declares that these rules must depend on life itself. And
finally he proclaims, and this seems to be in accordance with early Socialist
Realism, that the construction of the text, as well as its aim, ought to depend
on the social structure. We now refer to the year 1926, and the party of the
Bol'ševiki is increasingly harnessing cultural works: 'The states of being
that ask for expression, for rules, are put forward by life itself. The kind of
formulation, the meanings of the rules are determined by the party, by the
demands of our struggle'.[58]

Thus the poet Mayakovsky himself adapts the aims of Avant-garde
culture, and the function of the Avant-garde text, to the demands of the
political class that was governing the Soviet Union. Like Ėjzenštejn in the
context of film, the poet Mayakovsky subordinates himself to the rules of a

[55] Malevič, *Suprematizm*, p. 3.
[56] Instead of the notion 'work' ('sočinenie'), Velimir Chlebnikov, the most impor-
tant Russian Futurist, used the terms 'song' ('pesnja'), 'singing' ('penie') or 'play'
('p'esa').
[57] Zelinsky, *Poėzija kak smysl*, p. 92.
[58] Mayakovsky, 'Kak delat' stichi', p. 214.

totalitarian system and explicitly admitted that he 'stepped on the throat of his own song'.

This readiness to sacrifice the autonomy of the creating subject seems to be given by the example that inspired Mayakovsky. At the end of the nineteenth century, the Russian thinker Fedorov stated that the creation of the universe was incomplete, and he called upon scientists, scholars, artists, and writers to complete it. In Fedorov's vision, the human being had a cosmic task: he had to bring the creation of the universe to its conclusion. In Mayakovsky's view, the artist had to complete the development of a perfect society that should live an artistic life. However, this concept was taken *ad absurdum* by the late Russian Avant-garde, which replaced the high aims of the Futurists by the empty category of 'nothing'.

It is quite obvious that the replacement of the 'work of art' as a centre of the Russian culture in the eighteenth and nineteenth centuries by the 'text' and by the 'thing' coincided with a rapid change in the concept of the autonomy of art. Whereas art had become the prominent object and symptom of the civil autonomy of the human being, reflecting his situation and conceiving alternative models of society, the artefact in Modernism, and especially in Avant-garde culture, became an instrument to experience and to recognise the world. But it also became an instrument to discover and to assert the place of the artist in society and in the world: the place of the outlaw, of the secularised 'God's fool' ('jurodivyj'). It was this idea of a new social function of the artist, which provided the basis for the confidence in the Soviet system shortly after the revolution. But it rapidly became clear that the party of the Bol'ševists did not accept any autonomy either inside or adjoining its field of influence. The idea of the autonomy of literature and art survived the Soviet Union only in the work of poets like Josip Brodsky and artists like Ėrnst Neizvestny.

Thus, at the beginning of the twentieth century, Russian artists, writers, and critics, in replacing the concept of 'work of art' with the concepts of 'text' and 'thing', which have quite a different function, prepared the shifts in the institutions of art and literature that became obvious in Post-modernism at the end of the century. By diverting the focus of attention from the sound of the word to its visual qualities, they also paved the way for electronic communication that prefers pictures to sounds.

Some years ago the most famous Russian Post-modernist writer, Vladimir Sorokin, showed in his novel 'Roman' the end of the 'novel' genre. This text ends not only with the death of the hero 'Roman', but also with the end of the 'novel' genre (in Russian: 'roman'). Whether we may also call such a break in the 'novel' genre a 'contra-facture' is a completely new question.

THE END OF ARTISTIC AUTONOMY?

LITERATURE AND THE ARTS BETWEEN MODERNISM AND POSTMODERNISM

Peter V. Zima

We all know that the aesthetic phenomenon is not limited to art. Objects of nature which may fascinate the human eye by their extraordinary beauty are outside the artistic realm. It is also a well-known fact that Kant's aesthetic theory deals precisely with these objects rather than with works of art. In contemporary society, a vast array of phenomena – from fashion and photography to design and advertisement – compete with art on an aesthetic level. This is probably one of the reasons why late modern or modernist art has renounced and even debunked beauty in order to mark its distance from what Adorno and Horkheimer called 'culture industry'.

Jakobson and the Czech Structuralists were well aware of the fact that the aesthetic sphere is not a reserve of the artist and Jakobson explicitly rejects the somewhat simplistic idea that art coincides with the aesthetic function. 'Just as the esthetic work is not exhausted by the esthetic function', he points out, 'so the esthetic function is not limited to the poetic work'.[1] What does the specificity of art consist of? – one may ask at this stage. And the structuralist would answer: the specificity of art is due to the *preponderance* or *dominance* of the aesthetic function. One might add that the *autonomy* of art is also based on the 'foregrounding' of aesthetic features, while *heteronomy* rules when non-aesthetic (e.g. political, moral or commercial) elements dominate.

However, this is a somewhat dicey definition which disregards the process of functional change, of historical and social change: for, as we know, many objects such as icons, ancient Greek or Roman statues or medieval paintings which in the past fulfilled a predominantly religious function are now being considered as works of art and admired as such in museums – where (from a medieval or Greco-Roman point of view) they do not belong. Is it conceivable that in a postmodern society this functional metamorphosis

[1] Jakobson, 'The Conceptual Basis', p. 361.

will continue in the sense that art will no longer pretend to fulfil a primarily aesthetic function? One could radicalise this question and ask: Is it conceivable that art as an autonomous phenomenon will cease to exist in a post-modern context? In what follows, I shall try to answer these questions, at first in a theoretical and subsequently in a more practical perspective geared towards literature and some other forms of art.

The autonomy of art in a sociological and aesthetic context: From Luhmann to Bourdieu and Baudrillard

One of Niklas Luhmann's merits is his systematic attempt to describe and explain social differentiation. Of course this phenomenon has been quite thoroughly dealt with by such authors as Emile Durkheim and Georg Simmel who considered differentiation mainly in conjunction with the social division of labour.[2] Luhmann goes several steps further, however, when he views differentiation in the light of a systemic and constructivist (cybernetic) functionalism instead of regarding it as a process of individual or group interaction and interdependence.

It goes without saying that I shall not attempt a reconstruction of Luhmann's systems theory, which would exceed the limits of this article. I do propose, however, to deal briefly with one aspect of this theory which seems particularly relevant to the autonomy of social subsystems: the analogy between biological and social organisms underlying Luhmann's thought, which owes a lot to Humberto Maturana's and Francisco Varela's constructivist biology.

One of the fundamental tenets of this science is the idea that biological organisms ranging from the simple cell to the complex human brain are *autopoietic systems*, i.e. systems which construct and reproduce themselves using one particular code or language. Kneer and Nassehi put it as follows:

> A cell constitutes an autopoietic system for it continuously produces on the molecular level the elements ... which it needs in order to maintain its organisation.[3]

Luhmann has frequently been misunderstood as a proponent of systemic autarky, i.e. as saying that systems and subsystems are autarkical units. He says nothing of the sort but maintains that systems communicate with their environment by translating the stimuli of the latter into their specific codes. This means that: '*The closure of the autopoietic organisation is the presup-*

[2] Cf. Durkheim, *The Division*; Simmel, *Über Sociale Differenzierung*.
[3] Kneer and Nassehi, *Niklas Luhmanns Theorie sozialer Systeme*, p. 50.

position of its openness. Hence closure and openness are necessarily linked'.[4] All this has nothing to do with dialectics but simply means that whatever enters an autopoietic system is transformed into the matter this system is made of.

This is strangely reminiscent of various theories of aesthetic and poetic autonomy. Reading Luhmann's writings on art we are time and again reminded of the New Critics who argue that a poem is a verbal world *sui generis* which is destroyed as soon as it is translated into other types of language. Cleanth Brooks is quite clear in this respect: '... The poem itself is the *only* medium that communicates the particular 'what' that is communicated'.[5] In other words: the poem is the only linguistic expression which fulfils the function of poetry – and not philosophy, politics or religion.

We find an analogous argument in Luhmann's sociology of autopoietic systems when we are told that an autopoietic system – very much like an animal or human organ – cannot be replaced by another system, since each system fulfils a specific function in a specific way. There is a lot of common sense in this, for we all know that our stomach cannot replace our brain and vice versa and that politics or religion cannot replace poetry and vice versa. At first sight, we cannot but agree with the sociologist who points out: 'No functional system can be replaced by another; art for instance cannot be replaced by politics and the latter cannot be replaced by art'.[6] This seems fair enough for it corresponds to our daily experience and to our historical experience of aesthetic heteronomy in fascism or socialist realism.

In this context, Luhmann's theory of art can be understood as a theory of autopoiesis and of radical autonomy. We are again reminded of the New Critics and the Russian Formalists when Luhmann argues: 'The work of art therefore encourages the observer to observe the form'.[7] Why is the form paramount? Because it transforms all external elements into elements of the art system. This transformation ought not to be considered exclusively – as is the case in the New Criticism and in Jakobson's poetics – as a linguistic transformation, but also as a social and historical one. Luhmann explains: 'Along with the increasing autonomy of the art system the focus has shifted from hetero-reference to auto-reference'.[8] He does not mean *l'art pour l'art* of course, but the fact for example that the art system engenders its specific forms of communication (literary criticism is one of them) which makes it irreducible to other systems. He is quite explicit in this respect: 'The 'other

[4] *Ibidem*, p. 50.
[5] Brooks, *The Well Wrought Urn*, p. 74.
[6] Luhmann, 'Das Kunstwerk', p. 624.
[7] Luhmann, *Die Kunst*, p. 238.
[8] *Ibidem*, p. 240.

world' of art can only be communicated if references to our experienced world are deleted'.[9]

At this point, some sceptical remarks impose themselves. Can we actually understand Brecht's Epic Theatre as long as we completely disregard or bracket out the political situation of the 1930s? Can somebody who has never heard of Marx and Marxism understand this kind of theatre? Another problem crops up when we consider the expression *bestseller*. When the Austrian author Robert Schneider announces that he will launch a bestseller, we cannot possibly understand his discourse as long as we delete all our knowledge of the economic system and its market mechanisms. The *bestseller* (which can also be a cookery book) is not an aesthetic but a commercial concept.

And what exactly does Luhmann mean by art? Does he include commercial art and commercial literature whose forms are frequently dictated by markets laws? In other words: economic references and economic language seem to occur far more frequently *within* the art system than Luhmann is prepared to admit. In this difficult situation, The New Critics had an easy way out: they could argue that a bestseller or a soap opera were not art – and thus enhance the critical value of the poem which was their favourite model. The sociologist cannot possibly pursue this line of argument; for he cannot simply exclude the bestseller, the soap opera or John Fowles's *The French Lieutenant's Woman* (where is the limit?) from the art system without giving up sociology.

On reflection, the analogy between biological and social organisms (which Luhmann's system is based on) loses its plausibility. For it seems that social systems are less impermeable to external factors, less autopoietic than biological ones. Moreover, they are prone to heteronomy.

At this stage it seems useful to introduce – by way of contrast – some of Pierre Bourdieu's key arguments which reveal the precarious situation of artistic autonomy in a postmodern age. It is a well-known fact – and I shall not dwell upon details – that Bourdieu considers the social fields or *champs* as autonomous areas which are not functionally interchangeable. In this respect they are comparable to Luhmann's systems or subsystems: What Bourdieu calls social, cultural, linguistic or symbolic capital is irreducible to economic capital, for it goes without saying that I cannot simply buy friendship, linguistic competence or different forms of knowledge. It follows from this that success in the artistic, educational or scientific fields cannot be acquired by economic means. In order to succeed in the artistic or scientific field I need to acquire not only a certain amount of knowledge but also what Bourdieu calls *habitus*: the ability, for example, to take part in

[9] *Ibidem*, p. 247.

scientific or political discussions, to put forward coherent arguments, to listen to the arguments of my interlocutors etc.

But unlike Luhmann, Bourdieu does not define the social field as an autopoietic unit. Its autonomy appears to him as an historically changeable factor whose changing status is in itself an object and a topic of sociology. From his point of view, the cultural field appears as autonomous, but at the same time as inseparable from the economic field: 'It becomes immediately clear', writes Bourdieu, 'that it is only by the intermediary of the time necessary for acquisition that a link between economic and cultural capital comes about'.[10] To put it bluntly: I can only hope to earn a living in the cultural field if I spend a lot of time acquiring cultural knowledge and competence: cultural capital.

At the same time, Bourdieu realises that artistic autonomy as defined and described by the New Critics or Roman Jakobson is an historical phenomenon which cannot be taken for granted or considered as an anthropological constant. He blames Jakobson and the New Critics for viewing the historically unique and particular case of artistic autonomy as a universal model, and speaks of a 'universalisation of the particular case' ('universalisation du cas particulier')[11]. Artistic autonomy appears to Bourdieu and Luhmann as the result of a long historical process.

However, in Bourdieu's sociology this process is not so much an increase of differentiation and specialisation, but a struggle between antagonistic forces: between religious, political, artistic and economic interests. In his view, artistic autonomy is a result of this social and historical struggle which continues within the artistic and the literary field. The latter is not simply a system defending its autonomy, but a conflict area marked by clashes of class interests.

It is a well-known fact, also analysed by Bourdieu (in *La Distinction*), that within the bourgeoisie the interests of the liberal groups frequently collide with those of the grand bourgeoisie (the technocracy) and those of the petty bourgeois layer. Bourdieu and Darbel have analysed the diverging aesthetic interests of these strata and found that the autonomy of art (in the sense of the New Critics or Jakobson) is closely linked to the existence of the liberal layer which tends to adopt a Kantian view of the work of art.[12]

[10] Bourdieu (in: Accardo and Corcuff), *La Sociologie*, p. 93. (Here is the original: 'On voit immédiatement que c'est par l'intermédiaire du temps nécessaire à l'acquisition que s'établit le lien entre le capital économique et le capital culturel').

[11] Bourdieu, *Les Règles*, p. 394.

[12] Cf. Bourdieu and Darbel, *L'Amour de l'art*, chapts. I, II.

A Thesis

In this context it seems possible to put forward the following thesis: *The de-cline of the liberal groups which has been analysed by a large number of sociologists – from Adorno and Horkheimer to David Riesman, Daniel Bell and C. Wright Mills – weakens decisively the autonomy of the literary and the artistic fields, opening the field or the subsystem of art to heteronomous interests. The irruption of these new interests into the field or system is one of the factors responsible for the transition from artistic modernism to postmodernism.*

It is not by chance that Luhmann's aesthetics and poetics – if they exist – are reminiscent of New Criticism, Russian Formalism and Jakobson's poetic function: For all of these aesthetics are geared towards the idea of differentiation, autonomy and a strict separation between autonomous art and pseudo-artistic forms which yield to the temptation of (political, com-mercial or didactic) heteronomy.

This separation and rejection of heteronomy is not only characteristic of modernism in its critical and literary forms – of the works of authors such as Marcel Proust, Virginia Woolf, T. S. Eliot or Paul Valéry – but also of the aesthetic attitude of a liberal bourgeoisie whose interests are neither predominantly economic, as those of the contemporary grand bourgeoisie, nor moralistic and utilitarian in the sense of the petty bourgeoisie.

The decline of the liberal bourgeoisie (of the 'notables' as Daniel Halévy would say) inaugurates a process of de-differentiation in the course of which artistic autonomy is undermined by heteronomous factors: market forces, the search for recreation or for political and cultural identity.

It is against this background that one ought to consider what Scott Lash writes about the link between cultural de-differentiation and postmodern-ism: 'If modernization presupposed differentiation ... then postmoderniza-tion witnesses de-differentiation ...'.[13] Lash explains:

> On the consumption side, de-differentiation takes place in, for example, the tendency of some types of theatre since the mid 1960s to include the audience itself as part of the cultural product.[14]

Other forms of de-differentiation are: the intrusion of popular forms of cul-ture into high-brow art, the increasing orientation of art towards the market and the gradual obliteration of the distinction between art and non-art.

[13] Lash, *Sociology*, p. 11.
[14] *Ibidem.*

De-differentiation is also a process on the side of the public. Here, the liberal, individualist and autonomist bourgeoisie has been replaced by what Lash calls the 'post-industrial middle classes':

> It is the newer, post-industrial middle-classes, with their bases in the media, higher education, finance, advertising, merchandising, and international exchanges, that provide an audience for postmodern culture. Their cultural credentials are doubly dubious to the more established cultural groupings.[15]

The fact seems to be however that these 'more established cultural groupings' are in decline and that the autonomy of art declines with them as a more popular and more commercial postmodern aesthetic becomes more firmly established. (When, between the wars, Benjamin and Bakhtin associated popular culture with criticism and revolution, they took a somewhat one-sided view, for popular culture is also, and possibly predominantly, commercial culture.)

One could radicalise this problem by arguing – with Baudrillard – that this new, postmodern aesthetic is a 'trans-aesthetic' which obeys what Baudrillard calls the 'value', meaning the exchange value that can no longer be defined or named because of its omnipresence, because of the impossibility to distinguish it from any kind of 'use value'.

It is interesting to observe that – like Luhmann – Baudrillard compares the aesthetic with the biological system, but only to find a complete break-up of the aesthetic sphere: 'As a matter of fact, one could read in the contemporary disorder of art a break-up of the secret code of aesthetics, in very much the same way as in certain biological disorders one can read a break-up of the genetic code'.[16] Baudrillard adds that in this disorder it is no longer possible to distinguish the beautiful from the ugly: 'At this point we are neither in the Beautiful nor in the Ugly but in the impossibility to decide between the two and thus condemned to indifference'.[17]

This argument is undoubtedly an exaggeration like most of Baudrillard's statements. However, it seems to be a useful exaggeration, for it reminds us of the fact that the aesthetic sphere is far less codified in our age than fifty or a hundred years ago. It is less codified we might say, moderating slightly Baudrillard's sweeping statement, because non-aesthetic elements are increasingly impinging on the aesthetic realm: in particular economic ones. This brings me to the more practical part of my argument.

[15] *Ibidem*, p. 20.
[16] Baudrillard, *La Transparence*, p. 23.
[17] *Ibidem*, p. 26.

The Heteronomy of Postmodern Art

In some respects the European avant-garde movements (Surrealism, Vorti-
cism, Futurism) anticipate the decline of artistic autonomy towards the end
of the twentieth century. Peter Bürger certainly has a point when he defines
Postmodernism as 'the irruption of the avant-garde problematic into modern
art'.[18] For the avant-garde is the first artistic movement which radically
questions aesthetic autonomy. And although it is certainly not legitimate to
consider it as a postmodern phenomenon – as Scott Lash rashly does[19] – it is
certainly true that avant-garde artists defy the traditional definition of art as
a harmonious and closed totality by systematically introducing non-
aesthetic elements into the aesthetic sphere.

Let us think of Duchamp's 'ready mades', of Salvador Dalí's 'Lips of
Mae West' or of the surrealist *objet trouvé*. All of these phenomena could
be considered as protests against the kind of artistic autonomy defended by
such modernists as T. S. Eliot who asserts: 'When we are considering po-
etry we must consider it primarily as poetry and not another thing'.[20] The
avant-garde movements seem to defend the antithesis of this modernist the-
sis by considering all objects – from the used metro ticket to the advert – as
potentially poetic.

For it was their avowed wish to make art fuse with daily life in order to
turn the latter into poetry. The Czech Poetist Karel Teige, for example, be-
lieved that life itself could be made poetic if only we stretched our imagina-
tion in order to invent arts for all senses: for the eyes, the ears, the nose and
the mouth. He proposes the creation of tactile poetry in the sense of Mari-
netti's 'tactilism' and a poetry for the sense of smell: 'a symphony of per-
fumes'.[21] He appears as being poles apart from Eliot, Proust and all other
protagonists of modernism.

It is probably not by chance that in his well-known novel *Perfume* Pat-
rick Süskind parodies the modernist artist novel by turning perfume into an
art, placing it on the same level as music or poetry, and by introducing a
hero, characteristically called Grenouille ['Frog'], who is a genius of smell.
This hero dreams of nothing less than 'a symphony of perfumes' which
Teige seems to have seriously envisaged. Christian Dior as an artist? Why
not, the postmodern critic would say – somewhat uncritically. (I say uncriti-

[18] Bürger, 'Vorbemerkung', p. 11.
[19] Cf. Lash, *Sociology*, p. 158: 'I take the avant-garde of the 1920s to be postmoder-
nist'. Lash seems to forget that the utopian and revolutionary (anti-bourgeois) orien-
tation of all avant-garde movements contradicts this diagnosis.
[20] Eliot, *The Sacred Wood*, p. viii.
[21] Teige, 'Manifeste', p. 123.

cally in order to anticipate and pre-empt the suggestion that gastronomy is also an art – in which case Bocuse could be presented as a pleasurable alternative to Mallarmé.)

However, this irruption of the non-aesthetic world into the artistic sphere which seems to characterise postmodern art and literature is not simply due to the whimsical imagination of some contemporary artists. It is mainly due, I believe, to the fact addressed by Baudrillard that the border between the aesthetic and the commercial sphere is becoming increasingly blurred in our age.

More often than not postmodern novelists such as John Fowles in Britain, Umberto Eco in Italy and Robert Schneider in Austria design their works as bestsellers by consciously transgressing the literary field in the sense of Bourdieu. I have already mentioned Schneider's dictum that he was 'working on a bestseller'. A bestseller is not an aesthetic, an artistic or a literary concept, but an economic one. And the economic implications of novels such as *The Name of the Rose* or *The French Lieutenant's Woman* become manifest as soon as they are turned into films. For these films have precious little to do with art in the modernist or avant-garde sense: they are part and parcel of what Adorno and Horkheimer call the culture industry. They are economic rather than aesthetic events.

In other words: one salient feature of postmodernist art is its complicity with the market mechanisms, the mass media and the culture industry. This is one of the reasons why the Spanish-Catalan Author Félix de Azúa states quite explicitly in his well-known novel *Historia de un idiota* that art has lost its truth value, its metaphysical value which modernism attributed to it: it 'had arrived too late',[22] concludes Azúa's narrator. The North-American novelist John Barth adopts a different albeit complementary perspective when – in another parody of the artist novel – he considers literary texts as 'funhouses' constructed for the amusement of readers by somewhat unhappy outsiders such as Ambrose: 'He wishes he had never entered the funhouse. But he has. Then he wishes he were dead. But he's not. Therefore he will construct funhouses for others and be their secret operator – though he would rather be among the lovers for whom funhouses are designed'.[23] Literature as a funhouse? Why not? – our postmodern interlocutor could ask and thereby dismiss everything Mallarmé, Marcel Proust and Virginia Woolf have fought for.

It goes without saying that we still read the works of Umberto Eco, Robert Schneider and John Fowles as literature – but we no longer consider the corresponding films as manifestations of art. For they are funhouses

[22] De Azúa, *Historia*, p. 101.
[23] Barth, *Lost in the Funhouse*, p. 97.

which completely lack the subtle self-consciousness of Barth's Ambrose. Where is the limit? (A question deconstructionists would certainly enjoy · pursuing in order to show that it is impossible to decide and to define,)

In many respects, this argument also applies to Alain Robbe-Grillet's 'ciné-romans' (novels written for the cinema) which lack all the subtleties of the original Nouveau Roman and of the Nouveau Nouveau Roman of the seventies. The question is whether in the incipient electronic age (I do believe that we are just at the beginning) novels that count will be able to dispense with audio-visual divulgation. For the time being, this seems to be the case – but for how long?

Another factor which tends to accelerate the integration of art into the commercialised sphere of the media is the dramatisation of television analysed by the French sociologist Jean Duvignaud in conjunction with contemporary theatre. His idea is relatively simple and can be summed up as follows: 'By making immediate reality readily available, television has definitely eliminated the distance between the imaginary and the event'. Duvignaud adds: 'It has been said that dying on the stage would never be the same again for a public which has seen the assassination of Ruby on television'.[24] We all know that televised events are selected according to commercial criteria: assassinations, earthquakes and floods are chosen, not comparisons of GDP's within the European Union. Eventually, the dramatic functions of theatre are usurped by the audiovisual media which need dramatic tension for marketing reasons. More often than not, contemporary drama is transformed into a televised spectacle designed for a larger and hence commercially more interesting public.

Similar trends can be observed in exhibitions, galleries and museums: One of the salient features of a recent German art exhibition was a supermarket on the top floor, where all sorts of banal goods were exposed but not for sale. In this particular case, the aesthetic function simply consists in the prohibition of commercial transaction, a prohibition any shopkeeper can impose overnight – without necessarily becoming an artist. The organisers of the exhibition would presumably say that it was their aim to make people think about the aesthetic function. Fair enough – but where is the work of art? Has it become obsolete?

All this does not necessarily mean that art has come to an end, as Hegel would have it, or that it no longer exists in a society ruled by the media. It does mean that Baudrillard is not entirely wrong when he speaks of a *trans-esthétique*, because it is becoming increasingly difficult to draw the line between art and non-art, between good and bad works in a society, where all phenomena are considered from a quantitative rather than from a qualitative

[24] Duvignaud, *Spectacle et société*, p. 159.

point of view, where universities as scientific institutions are increasingly being made subservient to strictly utilitarian interests.

It also means that the differentiation of social spheres and systems, so thoroughly analysed by Niklas Luhmann, is probably not comparable to biological or organic differentiation. Unlike the latter, social differentiation is marked by group interests which Luhmann can only neglect to the detriment of his own theory. Social systems are probably not autopoietic systems in the sense of Maturana and Varela, but polymorphous spheres which constantly interfere with one another because they are conflict-ridden and constantly exposed to external interventions and subversions.

In this context, one can imagine that the artistic sphere might one day be completely annexed by the culture industry in which the aesthetic dimension will undoubtedly exist but no longer be dominant in the sense of Czech Structuralism. This annexation of art by heteronomous systems has multiple reasons, one of them being a gradual – and today clearly perceptible – reduction of contemporary society to its economy, to its market laws.

However, within this global development there seems to be a more specifically social cause for the weakening of artistic autonomy: the decline of the liberal groupings within the bourgeoisie. These groupings have been replaced by more specialised individuals (employees, managers, scientists or civil servants) who do not clearly distinguish – and possibly do not even wish to distinguish – between art and entertainment. For them art has become part and parcel of their economically organised leisure activities.

'Taste', argues Kant, 'is the ability to judge an object, or a way of presenting it, by means of a liking or disliking *devoid of all interest*. The object of such a liking is called *beautiful*'.[25] For the majority of contemporary art consumers leisure activities have become inseparable from what they call self-realisation. They ask: What's in it for me? This possessive and individualist question is in turn inseparable from the multifarious offer of the market. It excludes 'a liking or disliking devoid of all interest'. It also precludes the radical criticism of negative aesthetics in the sense of Mallarmé, Valéry and Adorno. For the average contemporary reader also tends to ask: Is it fun? It is against this kind of commercialised fun that aesthetic autonomy in the Kantian sense and negative aesthetics in the sense of Mallarmé have been conceived.[26]

It is probably not by chance that one of the most prominent early modernist poets, Edgar Allan Poe, associates beauty with sadness. In his well-known essay 'The Philosophy of Composition' he writes: 'Regarding, then, Beauty as my province, my next question referred to the *tone* of its highest

[25] Kant, *Critique*, p. 53.
[26] Cf. Zima, *La Négation esthétique*, chapt. I.

manifestation – and all experience has shown that this tone is one of *sadness*.[27] This tone of sadness may be characteristic of the modernist notion of beauty in most of its manifestations, because the modernists knew that the artistic autonomy they so staunchly defended was being eroded by market forces, by what Stéphane Mallarmé calls *universel reportage*.

These forces are not geared towards abnegation, negativity and sadness, but towards 'fun', towards immediate gratification and consumption. In this context, the sadness proclaimed by the modernist poet also anticipates the fate of autonomous art in postmodernism (which Fredric Jameson, following Ernest Mandel, associates with late capitalism).[28] Art might cease to be identified with the aesthetic function as its integration into the intermedial fun industry progresses, thus realising the dystopia of trans-aesthetics described by Baudrillard. The negativity of modernism – from Edgar Allan Poe and Mallarmé to Valéry and Virginia Woolf – is a last effort to stem the tide of commercialisation, utilitarianism and commodification.

In Woolf's novel *Orlando* which is also a novel about art and the artist, the narrator quite explicitly postulates an unbridgeable distance between the work of art and the commercial world. She says:

> She was reminded of old Greene getting upon a platform the other day comparing her with Milton (save for his blindness) and handing her a cheque for two hundred guineas. She had thought then, of the oak tree here on its hill, and what has that got to do with this, she had wondered? What has praise and fame to do with poetry? What has even seven editions (the book had already gone into no less) got to do with the value of it?[29]

The word 'value' of course refers to the aesthetic value and confirms Kant's view that 'the liking that determines a judgement of taste is devoid of all interest'.[30] It also confirms the final insight of Proust's narrator that art has nothing to do with worldly interests such as social success, politics or love.

Like Edgar Allan Poe's sadness, Virginia Woolf's questions are not naïve – for they anticipate a development which tends to identify the value of art and the cultural sciences with social and commercial success: with the bestseller, the successful project funding and in general public recognition. What has all this to do with beauty, truth – and the oak tree on that hill, one may wonder with the modernist writer.

[27] Poe, 'The Philosophy, p. 17.
[28] Jameson, *Postmodernism*, chapt. 8: 'Postmodernism and the Market'.
[29] Woolf, *Orlando.* pp. 309-310.
[30] Kant, *Critique*, p. 45.

Considering what has been said so far, one might conclude that Hegel was probably wrong when he argued that in modern society art would be superseded by philosophy or by 'science', as he put it literally. For the process of de-differentiation described by Lash does not seem to lead to a dissolution of art in conceptual thought. Rather, it might lead to a submission of art *and* conceptual thought to what Francis Bacon used to call the 'idols of the marketplace'.

AFTER ART

THE HYBRID AUTONOMY OF POP MUSIC

René Boomkens

A general view of twentieth-century art

Artistic practices and their products can by no means be seen as being sepa-rate from the social and cultural battleground that surrounds them. The no-tion of the autonomy of the arts must itself be seen as a part of an intellec-tual strategy on that battleground. According to Walter Benjamin, the nine-teenth-century ideal of the autonomy of the arts had been based on the Ren-aissance idea of a cult of beauty, which tried to liberate the arts from its re-ligious tutelage – something which became generalised in the bourgeois view of art as being independent of any ideology, be it religious or politi-cal.[1] Thus, the desacralisation was immediately followed by a resacralisa-tion of the arts as an autonomous cultural institution within bourgeois soci-ety, consisting of academies, scientific journals, specialised professional education, theatres and concert halls, historical research, etc. This again was followed by the rise of several avant-gardist movements that contested the institutionalisation of art and attempted to politicise art, or tried to connect or re-connect art with everyday life, or even claimed to develop artistic practices as integrated part of an aesthetics of living, a specific lifestyle, so to speak. I refer here to late nineteenth-century decadence and dandyism and to several more politically motivated avant-gardes that developed in the first three decades of the twentieth century, from futurism and expression-ism to Dadaism and surrealism. It is important to note that these movements shared the mixture of desacralisation and resacralisation of art with the offi-cial bourgeois aesthetics and, despite their ideals of the merger of art and everyday life, implicitly reaffirmed the exclusive and autonomous status of the arts in cultural life in general. A poet like Baudelaire could develop an aesthetics in which the focus was placed upon banal and sacrilegious issues while simultaneously defending his own version of *l'art pour l'art*. But it is exactly in the (in)famous notion of *l'art pour l'art*, which we can take as an extreme affirmation of the autonomous position of art as a cult of beauty,

[1] Benjamin, *Gesammelte Schriften*, p. 431ff.

that a forbidden bond with a dangerous enemy of the autonomy of art lurks. As Susan Buck-Morss pointed out, the aesthetics of *art for art's sake* comes close to a reduction of the specific-use values of artistic products to their abstract role as consumption products, i.e., to their user value on the art market.[2] This is exactly what both the official, academic notion of art as well as the avant-gardist version of artistic practices kept on denying: the fact that the concept of the autonomy of art is not logically inconsistent with the concept of art as a product on a specific market, but must be seen as a logical consequence of the marketability of art.

We now have to deal with at least three different notions of the autonomy of art: the first, official one relates the idea of autonomy to the existence of an artistic canon, based on the above mentioned institutions; the second, avant-gardist notion is based on the idea of autonomy as related to cultural or political opposition or transgression, or on similar notions of cultural spontaneity or authenticity; and a third notion in which the idea of autonomy or 'art for art's sake' is related to the functioning of the market, regarded as the processes of cultural production and consumption by an *anonymous audience*, to which the artist is now forced to relate. Whereas the official bourgeois notion of autonomy was based on a visible and located audience of *connoisseurs*, and the avant-gardist notion was based on the presupposition of a new or foreseeable collectivity by which opposition, transgression or rebellion was represented, the market version of 'l'art pour l'art' merely referred to the outcome of anonymous commercial processes. But, although this attitude easily lapses into simple populism, it also is the only one of the three that is able to accommodate the question of the audience for art as a serious *problem*, and not as something given.[3]

Seen from the perspective of the difference between traditional and modern art forms, this problem represents a shift from a situation in which the artist is embedded in a collective framework of meaning that fixes his relation with his audience to a situation in which the relation with a certain audience is an open question that has to be answered in and by the construction of the artwork itself. But, this constructivist aesthetics only came to fruition in a period in which the opposition between traditional and modern art forms had lost much of its initial explosive meaning. In fact, the whole idea of constructing a specific audience out of an anonymous environment has more affinity with traditional cult-oriented and ritualistic practices of art than with the modernist bourgeois or avant-gardist aesthetics that defines artistic autonomy as being based on the autonomous subjectivity of a fixed audience, automatically reflected in the attitude of the artist himself. Thus,

[2] Buck-Morss, *The Dialectics of Seeing*, p. 157ff.
[3] Frith, *Sound Effects*, pp. 3-15.

following this constructivist redefinition of the autonomy of art as the *rede-scribing* of specific traditions, rather than as transgressing tradition as such, we end up in a situation in which the supreme idea of Modern Art has to be abandoned, to be replaced by a notion of artistic practices which may be described as being *after art* in a certain sense – and also *before art.* This is, I think, our present condition.

To flesh out this rather abstract argument, I want to venture into the world of popular culture, which is, of course, the world of anonymous audiences per se, but also the world in which specific cultural collectives are constantly being constructed out of that anonymity. It is also the world in which the classical notion of artistic autonomy has been challenged time and again, without losing its acuteness. Although the rise of popular culture in the 1950s and 1960s, especially television and pop music, initially looked like a *spontaneous* outburst of cultural energy and resistance, forty years later that same popular culture proves to be the main source of a growing reflexivity towards the whole idea of modern culture and of the meaning of art as an ethical-aesthetical and also political force in that culture. Instead of addressing popular culture or pop music in general, I want to take the artistic career of one pop artist as an exemplary instance of that culture.

Elvis Costello and the aging of pop music

Pop music has always been studied in the context of young people and youth culture. At first, intellectual or scientific interest in pop music remained limited to disciplines like criminology and the sociology of deviance, and the sounds and lyrics of the music primarily seemed to provoke *moral panic* before any attempt at understanding its musical, let alone its artistic meaning had been made. In the seventies, moral panic was substituted for an interest in the function of pop music as part of subcultural resistance and of the cultural politics of identities, which became a dominant issue in post-modern circles of cultural studies. Nonetheless, the focus on pop music as being related to youth culture remained intact, and was actually enhanced by the spectacular success of the punk movement, and later by hip-hop.

Only at the end of the eighties and the beginning of the nineties did the first signs of a re-evaluation of pop music as a cultural genre and artistic practice in its own right become manifest. Historical research into the roots and prehistory of pop music and of its earliest icons and most important composers and musicians helped to create this new interest. The histories of soul music and of the roots of rock 'n' roll and of Elvis Presley, by Peter Guralnick, and of the musical career of Bob Dylan and of punk culture, by Greil Marcus, stood out as important and eloquent historical reconstructions of pop culture as more than a mere object of sociological research or a

manifestation of spectacular or problematic youth subculture.[4] This was fol-
lowed by the first sparks of aesthetic interest, especially evident in the work
of Simon Frith, who started as a typical sociologist of youth culture in the
seventies, but increasingly became a specialist in the broader cultural and
artistic significance and role of pop music in different fields of cultural pro-
duction, from cinema and music television to pop music as the pre-eminent
cultural expression of a new suburban life style. I want to present my reflec-
tions on pop music and the question of the autonomy of art as attempts to
develop further the arguments of Firth, Marcus, and others.

My example or case study was born in Liverpool in 1954 and experi-
enced the first wave of British pop or rock music in the sixties before enter-
ing a career as singer and songwriter in the seventies. His subsequent career
provides ample proof of the difficulties that accompany the attempts of pop
artists to develop a distinctive and unequivocal artistic identity. It also
shows that the era of the pop artist as youthful rebel is over in many re-
spects.

Declan MacManus was re-christened Elvis Costello in 1977, the year
the real Elvis died, and this 'blasphemy' kick-started his career as the brains
of punk, or as the intelligent nephew of Johnny Rotten (Sex Pistols). As a
fan of American soul music and of such diverse artists as Dionne Warwick,
Randy Newman, and the Band, Costello seemed the least likely candidate to
become the singer of a punk or new wave band. With his band the Attrac-
tions, and dressed and bespectacled as the second coming of Buddy Holly,
he made his debut with two records filled with short, aggressive and nerv-
ous songs, based on lyrics that were even more aggressive and which at-
tacked the favourite hate objects of the punk subculture: love, decency, con-
sumer culture, and the superficiality of everyday life, television culture,
while deriving his own material and artistic conventions from that same cul-
ture. 'I want to bite the hand that feeds me', Costello sang about the radio.

After three records this was all over. In the early eighties Costello made
a series of rather diverse records, from a tribute to country and country-rock
music and a record with songs that were reminiscent of the soul and R&B
music of his childhood to an eclectic record that was presented as a defini-
tive statement of artistic autonomy and identity (*Imperial Bedroom*, 1982).
But this identity was dubious, almost mysterious. He portrayed himself as 'a
man out of time', as 'just the oily slick on the wind-up world of the nervous
tick', and more specifically as someone who was always *Almost Blue,* the
title of a beautiful jazz ballad later to be covered by Chet Baker, in which
everything the singer does or wants becomes infected by that little word
'almost'. Finally, in *Kid About It*, Costello discusses the condition of pop as

[4] Guralnick, *Last Train*; Marcus, *Lipstick Traces*; *idem, Invisible Republic*.

swinging between 'big dreams of elegance' and a claim to authenticity, caught in the word play between the hopeful 'say you wouldn't kid about it' and the melancholic 'I want to be a kid again about it'.

After these first five years, Costello's career became increasingly un-predictable. Desperately seeking a world hit, he recorded two albums with potential hit songs, or so intended. The first contains the famous ballad on the Falklands War, *Shipbuilding*, written for ex-Soft Machine drummer Robert Wyatt, but just as convincing in Costello's own version, complete with Chet Baker's melancholy trumpet. But these attempts were unsuccess-ful. He decided to relinquish his stage name and return to his original name and to what he saw as his musical roots: American folk, country, and blues music. With artists who once accompanied the other Elvis, he recorded the remarkable album *King of America* (1986) in a semi-acoustic style, full of ironic comments on American culture and lifestyle. He returned to his original edgy and aggressive style on the next album, again in conjunction with the Attractions, to resurface a year later with a rather complex album on his Irish roots and on British culture under Thatcher, which in musical terms was a mixture of Irish folk, rhythm and blues, and New Orleans brass band music.

In the nineties, the musical development of Costello exploded into dif-ferent and completely opposing genres and styles. He recorded a much-acclaimed and simultaneously much-criticised CD with the Brodsky Quar-tet, a classical ensemble famous for their renditions of Shostakovich, *The Juliet Letters* (1993), a series of pop songs presented as a classical song cy-cle. He appeared on stage with good-old crooner Tony Bennett, or with jazz guitarist Bill Frisell; he co-operated with ex-Beatle Paul McCartney, played an important role in the come-back of rock virtuoso Roy Orbison, and re-corded a CD in 2001 with classical mezzo-soprano Anne Sofie von Otter, who performed pop songs composed by, among others, Beach Boy Brian Wilson. He wrote film music for different movies and television series, songs for Johnny Cash and soul singer and part-time undertaker and preacher Solomon Burke, and revived the stranded career of the king of mainstream American pop, Burt Bacharach, by recording a CD with him (1998). Bacharach and Costello scored a huge hit in the USA with the song *God Give Me Strength*, while Costello solo had an even bigger hit with the Aznavour composition *She*, a song that was part of the soundtrack of the feel-good movie *Notting Hill*.

Hybrid autonomy

After almost twenty-five years it would seem high time to find an answer to the question: who or what is Elvis Costello as a pop artist, composer, singer,

and producer of the music of many other artists? Costello has defied almost all the rules and regulations of popular and youth culture, not only through his extreme eclecticism and his constant change of styles, genres, and attitudes (Bob Dylan and David Bowie preceded him here, although in a less extreme way), but especially by bringing together musical styles and subcultures that always had been defined and experienced as strongly opposed in at least two ways: he identified and mixed genres which were seen by their fans as representing rigorously separated lifestyles or cultural attitudes, such as country and soul music, for example; moreover, he brought styles and genres together that had always been distinguished in terms of 'high' and 'low', or in terms of 'autonomy' versus 'market' – or in terms of 'seriousness' versus 'entertainment'. The strange thing is that this question concerning Costello's identity has not been posed at all. Pop critics do not pose it, neither does the larger audience, and his fans are the least surprised of all about his activities.

And this, we might say, is rather surprising in itself. Here is an artist who portrays himself as a man out of time, almost blue, secondary modern even, as somebody else, a town crier, a boy with a problem. In the meantime, he is not just an eclectic, a post-modern parody of a pop singer. On the contrary, he always represented an attitude of complete seriousness towards what we might conceive of as being the core of pop music: the song. Costello thinks he is a 'song and dance man', the honorary title once bestowed upon Bob Dylan. The cord that keeps all the stems and offshoots of his musical career together is his self-image as someone who sings and writes songs by rewriting the songs of his childhood or songs that made sense or were influential, sung by others in some other time. In his choice of material or inspiration, Costello is, like many of his colleagues, more benevolent or charitable than could be acceptable from a traditional viewpoint, i.e., from the viewpoint of an aesthetics that is based on a substantial and discretional notion of the autonomy of art and artistic practices.

You can ascribe a lot of more or less traditional criteria to this new aesthetics of the pop song, such as the pre-modern notion of craftsmanship or even the notion of authenticity, although it does not fit all manifestations of pop music to the same degree – much pop music builds its identity on all kinds of conceptions of inauthenticity, on show, pleasure, or success rather than on being real or authentic. If there is something post-modern in pop music then it must be the evaporation of the boundaries between the notion of all kinds of cultural practices (like pop music or cinema) that are primarily measured in terms of the fun or pleasure they provide, and the notion of art as serious and cerebral – or even transgressing any idea of pleasure.

Pop music is like architecture in this respect: it is almost impossible to reflect upon the 'autonomous' artistic value of pop music without including

its function as entertainment, its ability to provide 'fun', its central role in
the (dominantly youthful) culture of leisure: the Saturday Night Fever, so to
speak. Architecture shows a comparable mixture of artistic values and pre-
tensions and an irreducible functionality or user value in everyday culture.
As the Dutch architect and urbanist Rem Koolhaas wrote in his *Delirious
New York*, the only place where the aesthetic ideals of the modernist avant-
gardes in architecture were realised was the place where there was no avant-
garde: New York, or Manhattan, the place where modernist experiment was
combined with the excess of pleasure, success, and lack of direct useful-
ness. Here architecture was not seen as high art, or as the articulation of a
pure and transparent world vision, as was the case with the European avant-
gardes like the Italian futurists, the Dutch De Stijl movement or the German
Bauhaus, which in Koolhaas's view all overestimated the social and politi-
cal influence and importance of 'pure art' or the autonomy of a discipline
like architecture. The success of 'modernism' in Manhattan was possible
precisely due to the lack of such notions of autonomy or purity of art,
thanks to the absence of a 'puritan' avant-gardism.[5] The modernist skyline
of Manhattan was the result of a playful, highly commercial and eclectic de-
ployment of certain modernist ideas of building and urban development, in
which traditional architectural notions were combined with new and modern
concepts of art, building, and urban popular culture. After more than fifty
years, the skyscrapers of New York are seen as a classic example of mod-
ern(ist) architecture – and possibly as the most important or influential ex-
ample. But no-one relates this success to any notion of autonomous art, or
to the influence or meaning of 'pure art' in society, or culture in a broader
sense. One may say that this is not surprising because architecture has never
been a pure or autonomous art form in the first place, that architecture has
always been judged in terms of its usefulness or social function. Architec-
ture is a form of applied art – it lacks the specificity and autonomy of 'pure'
art forms like painting, sculpture, music, literature, or theatre. But this is
begging the question of course. Historically speaking, all art forms have re-
alised their canonised autonomy by creating a fault line between a so-called
'applied' history or pre-history and a 'pure' or 'autonomous' present. This
is even true for an artistic discipline like architecture, which seems to be de-

[5] The architectural critic Charles Jencks compared the attitude of modernist architec-
tural avant-gardes with that of Calvinism or Puritanism. He pointed at the severity
and strictness of the modernists, their obsessive refusal of any ornamentation, their
stress on a unified, purely functional and transparent architecture, the lack of play-
fulness of modernist buildings, etc. Modernist architecture refused all references to
the history of architecture, and in doing so it tried to establish itself as radically
autonomous and as purely functional as well (Jencks, *What is Post-Modernism?*, pp.
10-14).

fined by its applicability or functionality. And indeed: there is no possible definition of architecture that can meet the severe Kantian standard of our aesthetic faculties: disinterestedness.

But even architecture developed its own brand of purity or autonomy. Its history is full of laughter: Walter Benjamin pointed out how the pure art of architecture, as it was defined and claimed by the French Écoles des Beaux Arts in the eighteenth century, rejected the 'applied' and technologically informed practices of 'engineering' that realised the new buildings of the nineteenth century such as railway stations, bridges, factories, shopping arcades, or World Exhibition halls.[6] Nowadays we know that it is exactly these artefacts that are regarded as artistic monuments of early modern architecture, whereas many of the neo-styles of Beaux Arts architecture still require adequate aesthetic judgement. Nowadays we may register a huge gap between a quasi-philosophical universe of 'talking and writing' architects, who define themselves as 'real artists' but who are more prolific in creating mystical texts than in designing or creating relevant buildings, and the day-to-day practice of urban development and housing. The laughter rises from the anti-autonomy camp.

What is of importance here is the question as to whether this specific example of the 'broken' or inconsistent autonomy of modern architecture is just an exception, or should it be seen as the expression of a more general condition of modern (or post-modern) art forms and artistic practices. Following Benjamin's claim,[7] made in 1935, that it is impossible to develop a universal and transhistorical aesthetics without paying attention to the different media by which artistic practices or products are distributed and communicated, we could defend the proposition that all art forms and artistic practices that developed after the establishment of the academic, bourgeois canon of autonomous art in the nineteenth century share with modern architecture a hybrid status of quasi- or semi-autonomy, mixed with forms of functionality, applicability, or commercial appeal. The mixed or hybrid identity of new, modern art forms must not be seen as proof of the untenability of a Kantian aesthetics of disinterestedness. At the very most, it is proof of the co-existence of several aesthetic discourses which accompany modern or post-modern artistic practices. Pop music may be seen as a perfect example of this situation, and Elvis Costello's musical career as one of its most interesting and appealing consequences.

In the early years of pop culture, i.e., the rock 'n' roll era (the fifties and early sixties), pop music was not regarded as an art form at all. Rock 'n' roll was taken to be nothing more than entertainment for working-class

[6] Benjamin, *Gesammelte Schriften*, p. 431ff; *idem, Das Passagen-Werk*, p. 45ff.
[7] Benjamin, *Gesammelte Schriften*, p. 431ff.

youth, just dance music, aesthetically seen as the 'lowest culture', and de-scribed as 'raw', 'simple', 'direct', 'naïve', or 'primitive'. From a slightly different angle it was denounced as 'repetitive' music, produced in an in-dustrial manner (formula) and distributed commercially. Here, Adorno and Horkheimer's criticism of the culture industry resonated quite clearly. This situation changed drastically in the second half of the 1960s when pop or rock music found a new audience among middle-class youth and was re-lated to the rebellious 'counter cultural' movement of hippies, yippies, anti-war protesters, and to the student movements all over Europe and North America. The 'counter culture' or 'underground movement' developed its own aesthetic discourse of transgression by art (psychedelic music, for in-stance) – a discourse in which autonomy and political functions of art were related in the same manner as was the case with the modernist avant-gardes in the twenties and thirties. Pop music not only became 'the voice of a new generation', but it became the nucleus of a whole new style of living and of a completely new form of artistic expression, which permeated almost all other existing art forms, from theatre to cinema, from painting and design to new media like television and video. Initially these rather stormy develop-ments did not evoke serious debate in the field of aesthetics and theories of art, simply because pop culture was principally regarded as a youth phe-nomenon – as an expression of specific juvenile-cultural styles, which made it an object of anthropological or sociological interest, not an object of aes-thetic reflection.

Musicologists did not take pop music seriously – and remained focused on the classical tradition, on ethnomusicology (folk and non-Western mu-sic), or on modernist musical experiments (Schönberg, serialism, electronic music, et cetera). The reason why musicologists were not able to deal with this new musical reality is simple: they were used to dealing with simple demarcations between 'the musical' and 'the extra-musical', in other words: their notion of the artistic autonomy of the music was unequivocal, while the 'new autonomy' of popular music was hybrid, paradoxical, and all but clearly demarcated. The domain of research (the objects or sources of the scientific practices of musicologists) had been more than evident for about two centuries: written music, scores and, if possible, specific unique perfor-mances or series of performances. Nowhere else could one find the heart of the artistic autonomy of music.

This, of course, changed in many ways with the introduction of techno-logical reproduction of musical performances: the record, radio, television, tape recording, video, compact discs, et cetera. All these developments in the technological arena gradually changed the consumption and reception of music but, in the long run, they also influenced and changed the production of it: the role of the recording studio, the possibility of 'dubbing', technical

tricks like speeding up or slowing down sounds and rhythms, the introduction of microphones in live performances, et cetera. The electronic revolution of the last few decades has only strengthened the influence of new technological practices on the performance, production, and reception of music in general. Most of the popular hits of the last ten to fifteen years have been manufactured without the use of a single traditional musical instrument. This may not affect the autonomous status of musical art in a significant way – but it surely changes the sources on which the supposed artistic autonomy is based. Musical scores have not become completely obsolete, but their function has changed in a radical way: many professional musicians can do without them, and a musically informed audience that enjoys a performance with the score at hand must be seen as a prehistoric phenomenon. Written music plays an important role in musical education and in the practices of amateur musicians – in other words: it has exchanged its role as the core of the art of music for a role on the periphery of the musical world. Only musicologists have still to be informed about this change.

Pop musicians almost never read music. They listen to it. Radio and records, and later also television (but to a lesser extent) are their main sources of inspiration and information. More than other arts such as painting, sculpture, theatre, or literature, music strongly profits from the dominant presence of media like radio and television. These also instigated new rules for musical production, of course, in which the specific presentation of the musical product in the (new) media (radio, television) became one of the vital elements of its creation. New conditions like this have often been interpreted as killing the autonomous status of music as an artistic practice, but paying attention to the specific qualities of radio sound or television images is not so very remote from inspecting a theatre or concert hall and checking the acoustics prior to a musical performance. In fact, the whole notion of live performances (the use of the word 'live' as such) proves how strong and definitive the role of technology has become in the realm of music – and in the way the artistic significance of music is established nowadays.

But this is only half of the story: the other half concerns the reception of these new musical practices. Their meaning or 'value' is fundamentally established in the reception of artistic practices or products. This is where aesthetics comes in, rather than the productive and technical aspects. Here, too, Kant's disinterestedness can be put to the test. And, to a greater degree than on the production side where autonomy can be stretched and adapted to new technological circumstances, it actually fails the test.

It is almost universally claimed that post-modernism put an end to the traditional opposition or gap between high and low culture, or between 'serious art' and 'popular culture'. This is turning things upside down. Post-

modernism can be seen as a (not 'the') comment on and reflection of the actual erosion of the gap between practices of 'serious' or 'high' (or for that matter: autonomous) art on the one hand, and a whole series of new and mediated practices of 'low' or 'popular' or 'entertainment' culture on the other. As a cultural comment, post-modernism has always been true to its own 'programme': it produced superficial notions concerning the supposedly superficial character of the culture of the last decades of the twentieth century. But superficiality was not the most important dimension of the new cultural condition. It was mixture, hybridity, and a feeling of relativity concerning the classical idea of artistic autonomy. Simon Frith delivered the most convincing summary of our new artistic condition: instead of repeating the old complaints of tired modernists or affirming the endless parodies of post-modernists, he concentrated his research on the different ways audiences reflect upon musical performances and products by telling stories about them to each other. The meaning of a song is decided upon by conversation, so to speak. The 'artistic code' of the song cannot be derived from its musical and lyrical structure alone – it has to stand the test of musical consumption as well. And there, three discourses are engaged in mutual competition on the classical issue of artistic autonomy and cultural functionality. Frith speaks of the 'art discourse', the 'folk discourse', and the 'pop discourse'.

The art discourse stresses the autonomy and aesthetic relevance of (certain) musical performances or productions. It can only do so thanks to the existence of academic institutions, professional musical education, and an informed audience. The folk discourse stresses the spontaneity or authenticity of specific musical performances or products, and relies upon a more or less dynamic tradition of local, regional, or national musical practices. Here, the specific social or cultural functionality of musical practices (their role in all kinds of social rituals, be it weddings, funerals or communal festivals) plays an important role. The pop discourse puts fun at the centre of its evaluation of musical practices. It is based upon the existence of large commercial companies and mass media which operate as suppliers of huge quantities of music to be played in discotheques, dance parties, et cetera – music for pleasure, music as crucial ingredient of the globalised 'fun factory' which produces the Saturday Night Fever for millions and millions of people every week. According to Frith, pop music and popular culture in general can no longer be seen as an expression of 'low culture' opposed to an aesthetically dominant, elitist 'high culture', but must be seen as a middle-class cultural phenomenon, in which these three discourses of art, folk, and pop all play their distinctive roles.[8]

[8] Frith, *Performing Rites*, pp. 21-46.

This implies that pop music has developed from a specific juvenile (sub)cultural phenomenon into a dominant ingredient of everyday (middle-class) culture; pop music has become 'normalised', it has grown up, so to speak. That also explains the helter-skelter of Costello's musical career. His musical itineraries cover all three discourses on pop music, and they are covered without real contradictions. Of course, his sudden changes of musical direction caused a lot of debate and criticism but, in the end, only a few fans left the theatre. Costello succeeded in bridging the supposedly largest cultural gaps between audiences in today's mass culture: he started as the quintessential angry young man of a new avant-garde in pop culture, punk and new wave, only to record 'conservative' country music in Nashville, or make a record with the 'king of middle-of-the-road', Burt Bacharach, and let classical soprano Anne Sofie von Otter sing Beach Boys songs. Does this mean that we are now 'after art'?

After art

The idea that we might be able to envisage a form of art that need not exclude the pleasure factor, in order to do justice to the rational and coherent judgement of what may count as real art and what not, is still something we have to get used to. However, it was something that Walter Benjamin saw clearly in his essay (1935) on the work of art in the era of technological reproduction. There he suggested that modern masses or modern individuals in a massive setting act like distracted experts with regard to the movies or other modern art forms with which they are confronted. The casual glance, the distracted ear, or the unconscious mind are the building bricks of a future pop aesthetics, not something autonomous art is made of. Fortunately enough, reality is less rough. Perhaps we can best put it as follows: the history of modern art has been a continuous series of attempts to put art to death while hoping that this would help to rescue art. Pop music represented an intensification of that tendency, as well as a break with it. In its superficiality or apparent banality, pop music really put any idea of art – any idea of transgression or of the sublime – to death. Then again, at the same time, pop music never had any intention to put art to death – it was in fact quite insensitive towards the whole idea of art as such. It wanted fun and it made fun. This really was the death sentence for art: the simple fact that the killing of art was just an act of indifference or even of pleasure – without the afterthought of restoring 'real' art or maybe even a 'better' art after the act, without resacralisation, so to speak.

Elvis Costello is 'after art' or, more precisely, he is beyond any idea of the autonomy of art. His songs and his career escape the possibility of canonising them into a satisfying body of real art. He kills his stamp of authen-

ticity by copying the grand piano of ABBA, he kills his punk spontaneity by co-operating with Burt Bacharach or Anne Sofie von Otter, he kills his pop respectability by co-operating with the Brodsky Quartet, he kills any idea of art by almost everything he does by singing Aznavour's *She* at the end of the feel-good movie *Notting Hill*, or by using a country steel guitar in the middle of the punk rebellion. Or, even worse: by co-operating with all kinds of middle-of-the-road musicians and composers.

Here, we may finally have reached the definitive conclusion, by just accepting the fact that art has died a very silent and rather nondescript death, by just exiting through the backdoor. But this is really too simple, be it only because so much of Costello's music, and for that matter so much of pop music in general, just looks, feels, or sounds so much like art. Should we not have done what Benjamin already suggested: not to try to define pop music in terms of what we have defined or conceptualised as 'art' until now, but to do it the other way around: to try to define what kind of art might result after four decades of pop music? Just like photography, film and video, pop music has not only redefined the criteria for artistic value, it has also opened new fields or domains for artistic practices – and it has done so without bothering about the state of the art itself. Maybe that is the key that opens the door to the mystery hall of pop culture – it has become art without being aware of this evolution, resulting in the enormous and frightening fact that the question 'is this art?' has lost its meaning, and can be exchanged for the question: 'is this pop?' Fortunately no one nowadays knows what 'pop' means – it has nothing to do with popularity, that much we know. To be able to say something normative or qualifying about it at all, we can only refer to the despondent phrase of Simon Frith, who suggested that to be able to say something relevant about pop music we should be able to say something relevant about musical products that you might call unpopularly popular. That is something we are used to say about things which are loved by all but us, or are loved by us but not by all the others – and isn't that a perfect definition of a cultural battleground? Art has nothing to do with purity or autonomy – art is dirty and contagious, or it should be anyway.

CROSSED BORDERS?[*]

THE DEBATE ABOUT CULTURE AND ART IN SOUTH AFRICA
DURING THE PERIOD OF POLITICAL TRANSFORMATION[1]

Margriet van der Waal

Introduction

In 1990, Albie Sachs, a human rights lawyer and member of the African
National Congress's Executive Committee, delivered a speech to an in-
house ANC delegation, suggesting that 'a ban' should be placed on calling
culture 'a weapon in the struggle'. In doing so, Sachs caused quite a stir a-
mongst those who were engaged in the discussion about the role and func-
tion of culture and art during a period of transition in South Africa. The
Sachs incident and the responses to it form part of the discussions about
'art' and its supposed function(s) in South Africa.[2]

[*] I would like to express my sincere thanks to a number of people whose comments
on draft versions of this paper have helped me greatly in formulating my arguments.
In particular, I would like to say thanks to Liesbeth Korthals Altes, Barend van
Heusden, Gillis Dorleijn, and Kees van der Waal. I would also like to acknowledge
subsidies granted to me by the Netherlands Organisation for Scientific Research
(NWO), the Nicolaas Mulerius Fund, and the University of Groningen that enabled
me to conduct research for this article in South Africa.
[1] Coetzee and Polley, *Crossing Borders*, is the title of a book that was published as
the result of a meeting of Afrikaans writers with ANC officials in Zimbabwe, July
1989.
[2] Right from the start, it is clear that there is some semantic confusion regarding the
word 'culture': very often the word 'culture' is used when referring, in fact, to art or
the arts. Raymond Williams distinguishes at least three meanings contained in the
concept 'culture', one of the most complex words in the English language, as he has
said: Culture as a 'general process of intellectual, spiritual and aesthetic develop-
ment ... [or] ... a particular way of life ... [or] intellectual and especially artistic
activity' (*Keywords*, p. 90). The general discussion on the 'role of culture' in South
Africa mostly refers to the role of the arts (music, drama, literature, fine arts, etc.).
The distinction between culture and art is a heuristic one and not an ontological one.
Wendy Griswold makes the distinction between implicit culture and explicit culture
(i.e. art) as follows: Implicit culture is an 'abstract feature of social life: how people
live and think. Explicit culture is a tangible construction, performance or product

In this essay, I discuss some specific moments in the debate on the function and position of the arts in South Africa that took place during the last decade of apartheid, and during the first decade of democracy. This discussion covers the way in which the idea that art is relatively autonomous was dealt with in these debates in the South African context, keeping in mind that this idea is generally also held by Western European intellectuals. What influence, for example, has political change had on the way art is understood, and which function has been allocated to art in South African society? It is my aim here to examine the participants in the debate, the positions they represent, and the ways in which their arguments are constructed. The South African case shows different, occasionally conflicting conceptions regarding the arts, in a context marked by deliberate political transformation. Noticeable, then, is the influence of politics on the different positions taken and claimed by the actors participating in the cultural field. However, as I would like to show, the debate about art is also marked by economic concerns.

The context of the (public) discussion on the autonomy of art forms an important part of the debate about the position and function of art within society. It is for this reason that I turn my attention to an extra-European context to see how the 'debate about culture' in South Africa was waged during the 1980s and the 1990s, in the hope that understanding this discussion within this specific context could contribute to the general debate on art.

The Autonomy of Art?

In Western Europe, the idea that art and artistic practices form a relatively autonomous field was, until recently, more or less accepted as a valid way of thinking about the relation between art and those who do something with art. It has been extensively described and many theories have been formulated, including Pierre Bourdieu's renowned *The Field of Cultural Produc-*

that is produced' (cited by Alexander, *Sociology of the Arts*, p. 3). Note here that there is no normative requirement in this definition. This is in line with a sociological approach to art that does not take value judgements as criteria for studying arts, but rather considers how people use proclaimed aesthetic products in particular ways, and in particular settings (cf. Heinich, 'The Sociology'). Perhaps the currently perceived 'crisis' in legitimating 'the arts' could be held responsible for this new attitude towards art. Influenced by democratic principles, this crisis has to deal with the question 'What is art?' and the answer to this question often resembles a semiotic practice rather than a normative evaluation; cf. Larry Shiner, who defines art as 'something that makes a statement and self-consciously embodies it' (*The Invention*, p. 16).

tion (1993) and *The Rules of Art* (1996). Ascribing autonomy to the artistic field is explained through a historical process in which key historical developments are identified as having played an increasingly important role in Western Europe since the eighteenth century: the development of a middle-class society, increasing individualisation, the development of a market-driven economy, and the development of democracy as a political system. Combined, these elements made it possible to think of art and artistic practices increasingly as something to be regarded in their own right, as a system of practices and role players that can be grouped together and which, subsequently, seem to operate more or less on the basis of their own logic. Hence the idea that art, with all its elements – role players, practices, etc. – constitutes a relatively autonomous field.[3] This field operates more or less according to its own rules, and changes in related fields, such as political and economic fields for example, will not directly influence the field of art, but the field of art will rather interpret these changes according to its own rules and logic – that is why it is said to be *relatively* autonomous.[4]

Secondly, following Immanuel Kant, the idea that art is autonomous also came to mean that art cannot or should not be used for anything else but the enjoyment of itself: the artefact refers only to itself, and not to something else outside of it. This is the famous *l'art pour l'art* idea, taken to be characteristic of elite culture and which is understood to stand in opposition to the idea of art as popular culture, in which art is seen as something that entertains, instructs, or shows reality in a particular way. As has been argued by some,[5] the development of the *l'art pour l'art* ideal is related to the rise of the ideas typically associated with the middle class or bourgeoisie (a particular morality, secularisation, etc.). Taking the aesthetic ideals developed in this process as being more valid, more interest-free, or more essential with regard to the nature of art than other ideas concerning it, is to over-

[3] In an attempt to explain to a non-French reading public some of the more important tenets of this new field of sociological inquiry concerning the study of an artistic field (Bourdieu's *The Rules of Art* for example, was only translated in 1996); Broady ('French Prosopography', p. 384) argues that an autonomous field exists when 'it possesses its own consecration instances, such as – to stick to the literary field – renowned publishing houses, academies, prize committees, leading literary journals, and influential critics and other arbiters in literary taste. If politicians, company managers or television talk show hosts are able to judge on the value of literary achievements, then the field suffers from a lack of autonomy'. (Broady's article suggests that this field-theory related research is more a French (or continental) scientific undertaking than an Anglo-American one.).

[4] See also Schmidt, *Die Selbstorganisation*.

[5] For example, Shiner, *The Invention of Art*; Tak, *Das Problem der Kunstautonomie*.

look the historical development of this type of thinking; it robs this development of its context.

Nevertheless, from this particular historical development concerning the arts – that is, art as autonomous, as interest free – it has become almost commonplace to accept a number of ideas regarding the arts. But, as the currently perceived 'crisis' in the arts demonstrates, these commonplace ideas should be subjected to critical scrutiny: What is art? Who is an artist? What are the possibilities or restraints with regard to the artistic process/ product? (e.g., distribution processes, role of gatekeepers, etc.) Who should support the arts? The state perhaps? How? Whose opinion is more important or significant regarding the arts, and why? During such moments, the fracture lines in the thought processes concerning the arts begin to appear, showing a number of *a prioris* on which particular consensus is based.

Within this proclaimed autonomy of the artistic field, a number of aspects have to be distinguished with respect to the idea of autonomy: artefacts are regarded as autonomous creations, in other words: we isolate different artefacts as individual 'texts', with which we then 'do' something (consume, enjoy, analyse, criticise, etc.). A second aspect relates to the function of art: during the twentieth century, a distinction between entertainment and art has become significant, one of its main reasons being the different tasks ascribed to each. In the same light, a distinction is maintained between art and craft. Thirdly, role players in the artistic field can only function in this domain nowadays as long as their participation offers them economic independence: artists have to be economically autonomous in order to continue their occupations as artists, otherwise they will have to seek economic independence in other fields. Therefore, a further aspect is that of economic independence. This independence does not, in this age of increasing specialisation, just happen by itself, but becomes possible through a whole system of institutions dedicated to the formation of artists and other role players, and their subsequent employment. Special training opportunities for artists, dedicated publications, expert forums and advisory committees, policy-making bodies, etc. are all evidence of the fact that, within the field of art, institutional autonomy is a fourth aspect implied by the notion of the autonomy of art.

A final aspect is that of politics and morality: according to the Kantian position, art can have no purpose beyond itself: it should never be used to instruct on a political level or teach lessons in morality (this idea has often been challenged, even within the Western European system of thinking. An example would be the Victorian Anglo-Saxon reading tradition of Matthew Arnold and F.R. Leavis, and their emphasis on the moral possibilities of literature).

Before turning to the discussions about culture in South Africa during the past two decades, it is necessary to point to the following: one should be aware that the notion of art's relative autonomy is not a universal concept. As the cursory exposé above shows, it is mainly a Western European construct of recent invention. In South Africa, with its history of colonialism and apartheid, one can trace the transportation of some Western ideas to a non-Western, African setting: a number of these ideas and concepts have been adapted to suit local conditions, but are not necessarily accepted by everyone. In the case of art, parts of the processes resulting in the relative autonomy of art, according to the Western European model as described by theorists such as Bourdieu and Schmidt, have evolved in some parts of the country – mainly the urbanised, 'Westernised' parts of South Africa before 1994. The idea of art's relative autonomy is principally held by white South Africans, with their high regard for the individual, which has been poetically expressed by the Afrikaans poet N.P. van Wyk Louw: 'my naakte siel wil sonder skrome/in alle eenvoud tot jou gaan'.[6] In contrast, an Africanist way of thinking is often said to be more collectively oriented, and takes the value of a person as residing in his or her group membership; this is embodied in the philosophy of 'ubuntu' (summarised concisely by the Zulu saying 'I am a person through other persons'). Differences such as these have had an impact on the perceived conceptions and functions of art. Thus, it is important to keep in mind that the question involving the autonomy of art is mainly a Western concern, and may seem totally trivial to many people. However, using this Western European idea as a searchlight and not as a normative measuring rod provides one with an instrument to analyse debates regarding culture and art in South Africa in a meaningful way.

I now turn to the case of South Africa and consider several discussions about art, in order to investigate how this 'dominant' Western conception concerning art, namely, that it forms an autonomous field, has been dealt with in the case of South Africa.

Discussions about culture during the 1980s

Far-reaching political changes have taken place in South Africa over the past couple of decades. It is in this light that the role of politics will be considered in relation to art, specifically the debates about art and how the issue

[6] Van Wyk Louw, '*Grense*', p. 4. Coetzee, Smith and Willemse ('Afrikaanse Letterkunde', p. 64) state that 'Van Wyk Louw het ons geskool in die aristokratiese ideaal, die aristroksie van die kuns, die heiligheid van die individu en die aanbidding van die skoonheid' ['Van Wyk Louw educated us in the aristocratic ideal, the aristocracy of art, the holiness of the individual, and the worship of beauty'].

of politics manifests itself in these debates. Whereas established, Western European ideas regarding the relative autonomy of art imply an independence of art from politics, the South African situation clearly presents a different picture.

The Cultural Boycott

As far back as 1954, Father Trevor Huddleston asked for a special cultural boycott of South Africa. In 1968, the General Assembly of the United Nations adopted Resolution 2396 (XXIII), requesting

> all States and organisations to suspend cultural, educational, sporting, and other exchanges with the racist regime and with organisations and institutions in South Africa which practice *apartheid*.[7]

Two more resolutions were adopted in 1980 and 1981, calling for an academic and cultural boycott of South Africa.[8] This boycott included a register (a kind of 'black list'), published for the first time in 1981, containing the names of performers and artists who had visited South Africa. Such artists were boycotted in the West for their perceived 'support' of the apartheid regime.

To understand the cultural boycott, one has to consider the context of the intensifying struggle for liberation and the liberation movement's political goal of creating a 'united, democratic, and non-racial South African state'.[9] The flipside of the cultural boycott was envisaged to be the creation of a viable and lively 'people's culture', as it was called within the liberation movement. Developments supported as people's cultural initiatives included the establishment of (independent) artists' collectives, publishing houses, musicians' associations, and craft cooperatives, all being institutions functioning without government or elite support.

The ANC received much criticism for its support of the boycott. The underlying motivation for this criticism seems to have been the idea that a political party, i.e., the ANC, should not involve itself with matters such as artistic production, or culture in general. Furthermore, the boycott was regarded by many as a form of censorship, because a process of selection formed part of the boycott: those whose cultural products were deemed disruptive of the government's ideology of white rule were allowed to perform (inside and outside of the country), but those who were supportive, or non-

[7] The United Nation General Assembly, 'Resolutions', p. 20.
[8] United Nations Centre against Apartheid, 'Introduction'.
[9] Masekela, 'The ANC', p. 187.

critical of the National Party (NP) regime, might not – in other words, they were censored. The boycott was also read by some as a sign of the ANC's 'hunger' for centralised power.[10] Barbara Masekela (as head of the Department of Arts and Culture of the ANC, also called the 'Culture Desk') was very aware of the criticism of the ANC's call for, and support of, a cultural boycott. She argued that the cultural boycott was not an attempt by the ANC to prescribe the type of art that should be produced, but was an attempt to force the NP government to start negotiations that would result in democratic elections for all South Africans. The boycott, said Masekela, was also intended to foster the development of a culture that was not the 'handed down' elite culture of white South Africans, but an 'authentic' cultural expression of black South Africans themselves (i.e., people's culture, a concept I shall discuss more extensively shortly):

> We [the ANC] are not dour-faced dogmatists calling for a rigorous code that every song and poem should reverberate with heady revolutionary fervour. Neither do we have a secret formula which advocates percentages or quotas for humour, slogans, names of leaders, history, and so forth.[11]

The position that Masekela defended encouraged people's culture to promote social change; an endeavour often considered to have been performed with grave seriousness and according to particular restrictions, rules and regulations, as her comment illustrates. From this it follows that people's culture was set against what was perceived as high culture's limited scope: non-committed introspection and provision of aesthetic pleasure, regarded, arguably, as frivolous in a time of serious social discrimination.

The reactions to the boycott can be divided into three categories: those in favour of the boycott, those absolutely against it, and those who urged a revision of the boycott, but supported it in principle. The most frequently-used argument against the boycott was that it embodied a limitation of the freedom of expression. Other arguments against it were that the boycott was difficult to enforce, and that it could possibly work in a counter-productive way: the boycott could result in the complete isolation of the country, including sealing off all possibilities of cultural participation for those who

[10] The struggle against apartheid was directed by the United Democratic Front, a collection of political parties and cultural organisations, of which the ANC was the most influential, and powerful. Although it was clear that, when apartheid would finally be eliminated, the ANC would become the governing party, people nevertheless hoped that the ANC would not become a despotic party, but would maintain the culture of democratic negotiation as it was established within the United Democratic Front during the 1980s.

[11] Masekela, 'The ANC', p. 191.

were already culturally isolated due to the apartheid system. The result of the boycott, according to this argument, would be the double isolation of those who were already oppressed and isolated by the government, rather than creating an opportunity for them to nurture the growth of an alternative to 'apartheid culture'.

The different positions taken with respect to the cultural boycott can be considered to be different ways of understanding the boycott: did it serve a legitimate political function or was it an infringement of the rules of the autonomy of art and culture? (A neo-Marxist would ask whether these two issues can be separated at all). If the arts and culture are considered to be political issues, then the boycott seems to have been a legitimate action. From the perspective that grants autonomy, to whatever extent, to the arts, the boycott is more problematic. The problem arises primarily from the notion of freedom of speech, which itself is strongly entrenched in democracy, being exactly what the liberation movement was fighting for. One could argue, looking at the aim of the boycott and the ANC's attitude towards art in general, that *only a particular type* of artistic expression was to be allowed within the struggle for freedom – an expression of experiences and emotions found among those sections of the population oppressed by apartheid and participating in the struggle for liberation – thus implying a limit to the freedom of expression available to artists. One should remember, on the other hand, that freedom of expression was always curtailed by the government's censorship system, regardless of the side of the political spectrum from which it originated: censorship applied to those opposed to apartheid, AND to those who supported apartheid.

An important qualification, however, made by supporters of the boycott, suggested that freedom of expression can only exist in a situation where cultural freedom already exists, and that was not the case in South Africa due to the restrictive measures of apartheid. These restrictive measures were not experienced by everybody though, that is for sure, as white South Africans enjoyed much more freedom than their black compatriots did. In November 1989, Hein Willemse wrote an article in the left-wing intellectual monthly, *Die Suid-Afrikaan*, discussing the cultural boycott.[12] In the article, he gave an historical overview of the boycott and explained that the institutions and areas targeted by the boycott, that is, mostly white universities, art theatres and organisations, representing minority group inter-

[12] The context of this article's publication is significant, because the main readers of this monthly were white, left-wing intellectuals (the magazine no longer exists). It implies curiosity amongst this group about standpoints of the ANC on this issue (and others), and, perhaps more importantly, that information on the ANC was not readily available in South Africa.

ests of the political elite, were those that profited most from a situation where they already occupied privileged positions. The main reason for this was the special promotion of white interests guaranteed by apartheid: exclusive access to resources and networks, and subsequently the right to legitimise a particular conception of art. The ANC's strategy was to isolate white South Africa from academic and cultural contact with the rest of the world, because members of this minority group were, either directly or indirectly, not only the creators, but also the beneficiaries of apartheid:

> Dis nie moeilik om akademiese of kulturele voortreflikheid in 'n minderheid te bereik nie. Veral nie in 'n situasie waar die meerderheid Suid-Afrikaners van mag en toegang tot volle ontwikkeling ontsê is nie.[13]

Support for the boycott made sense from the perspective that it was an instrument with which to exert pressure in order to change the political situation – to ensure the freedom of society in all spheres, not least the cultural sphere. Artists were urged to regard the boycott as necessary in order to ensure the recognition of other more basic human rights for all South Africans. The boycott can be regarded as a political strategy, using art and culture as instruments, whereby the perceived functional and political autonomy of art is placed under pressure.[14]

Art and politics

The National Party Government

On the side of the rulers, not surprisingly, one found proponents of the argument that the field of the arts and culture should be kept free from political interference. At a conference on arts and culture policy in 1988, F.W. de Klerk (the erstwhile Minister of Education), defined the role of artists as one that should be characterised by 'freedom':

[13] 'For a minority it is not difficult to obtain academic or cultural excellence. Especially not in a situation where the majority of South Africans are denied the power and access to complete development' (Willemse, 'Kulturele Boikot').
[14] In May 1989, the ANC adopted a position paper on the Cultural and Academic Boycott, in which it reiterated its support of the boycott as a strategy to isolate the regime from international contact. The crucial role set out for culture as instrument for obtaining liberation was also explicitly mentioned (ANC, 'Position Paper').

Die kunste is 'n lewensverband wat by uitstek vryheid nodig het om te kan asemhaal en te kan floreer. Dit moet op elke vlak so vry as moontlik kan funksioneer. Daarom moet dit nie aan onnodige voorskrifte onderworpe wees nie.[15]

To underline his ideas about granting arts a free space in which to exist, he referred to the position of the arts in relation to the state:

Daar moet ... nie eers rede wees om te vermoed dat die Staat die sake van die kunste reël of wil reël nie. Andersom moet die Staat ook nie by die politiek en interne sake van die kunste betrek word nie. Die kunste moet sigself orden en organiseer.[16]

The minister was quite adamant that art policy and art infrastructure was, and should remain an 'own affairs' issue, which meant that each house in Parliament ought to have its own say regarding matters such as culture and the arts.[17] Taking this into consideration, De Klerk's words have an unconvincing ring: the disproportionate expenditure, access to resources, etc. that resulted from the tri-cameral political system of that time was most certainly not conducive to the type of freedom he envisaged for the arts, not to mention the problems that arose when artists from different contexts attempted to gain access to one another's work. Furthermore, underlying questions as to the influence of repressive laws, limitation of movement,

[15] 'The arts form a context of life that most certainly needs freedom in order to be able to breathe and flourish. It should be allowed to function as freely as possible on all levels. Therefore, it should not be tied down by unnecessary regulations', in: De Klerk, 'Die Kunste'. The Ministry created an advisory body to counsel the Cabinet on matters concerning the arts. Later in his speech, De Klerk mentioned that the Government should provide the structures and funding to support the arts, but that it should not get involved on the level of limiting the arts in any way.

[16] 'There should ... not even be reason to suspect the State of organising, or wanting to organise the affairs of arts. On the other hand, the State should also not be involved with the politics and internal affairs of the arts. The arts should manage and organise themselves' (*ibidem*). This seems rather ironic, given the fact that the State had developed a censorship system, and, in the case of literary education for example, a clear interference between the State and the arts can be inferred from the centralised reading lists to which schools had to adhere regarding the books that were allowed to be read at school.

[17] A tri-cameral parliamentary system was introduced in 1984: a white House of Assembly, an Indian House of Delegates, and a Coloured House of Representatives, but allowing no parliamentary representation for black South Africans. The Government formulated a policy of 'own/general affairs' which meant that a particular issue either was something to be decided upon by the central government, (general affairs) or by the House itself (own affairs). Cultural matters, such as art and creative production, were considered to be an 'own affairs' matter.

and strict content control upon art and the artist and his capacity to produce 'free art' were, for the sake of effective rhetoric, not examined or even mentioned by proponents of official ideology. It is clear that the type of art De Klerk envisaged was art that would not undermine the government's ideology, and this restriction was already a limitation of the artistic 'freedom' De Klerk purported.

As Charles Malan pointed out, the government did take all the necessary steps to make it seem as if they supported the idea of artistic autonomy, but this could be interpreted in the light of denigrating art to the status of being something that is not dangerous or threatening. For example, in 1986, the writer André P. Brink wrote an open letter to President P.W. Botha, urging him to reconsider the political programme of the NP. But Brink's efforts did not elicit any political reaction from Botha. Malan interpreted this as a Government stance with regard to the arts that was clearly different to the position it had assumed during the 1970s when writers were banned because of their disruptive and subversive potential. Furthermore, when the government lifted the ban on a number of texts by black writers during the state of emergency (declared in 1985, and renewed for an unspecified period in 1986), one cannot but interpret this as a sign that the government had exiled art to an autonomous field where it could exert little or no threat to the political system itself.[18]

The liberation movement's position

If the National Party appealed for artistic autonomy, even if its argument for artistic autonomy did not really concern art but was an attempt to maintain its own political ideology, it will be no surprise to find the opposition championing ideas on art different to those of the erstwhile Government. In the wake of a cultural event organised in Gaberone, Botswana, in 1982, where culture was defined as 'a weapon in the struggle', a follow-up conference was organised in Amsterdam in 1987: 'Culture in Another South Africa' (CASA). Three hundred delegates from inside and outside South Africa participated in this ten-day event. The organisers described it as

> the first exchange on so large a scale between exiles and non-exiles, between professionals and amateurs, between members of the democratic movement inside South Africa, non-aligned artists and the African National Congress ... a gathering of major historical importance.[19]

[18] Malan, 'Introduction', p. 12.

[19] Campschreur and Divendal, 'Preface', p. 9. The contributions to the Conference were published in 1989 in Britain, and the book is an interesting memento of the

Issues that were discussed included the responsibility of artists and cultural workers to align themselves with the democratic process, the obligation of artists to disseminate information about life in South Africa, the function of literature and the arts in the education system, and the censorship system.

A few months later, in June 1988, resistance to the Government's position on culture (and, by extension, the arts) was formulated – rather surprisingly – at a conference held in Cape Town, organised by Government institutions and heritage and cultural conservation societies.[20] A number of issues regarding the 'conservation of culture' were discussed. At the end of this conference, contrary to what one would have expected from such a context, the participants rejected the Government's 'own affairs' position with regard to culture, and adopted a statement that reflected the language of the *Freedom Charter*.[21] Although there were, predictably, some people who fiercely rejected this position, it was surprising that, at this kind of occasion where State interest was officially represented, criticism of the Government and support for the ANC's ideas were expressed: these ideas being the equality of every South African, based on a notion of non-racialist democracy. It implied, if not an outright rejection of elitist culture, at least the equal recognition of people's culture.

Even stronger support for the ANC's position on culture came in July 1989, when a delegation of Afrikaans writers and academics met with the ANC at the Victoria Falls, Zimbabwe, to discuss various issues, including the cultural boycott. At this meeting, progressive Afrikaans writers expressed their support for the boycott, provoking hefty reaction in South Africa. Mainstream (i.e. Afrikaans) writers and intellectuals denounced this group's decision to support the boycott, causing a rupture in the Afrikaans writers' organisation and within Afrikaner intellectual circles.

Despite protests from conservative voices, it was clear that certain irrevocable changes were in the air. Not only did F.W. de Klerk announce on 2 February 1990 that the ban on the ANC would be lifted and that Nelson

event, with photos, poems, and papers that were presented during the Conference. When copies of the book arrived in South Africa, they were confiscated by custom officers at the airport, because they contained references to, and contributions by 'listed persons'. The censorship laws in South Africa at that time did not allow references to be made to people who were placed under censorship (Luesly, 'Police seize books').

[20] Although the arts did not form the crucial concern of interest at this event, culture as context for artistic production was discussed

[21] The *Freedom Charter* was adopted in 1955 by the Congress of the People and acted as inspiration for the ANC's policy regarding a democratic future for South Africa.

Mandela would be released from jail, but reference was also made in the media to a speech given by Albie Sachs, a human rights lawyer and member of the ANC, in which he called for a 'ban on culture as a weapon of struggle'.[22] Sachs said: 'We should ban ourselves from saying that culture is a weapon of struggle. I suggest a period of, say, five years'.[23]

He immediately qualified this request by arguing that one cannot separate art and politics, and that he was attempting to avoid a 'shallow and forced relationship between the two'.[24] Although some claim that he was most certainly not the first to do so, Sachs emphasised an interesting dimension of the debate from the side of the democratic movement, where art had been, until then, regarded as subordinate to the political goal.[25] He underlined an understanding of art as something that can provide criticism; in other words, art is not simply something that should faithfully represent a particular social situation. Furthermore, he distinguished between 'real' criticism and 'solidarity' criticism, by condemning the acceptable standards regarding art, current within the liberation movement at that time:

> Our artists are not pushed to improve the quality of their work; it is enough that it be politically correct. The more fists and spears and guns, the better. The range of themes is narrowed down so much that all that is funny or curious or genuinely tragic in the world is extruded.[26]

In his paper, Sachs lamented the fact that the art produced as part of the process to establish democracy displays very little ambiguity and contradiction (the demands of the struggle seemed to disqualify art's capacity for ambiguity as a privileged characteristic of art). He also problematised the vision of culture current in the struggle context, suggesting that culture (and art) has (have) a far wider range of functions than merely that of confirming its political identity:

> The fact is that the cultural question is central to our identity as a movement: if culture were merely an instrument to be hauled onto the stage on ceremonial or

[22] This speech was published as 'Preparing ourselves for Freedom'.

[23] *Ibidem*, p. 187.

[24] *Ibidem*.

[25] Meintjies ('Albie Sachs') points out that many hailed Sachs as a kind of prophet for having said these things, but others, such as Nadine Gordimer and Njabulo Ndebele, for example, had argued this position previously: 'all [have] been crusading for an art that goes beyond the knee-jerk responses to the hurt caused by apartheid'.

[26] Sachs, 'Preparing ourselves', p. 187.

fund-raising occasions, or to liven up a meeting, we would ourselves be empty of personality in the interval.[27]

Sachs also touched on the issue of freedom of speech and expression: according to his argument, a democratic situation required political pluralism, in other words: the right to express different (political) opinions. He declared that the ANC should strive for leadership, not for control over the people:

> This has significant implications for our cultural work, not just in the future but now ... We are not afraid of the ballot box, of open debate, of opposition ... Certainly it ill behooves (sic) us to set ourselves up as the new censors of art and literature, or to impose our own internal state of emergency in areas where we are well organised.[28]

It was, of course, interesting to see how the ANC's Department of Arts and Culture would react to Sachs's statements, and the newspaper heading dealing with its reaction is telling: 'Culture IS struggle's weapon – Desk'.[29] The ANC reiterated its position that support for people's culture is the way to ensure a truly non-racist society: above all, one is part of the struggle and, additionally, also a cultural worker. However, maintaining the 'spears and fists' position was no longer a tenable option for the ANC, and in its statement it said that: '[The Department of Arts and Culture] does not demand that all art should be 'political' in a very narrow sense of the word, but should express all aspects of humanity that will make up a non-racial way of life'.[30]

Carol Steinberg attempts to explain why Sachs's paper evoked so much response, and suggests that the paper was presented at exactly that moment in South African history when the turning point was really reached. Steinberg argues that a particular laissez-faire attitude with regard to protest art had gradually become acceptable, but Sachs 'broke through this convention of just accepting any kind of art in the name of the struggle'.[31] The challenge was no longer to make the country ungovernable, but to take over the leadership and start to run the country. Steinberg sums up the response from

[27] *Ibidem*, p. 189. In a similar vein, culture and the arts have been defined, for example, as that which can aid in the recovery of 'our beleaguered people, black and white' (Mandela, 'Statement').

[28] Sachs, 'Preparing ourselves', pp. 192-193.

[29] Molefe, 'Culture'.

[30] *Ibidem*, citing from a statement released by the ANC's Department of Arts and Culture.

[31] Steinberg, 'Albie Sachs', p. 195.

the left as being 'defensive' (nobody on the left really publicly applauded Sachs paper) and 'reek(ing) precisely of the ethos of dogged closedness that Sachs takes as his project of criticism'.[32] Although some 'grassroots-level' organisations welcomed Sachs's challenge to produce 'imaginative' art, the most favourable reaction came from white academics, critics and artists – such as Steinberg herself, I suppose! And Sachs's own response to the debate? 'The culture of debate is perhaps more important than the debate of culture'.[33]

Key issues

Art? Autonomous?

Looking at the debates, there seems to be some inconsistency about the use of the terms 'culture' and 'art'. No one should be blamed for thinking that the terms 'culture' and 'art' are occasionally deployed as synonyms. The apparent carelessness with which these two terms are used interchangeably at times perhaps says something about the nature of the position of art in South Africa: a relatively weak and unimportant position in society. From the side of the resistance to apartheid, it seems that art was regarded not as an autonomous field of practices (an established idea of art within elite-culture thinking), but rather as a practice within the cultural field (although what this practice exactly included or had as its function is far from clear). If this was actually the line of thinking, it made it possible to call artists 'cultural workers', and to imply that 'people's culture' also includes art, and that art is 'people's culture'. The operative logic seems to be: why, if one is involved in a struggle for the recognition of the equality of every person, would one wish to distinguish one type of production from another? Within the ideology of a working class revolting against middle-class oppression, it would seem treasonous to create a separate category of production for artists, as this could imply that artistic production was significantly different from other types of production. The questions: 'What is an artist?', 'What is the role of the artist?' (is he or she a gifted individual or a mouthpiece for a group of people?) are questions underlying the distinction between elite/high culture and 'people's culture/art'.

Within the elite-culture train of thought (represented by white middle-class interests), art was readily accepted as a separate sphere of cultural activity, as white society in South Africa largely inherited the established way of thinking prominent in Western Europe, where art is granted a relatively

[32] *Ibidem*, p. 196.
[33] *Ibidem*, p. 198.

autonomous space in society and where a value distinction operates, distinguishing between art (usually thought of as Art), and popular/folk art. However, there are some interesting differences between South African society and European society regarding the way one thinks about art.

One such distinguishing aspect is the current extent of secularisation of society. South Africa is much less secularised than Europe and traditional religious (mainly Christian, but also Jewish and Muslim) values still permeate society. The attitude towards art in South Africa is perhaps more similar to that in the USA, where art is often not regarded as being disinterested but is seen as commenting on (and threatening) particular values, such as Christian morality. Art, especially literature, was (and still is) often deemed to be powerful enough to undermine the morality of people, and should therefore not be enjoyed for its own sake.

A case in point is made by Marlyn Martin, director of the South African National Museum, in an article in which she commented on the Minister of Home Affairs and Communication, Stoffel Botha, who warned that the Government would tighten up censorship regulations if the 'growing wave of permissiveness' in South Africa continued.[34] In his opinion, literature, art, and entertainment were used in such a way that they abused morality. Martin's reaction to this was that the argument blaming the arts for the moral crisis was an easy manner of deflecting attention away from the responsibility that the Church and Government should accept with regard to social concerns. These institutions found it easier to blame the arts, ban books, refuse awards to particular artists, or close exhibitions, according to Martin. If the situation was such that the arts were seen to be more autonomous with regard to morality, the Government would certainly not have threatened with such measures! The aspect of the *moral* autonomy of art seems to be absent from the debate on the autonomy of art in the European context (where the issue of autonomy is usually discussed in terms of either political or economic autonomy) more often than in the case of South Africa or the USA. This could possibly be attributed to the higher degree of secularisation in Europe than in either the USA or South Africa.

People's Culture

The subsequent question would appear to concern whether or not 'people's culture' is actually the same as popular/folk art, which is usually understood to be diametrically opposed to Art. Therefore one needs to raise the issue of what is meant by 'people's culture'. What are the parameters of its position in society? The first step in answering this question is to decouple the no-

[34] Martin, 'Blind vir die Kunste'.

the notion of 'people's culture' from the Western concept of 'popular culture', and/or 'folk culture' which became an alternative to the exclusive, elitist ideals represented by 'Art'. In the Western sense, popular culture represents that which entertains (in a negative sense, mass culture, cf. Adorno), while folk culture is seen as having to do something with the handing down of traditional knowledge, and which creates a sense of community, as Simon Frith suggests.[35]

The notion 'people's culture', as it operates in South Africa, comes closest to the notion of 'folk' discourse in the distinction that Frith has made (i.e., that which creates a sense of community), but it also contains a strong, overtly political dimension, instead of being primarily an aesthetic category. In a collection of 'struggle poems', *I Qabane Labantu*, published in 1989, the editors gave some indication as to what the notion of 'people's culture' refers to.[36] They argued that the term is not the same as 'Volkskultuur' (a notion appropriated by the Afrikaners in the South African context, in the process of developing an ideology of white supremacy), but refers to cultural activism in the context of the United Democratic Front. The concerns of this movement are partly played out in the field of cultural production, including the production of 'struggle poetry', for example, of which *I Qabane Labantu* is an example. More importantly however, people's culture is situated in a larger context, namely, the struggle against the inequalities of existence that manifest themselves in issues such as house rent, electricity supply, bus fares, salary disputes, education, detention without trial, militarisation of the townships, and military conscription. In the process of campaigning against these inequalities, poems were recited in public (according to the oral tradition), theatre pieces were improvised and performed, and songs were sung:

> Wat voorheen as verwyderde, onfunksionele artefakte en onkenbare, vervreemde kuns ervaar is, word in hierdie proses gepopulariseer en omvorm tot tersaaklike onderdele van 'n gemeenskapslewe en -stryd.[37]

[35] Cf. Frith, 'The Good, the Bad and the Indifferent'.

[36] Cf. Coetzee and Willemse, *I Qabane Labantu*.

[37] 'What was previously experienced as distant, dysfunctional artefacts and unrecognisable, alienating art, is popularised and transformed in this process into relevant parts of community life and community struggle' (*ibidem*, p. 14). The editors seem to be blind to the fact that there is at least one obvious similarity between the Afrikaner Volkskultuur and people's culture. Both movements had clear political concerns, and used art as a means beyond itself. For the Afrikaners, art was a way to prove that their new language was strong enough to express all kinds of nationalist sentiments in artistic ways; for the democratic movement, art was a means to deal artistically with the issue of liberation.

The notion of 'people's culture' was thus primarily a political one, and was formulated within the discourse about opposition to the white ideology and everything associated with it (therefore also to Art and elite culture, or 'culchah' as Raymond Williams quipped). 'The people' not only refers to those who are not 'the experts', or 'the public' but rather implies the oppressed population of South Africa. The idea of a 'people's culture' (sometimes called 'alternative culture') stands, above all, in opposition to the idea that culture is exclusive in terms of race. In addition, it contains a strong class element: it belongs to the 'workers'.[38] Moreover, it can be said to be informed by postcolonial concerns: i.e., culture is that which is not derived from colonial traditions, is basically authentic, is relevant to one's own experience, rather than being that which is handed down; it is not acknowledged by the own group because it was created by the settlers.

People's culture in this case also implies a particular aesthetic functionality: art cannot be disinterested, but has to contribute to the demise of apartheid. What people's culture furthermore tries to establish is an awareness that aesthetic conventions do not exist a-historically, but are portrayed as such in an attempt to create cultural hegemony. One could say, *mutatis mutandis*, the same of 'popular culture': the only way to understand the aesthetic conventions propounded by the advocates of a people's culture is to place them in their historical context and regard them as part of a process to establish democracy. Within this process, art is seen as an instrument to help achieve a particular goal. In accepting this, something interesting happens: the acknowledgement that art is a definable field (which can be instrumentalised) implies that art is regarded as possessing some autonomy, otherwise it would not have been a 'field' but would simply have been an element of something else. On the other hand, the fact that those advocating art as being 'free' of any interests have to qualify the conditions for such an art to exist, indicates their realisation that the autonomy of art is not an essential quality of art, but rather a particular conventional way of thinking

[38] Two aspects were important determining factors of South African society: the white middle class as the ruling power, and the black working class as the oppressed. These divisions eventually became political identities: 'black' meaning not people who are racially black, but those who supported opposition to racial discrimination; 'white' did not refer to people from a particular racial group, but to those who supported an exclusive, Eurocentric way of thinking. One of the questions that this kind of division leaves unanswered is, of course, where should one place black intellectuals, members of the black middle class, especially after 1994, when the black working class was not dissolved, while an upsurge in the black middle class occurred at the same time. Whose ideals would they support and follow?

about art.[39] The South African case is certainly not unique with regard to this tension (the whole neo-Marxist school of thinking is also evidence of this). As Shiner argues:

> The declarations of a Gautier, Wilde, or Bell that Art has nothing to do with morality, politics or 'worldly' life but exists only for itself are a sort of reverse image of the declarations of a Proudhon, Tolstoy, and some Marxists that Art exists primarily to serve humanity, morality, or the revolution. The extreme expressions of both positions assumed that Art is in fact an independent realm that has an external relation to the rest of society.[40]

Whose aesthetic norms?

The question inevitably arises as to what one should do in a situation where there is no consensus about what constitutes art? One could, of course, ask if there is ever consensus about what constitutes art. That is another aspect of the whole discussion, one that implies a struggle about aesthetic norms. The capacity to legitimise something as 'art' implies a hegemonic consensus. In the Gramscian sense of the word it refers to obtaining the consent of the subordinated groups through a process of constructing ideological approval – in this case the process of constructing the validity of particular aesthetic criteria, rather than the forceful coercion of specific aesthetics.[41]

However, as the Sachs case indicates, such hegemonic consensus does not exist (although this is not peculiar to South Africa), certainly not in a period when talking about art or culture being 'in crisis'. Another telling example is the reaction to *I Qabane Labantu* (1989). Most noticeable among the reactions to this collection of poetry is the idea that these poems 'cannot be called art', at least not according to academic standards defining literary quality. More moderate views stated that the evaluation of these poems should take place by acknowledging the context in which they were created and performed, rather than by appraising them as something that exists by itself or for itself. Such comments seriously undermined the well-established New Criticism paradigm of literature evaluation and analysis in South Africa.

[39] The government of the day tried hard to pretend that it regarded art as an autonomous issue: the division of arts and culture matters as an 'own affairs' issue can be read in this light. Each racial group should personally decide about artistic and cultural matters, but as an 'own affairs' matter – this seems to be the suggestion – it has no links or ties with other issues such as economic or political ones.

[40] Shiner, *The Invention of Art*, p. 224.

[41] Cf. Gramsci, *Selections*.

Those opposed to 'people's poetry' usually argue that this type of poetry demands the suspension of aesthetic criteria in the process of evaluation, implying, thereby, that exists something like standard 'aesthetic criteria'. An example of this train of thought can be found in the scathing remarks of a reviewer of *I Qabane Labantu*:

> Kuns word nou die opium van die massas, maar ek moet beken hierdie straatopium is van so 'n gehalte dat dit net by die ongesofistikeerdste van gebruikers 'n 'high' sal veroorsaak.[42]

However, taking into consideration that modern South African poetry (including 'struggle poetry') has been introduced as a compulsory component of literature education in South Africa, one can trace a slight change of opinion regarding the literary merit (read aesthetic merit) of this genre. Including this genre of literature into the literary canon suggests that, either aesthetic norms are being reconsidered, or the poems revalued. Whether the authors of such 'struggle poetry' are happy about this 'co-optation' is a different matter altogether!

Actions such as the inclusion of this poetry as legitimate literature in the school curriculum could be expected to have been the outcome of serious debate regarding differences in aesthetic norms and criteria in the years after democratic rule was established in 1994. However, apart from the ANC's statement that black culture should be seen as something to be proud of and ought to be given its rightful place in the South African cultural field,[43] very view debates on the issue 'What is art?' have actually taken place. A most noticeable exception was when the ANC, in 2000, attacked *Disgrace* by J.M. Coetzee for its interpretation of the white South Africans' belief, as the ANC stated, that Africans are: immoral and amoral; savage; violent; disrespectful of private property; incapable of refinement through education; and driven by hereditary, dark, satanic impulses.[44]

Most obviously absent from the (small) public debate on art and its function in the South African context is the lack of serious inquiry into the hegemonic position still occupied by elite notions of art. These elite notions mostly represent white artistic interest. Furthermore, the debates after 1994

[42] 'Art now becomes the opium of the masses, although I have to confess that this street opium is of such a quality that it will only produce a 'high' amongst the most unsophisticated of users' ('I Qabane Labantu').

[43] Cf. Barbara Masekela's speech at the Grahamstown Festival Winter School in 1990 (published in *Die Suid-Afrikaan*, August 1990), and the ANC's *Draft* as well as the Department of Arts' *White Paper on Arts*.

[44] Barrel, 'A mean, insecure, fevered spirit'.

have turned out to be more of a fight for money than a fight for legitimating different practices as art.

Discussions on art after 1994

When the 'negotiated revolution' became a reality, it was evident that the ideas espoused by the United Democratic Front, and especially the ideals of the ANC, would have to be turned into real-life practice. It became important to make plans on how to concretise the liberation ideology, and this aspect took priority above the further development of complex ideological arguments. After all, the struggle for democracy had, to some extent, already been won by the early 1990s. In 1992, the National Arts Policy Plenary (NAPP) was launched to discuss these issues (arts policy, funding, organisation of structures, etc.) on a structured basis.[45] It was mainly the progressive cultural organisations that participated in these discussions, as establishment arts organisations already had much support, institutional backup, etc. The NAPP negotiations certainly did not take place without any hitches or differences of agreements, and various parties saw this – the negotiation of new power relations and liaisons – as their chance to clinch as good a deal as possible regarding their own interests.

On the one hand, the many smaller parties and groups of the United Democratic Front expected the ANC to 'put its money where its mouth is', i.e., give the organisations and people who had been discriminated against by the previous regime access to resources, infrastructure, and networks. On the other hand, in the spirit of fairness and impartiality, the ANC realised that it could not side with any particular segment of the democratic movement for fear of being judged as biased and guilty of preferential treatment and, perhaps most importantly, be accused of meddling in the affairs of 'an autonomous field'. I think that the differences in opinion (for example, how to grant and regulate art subsidies) that emerged from within the democratic movement during these times are indicative of greater problems that were already evident but had not been investigated for the sake of fighting the struggle on a unified basis. It was the ANC's professed position that it would help interest groups to convene, facilitate negotiations, and then withdraw in order not to be directly involved in the policy making (a rather naïve ideal of the future ruling party that, after winning the election in 1994,

[45] Under NP rule, there had not been a separate Arts or Culture Ministry or Governmental department. This level of representation in the Government was negotiated during this period of transition.

installed a national government department of Arts, Culture Science and Technology, as well as a dedicated ministry!).[46]

As the disconcerted remark of Maria Pisarra (General Secretary of the Cultural Workers' Congress) below shows, the general grab for authority and power positions at that time turned out to be even more important than debates about the definition and function of art:

> We are no longer comrades and cultural workers. These days we are all professionals. 'Comrade' has become 'colleague', 'Doctor', 'Professor', 'Mr/Ms'anything but 'Comrade'. Another casualty of NAPP's 'newspeak' is the controversial 'cultural worker' which has become 'arts practitioner' (or educator or administrator).[47]

If this is anything to go by, the debates at such meetings were no longer about the form and content of the arts, but about who gets money, what to call oneself as a functionary in a new position, and how to label the newly-assumed positions: real bureaucratic issues! In the mean time, the established, elite organisations continued to occupy a privileged position, producing more elite culture mainly for a minority, white public.

The fact that established cultural organisations had something (perhaps even much) to lose can be read from warnings such as the one expressed by writer and academic André Brink in a paper delivered at the University of Cape Town, on the future of control over publications and free dissemination of information in the country. He accused some ANC members at the Department of Arts and Culture of dictatorial inclinations, and warned that:

> sommige misbruik (kultuur) in 'n poging om mag te bekom. Hulle ly nog aan die wonde van apartheid en hul onvermoë om te verander voorspel niks goeds vir die toekoms van vryheid van spraak nie.[48]

Joan Hambidge, poet and academic, reacted positively to Brink's criticism, and said that:

> Skrywers is veronderstel om enige voorskrifte te bevraagteken veral wanneer dit van kultuurorganisasies en onder die voorwendsel van politieke 'edelheid'

[46] Van Graan, 'Some of my best friends'.
[47] Pisarra, 'Some of my best friends. Reply to Mike van Graan'.
[48] 'Some abuse (culture) in an attempt to attain power. They still suffer from the wounds of apartheid, and their inability to change does not bode well for the future of freedom of speech', 'ANC-lede "neig na kultuur-diktatuur"'.

kom. Want dit beteken immers 'n nuwe groep, 'n nuwe hegemonie, 'n nuwe klomp beterweters, 'n nuwe klomp ons-gee-net-vir-onsself om ...[49]

The problem is: should one read this as an attempt to negotiate a strong position for a group that previously occupied a strong position, thereby recognising that they had access to all the support that makes dominance possible, or is this valid criticism from a group that no longer represents the old order but is critical of the way the new order is doing things? This question arises because their behaviour and arguments remind one of the previous situation: is this a case of old wine in new bags? These days, one gets the uncanny feeling that much of the criticism against the actions of the ANC are not attempts to participate in debates on genuine transformation, but are rather efforts to retain or maintain power. For example: in 1999 an open letter was written to President Mbeki and signed by a whole group of prominent Afrikaner thinkers, writers, and academics. In this letter, the hegemonic power of English is deplored, and the writers urged Mbeki to undertake action to protect linguistic minorities. The fact that their demand was made in the interest of all the 'minority' languages, but only had representatives of Afrikaans as signatories, considerably weakens the validity of who they say they represent.[50]

Accusations about the Government's appetite for control have also emerged from other sources. Furthermore, a general dissatisfaction with the state of the arts and culture in the country is often expressed. From the progressive side, complaints were heard about the Government's ineffective and perhaps even disastrous culture and arts policy. Mike Van Graan, an active participant in the arts policy debate (and with impressive 'struggle' credentials), described the current situation as follows (perhaps a little polemically):

[49] 'Writers are supposed to question all instructions, especially when they come from cultural organisations, and under the motto of political 'nobleness'. Because, after all, this implies a new group, a new hegemony, a new bunch of wise guys, a new bunch of we-care-only-about-ourselves ...'. Cf Hambidge, 'Haal af die pampoenbrille'.

[50]'Pres Mbeki, luister asb na ons'. Another telling example is the case where the Government had cut the subsidy to the National Symphony Orchestra, resulting in the (mostly white) theatre going public crying out against this 'attack' on Eurocentric art forms by the government: 'Waarom moet die kunste die prys betaal vir 'n voorheen foutiewe bedryf, of politieke bestel?' ['Why should the arts pay the price for a previously wrong institution or political system?'] asked an Afrikaans daily newspaper, under the heading 'Eurosentrisme?' (in: *Beeld*, 6 May 1995).

Instead of seven years of milk and honey, it seems like it has been seven years of a plague of locusts. Closed theatres. Liquidated orchestras. White elephant community art centres. The flight of skills abroad. The migration of audiences elsewhere. NGOs that have collapsed. Museums unable to fulfil their mission to preserve the country's heritage. Declining budgets. Skilled administrators who have fled to greener pastures. Technicians who opted for the security of casinos.[51]

This rather pessimistic picture is somewhat corrected by his mentioning the success stories, such as the creation of the National Film and Video Foundation, and the National Arts Council. The questions remain the same, however: who has access to money, and who controls this access? The structures are there, but those who were intended to be the receivers of money and subsidies in the new system have not (yet) become the recipients, thus directly affecting the economic aspect of autonomy for artists and arts practitioners. Some analysts, disparagingly, point to the lack of tolerance from the Government's side in dealing with criticism, resulting in a barrier to access to resources:

Artists are fearful of raising criticisms in their work lest they upset the new gatekeepers of resources. They refrain from questioning the contradictory decisions and inefficiencies of official structures for fear of later victimisation ... The independent are marginalised. The praise-singers are promoted. The critical are told to go to hell ... A conference on cultural policy was cancelled and the funds returned to the international donor because of the fears of some that such a conference would be critical of current policies.[52]

The ANC's problematic attitude towards criticism implies a complicated relationship between the aspect of politics and the autonomy of players in the arts field (and other fields) and the Government. One group that seems to operate with political autonomy and makes critical statements against the government through its art is the hip-hop band, Skwatta-Kamp. But those in power contest the political autonomy of artists and groups such as Skwatta-Kamp, whose critical rap lyrics prompted the ANC Youth League to try and convince a radio station to stop giving the band air time.[53]

In South Africa, part of this discussion about the function of art is the plea of some to move onwards, leaving the overt 'polytonality' of the South African situation behind. The role of the artist is to start paying attention to

[51] Van Graan, 'Some of my best friends'.
[52] *Ibidem.*
[53] Ndlangisa, 'Hip-hop hullabaloo'.

the private and individual: the small stories of being human rather than the grand narratives of politics and history. Others, however, argue that, until transformation has reached all aspects of South African society, such a wish is naive and selfish.

Conclusion

One could conclude that, in the South African case, political, institutional, functional and economical factors are clearly involved in a field claimed (sometimes) to be relatively autonomous. Some role players acknowledge these factors, while others clearly refuse to do so in an overt manner. Today, the 'struggle artists' find themselves no longer protected by a particular political ideology, and are confronted with the reality that there are basic market principles regulating cultural and artistic activity. On the other hand, one finds people (still) arguing the case for the existence of an elite culture (taking their example from European ideas born in the eighteenth century), and who do not want to concede or accept the expiry of the sell-by date of their arguably highly exclusivist attitude to art and culture.

The problem seems to be contained in the suggestion that thinking about art is an 'either/or' situation. The discussions – before 1994 about the 'correct' approach to culture, and after 1994 about 'what merits government funding' – indicate that, underlying these debates, one could perhaps find the shared idea that there is, somewhere, the 'right' approach concerning the arts. It may prove more useful to keep the particular 'double-speed' features of the South African situation in mind. Usually, a totalitarian regime, such as the South African one used to be, is associated with a restricted economy at some point, whereas a democratic structure is usually associated with the ideals of a liberal economy.[54] In South Africa, where the liberal humanist ideals associated with such a market economy were more or less reality for the white part of the population (or the elites), this was certainly not the case for the black part of the population. Free-market mechanisms operated more or less in white South Africa as they did elsewhere in the world and, not surprisingly, one sees that the development of an artistic field as characterised by Bourdieu can be detected, for example, in relation to literature. Although the literary field is by no means as extensively developed in South Africa as it is in Europe, it contains most of the necessary elements to be called a field on its own. But, the differences between the production and functioning of Afrikaans and English literature, with both displaying typically autonomous field qualities à la Bourdieu, and that of the African languages, prompts one to consider the co-existence, not of one literary field,

[54] Cf. Sapiro, 'The literary field'.

but of many fields: a polysystem, as Itamar Even-Zohar has theoretically described such widely different situations.[55] An example should suffice here: whereas access to books had never really been a problem in 'white South Africa', the first bookshop in Soweto was only opened in 1995. This leads, however, inevitably to the question: should the different literary domains in South Africa mimic the field as it is in Europe (and which, with some minor changes here and there, the Afrikaans and English literary fields more or less already resemble), and should the decision and policy makers in South Africa encourage the African-language literary fields to develop towards this ideal, or should one reconsider the notions of the literary field (or art field) with the aim of serving the particular situation in South Africa better?

It is a question I shall not try to answer here. Nevertheless, I would suggest that a critical examination of perceptions regarding art and its function should be part of the answer. For those involved in making policy and commenting on it, it is perhaps enlightening to look around and see how art is produced, to discover which function it actually fulfils in South Africa, instead of spending energy on trying to figure out how art *should* be produced in South Africa, and what function it *should* fulfil. This will be instructive not only for those in South Africa who deliberate on the issue. As a highly interesting field case, it might also contribute to the debate on art elsewhere.

[55] Even-Zohar, 'Polysystem Theory'; *idem*, 'The Literary System'.

TORN BETWEEN TWO (AUTONOMOUS) LOVERS

MIMESIS AND BEAUTY IN MODERN ART[*]

Barend van Heusden

Introduction

In a recently published book entitled *The Blank Slate. The Modern Denial of Human Nature*, the well-known linguist and cognitive scientist Steven Pinker, author of the bestsellers *The Language Instinct* and *How the Mind Works*, devotes a chapter to the alleged crisis in the arts.[1] The first sentence reads: 'The arts are in trouble.' After having illustrated his claim with a list of apocalyptically sounding titles like 'The Death of Literature', 'The Decline of High Culture', or 'The Humanities At Twilight', Pinker offers the following startling diagnosis: 'As a matter of fact, the arts and humanities are *not* in trouble', and: 'We are swimming in culture, we are drowning in it'.[2] And yet, he continues, there are certainly things about which one can become depressed. These are to be found in three areas: the traditions of elite art descended from prestigious European genres, the guild of critics and cultural gatekeepers, and the groves of Academe 'where the foibles of the humanities departments have been fodder for satirical novels and the subject of endless fretting and analyzing'.[3]

According to Pinker, the causes of the troubles in which we find ourselves must be sought in Modernism. In Pinker's story of art, Modernism is definitely the bad guy. It was Modernism that left the high road of human nature behind (when and where in history did we hear something similar about Modernist art?), and ventured into the no-man's land of something 'different'. In fact, Modernism was an attempt to reflect, in art, 'a changed human nature'. But human nature is not a blank slate, as Pinker has made clear time and again in his book, and it certainly did not suddenly change in or around 1914. Art is part of that stable human nature; it resides in our

[*] I want to thank Liesbeth Korthals Altes and Hans van Maanen for their critical comments on an earlier version of this paper.
[1] Pinker, *The Blank Slate*, pp. 400-420.
[2] *Ibidem*, p. 402.
[3] *Ibidem*, p. 403.

brain and genes. Proof is hardly needed: in all known societies, people play music and generate theatre, they dance and tell one another stories. We know that jewellery, sculpture, and musical instruments date back at least 35,000 years, and we find rock paintings as old as 50,000 years. During all these thousands of years, human nature did not significantly change, nor did art.

In support of his argument, Pinker lists the seven universal features of art as identified by Denis Dutton, which are: expertise or virtuosity, non-utilitarian pleasure, style, criticism, imitation, special focus, and imagination.[4] These principles may remind one of the eight principles of artistic experience discovered by the neuro-psychologists Ramachandran and Hirstein: peak shift, isolating a single cue, perceptual grouping, contrast, perceptual 'problem solving', an abhorrence of unique vantage points, metaphors (the most enigmatic principle, according to the authors), and symmetry.[5]

As Pinker explains, organisms get pleasure from things that promoted the fitness of their ancestors. Recent research in evolutionary aesthetics has successfully documented which features make a body, a face, or an environment beautiful. In good works of art, these aesthetic elements are layered, thus turning the whole into more than the sum of its parts. Pinker relies heavily on Ellen Dissanyake's work on biological and evolutionary aesthetics, but the important work done by Eibl-Eibesfeldt, who reached similar conclusions, should also be mentioned.[6] The existence of these universal aesthetic features may well explain why some art, although its content may be local and historical, is universally valued: the strategies displayed are more or less the same everywhere and always.

So what is the problem? The problem, says Pinker (and Turner and Pöppel made a similar claim in 1988), has to do with the art of Modernism and Post-modernism.[7] This art denies the universal principles of the aesthetic, and therefore denies human nature. Modernism glorified pure form, and had a disdain for beauty and 'bourgeois pleasures'. Things got even worse in Post-modernism: Art is whatever we call art: 'Once we recognize what Modernism and Post-modernism have done to the elite art and the humanities, the reasons for their decline and fall become all too obvious.

[4] Dutton, 'Aesthetic Universals'.
[5] Ramachandran and Hirst, 'The Science of Art'.
[6] Dissanyake, *Art*; *idem*, *Homo Aestheticus*; Eibl-Eibesfeldt, 'The Biological Foundation'.
[7] Turner and Pöppel, 'Metered Poetry'.

The movements are based on a false theory of human psychology, the 'Blank Slate':[8]

> Modernism and Post-modernism cling to a theory of perception that was rejected long ago: that the sense organs present the brain with a tableau of raw colours and sounds and that everything else in perceptual experience is a learned social construction.[9]

In Modernism, only the very aberrant still provided prestige. Modernist art stopped trying to appeal to the senses, *it stopped being beautiful*. A team of specialists was needed to understand and interpret art.

> The dominant theories of elite art and criticism in the twentieth century grew out of a militant denial of human nature. One legacy is ugly, baffling, and insulting art. The other is pretentious and unintelligible scholarship. And they're surprised that people are staying away in droves? ... The currents of discontent are coming together in a new philosophy of the arts, one that is consilient with the sciences and respectful of the minds and senses of human beings. It is taking shape both in the community of the artists, and in the community of scholars and critics.[10]

It would be, I think, far too easy to have a laugh at Pinker's 'venture into the world of art', and leave it at that. His argument, though sweepingly stated, is serious and important. Moreover, Pinker's voice is certainly not the only critical sound in the debate about the crisis in contemporary art.[11] One cannot neglect his designation of anthropological aesthetic universals. I do not think the diagnosis given is entirely correct, but what could offer an alternative explanation? Where does the argument fail? I will argue that Pinker's argument, as well as similar claims that have been advanced by others, probably derives from a misunderstanding regarding the relation between beauty and art. Moreover, it seems to me that Pinker's analysis of Modernist and Post-modernist art fails to take into account a general historical trend toward autonomy in all domains of modern culture. Art is no exception to that development. As I shall try to make clear, the 'excesses' of

[8] Pinker, *The Blank Slate*, pp. 411-412.

[9] *Ibidem*, p. 412.

[10] *Ibidem*, pp. 416, 417.

[11] In the Netherlands and Belgium, for instance, the crisis in the arts has recently been the subject of an intense debate among art critics, art historians, and museum directors (cf. Tilroe, *Het blinkend stof*; Wolfson, *Kunst in crisis*; Van de Veire, 'I love art'. In Great Britain, the art critic and museum director Julian Spalding (*The Eclipse of Art*) defends a position that is very similar to Pinker's.

Modernist and Post-modernist art may well have the same origins as Pinker's own scientific thinking.

Semiosis

Instead of tackling head-on the complex and difficult question of the relationship between art and beauty, I prefer an approach that is a little more oblique. Rather than starting a search for convincing definitions of art and beauty, I shall follow a path that does not start with such definitions but will eventually lead us to these. My point of departure is the generally accepted insight that the human being is the *animal symbolicum*, or semiotic animal.[12] Human semiotic behaviour, or *semiosis*, grounds human culture in its myriad of forms: from simple gestures to elaborate theories, from simple tools to highly sophisticated technology. To arrive at art, we will have to take a number of steps.[13]

A first step takes us from the general phenomenon of representation to human semiosis. As anything can become a sign to someone in some respect or capacity, signs are not empirical realities. But the sign process, or *semiosis*, as an activity of the human mind, is certainly this kind of reality. Representation can be defined, in general terms, as the internal sensory-motor organisation, or 'memory', that allows an organism to interact with its environment. This kind of representation can be sophisticated to a greater or lesser degree, ranging from very elementary chemical reactions to very complex stimulus-response mechanisms. In humans, and possibly also in other higher primates, we witness a *doubling* of the representation, resulting in an awareness of a *difference* between past and present, or memory and actuality, as well as the need to deal with it. It is this double re-presentation and the sense of difference it generates that provide the basis for semiosis, as they turn memory into a reservoir of signs, and the process of representation into a process of interpretation in which memory is continuously matched with actuality. This semiotic process accompanies action and, once this system is set in motion, humans live in a world in which consciousness (representation) does not always coincide with action. The former does not necessarily entail the latter, although the latter always presupposes the former.

A second step takes us from semiosis on the level of perception to semiosis on the level of concepts and, finally, to semiosis on the level of structures. This development is the result of the increasing complexity of

[12] Cassirer, *An Essay on Man*.
[13] For a more elaborate treatment of these issues, see Van Heusden, *Why Literature*; *idem*, 'The Emergence'; *idem*, 'A Bandwidth Model'.

semiotic structures.[14] One-place perceptual or iconic signs are sounds, images, smells, and feelings. Two-place conceptual or symbolic signs consist of a signifier and a signified. A lexicon is probably the most elaborate system of two-place symbolic signs. Three-place theoretical or indexical signs consist of a signifier, a signified and an object. An abstract structure has taken the place of conceptual meaning, and the three entities constituting the sign relate to each other on the basis of structural identity. Models and diagrams are examples of theoretical signs, and so is the syntactic structure of linguistic utterances. Three-place signs enable logical and mathematical reasoning.

Thus we distinguish three levels of semiosis: a first level of icons in perception, a second level of symbols in conceptualisation, and a third level of indices in theoretical reasoning. These three sign types constitute the building blocks of any human culture. They cumulatively build upon each other in different genetic developments: phylogenetic, ontogenetic, historical, and actual.

A third and last step takes us from first-order to second-order semiosis. From the very beginning of semiotic evolution, the semiotic process itself has become an object of semiosis, that is, of interpretation. Reflexivity and self-consciousness are inherent in the process of semiosis: (self)-consciousness is nothing but the interpretation of the semiotic process: when the memory I have of myself does not exactly coincide with the actual perception of me, this difference generates a reflexive semiotic process. On this level of meta-order or second-order semiosis, we find the same levels of abstraction, as well as the same developmental logic, as in first-order semiosis. This means that semiotic reflexivity or self-consciousness comes in three forms: as an icon, as a concept and as a structure ... and in that order.

We now have at our disposal a relatively simple structural model of the semiotic process, which allows us to distinguish a number of basic semiotic modes – or 'symbolic forms', in Ernst Cassirer's terminology. In fact, we found six of them: first-order perceptual, conceptual and theoretical semiosis, complemented by the same triad at the second-order level of meta-semiosis. In a process of increasing abstraction and complexity, culture develops, as it were, from a one-layered to a three-layered structure. Moreover, the relationship between the different levels of abstraction is itself determined by the dominant level of semiosis. Thus, in a culture dominated by theoretical semiosis, such as Western culture since the eighteenth century, the relationship between icons, symbols and indices is structured in a theoretical manner, that is, on the basis of structural

[14] Cf. Donald, *Origins*; *idem*, 'Mimesis'.

properties.[15] The autonomisation of art in modernity, which has its roots in ancient Greece but received its greatest impetus in the seventeenth and eigthteenth centuries, is a striking example of this semiotic developmental logic.

Art

I would now like to propose the following hypothesis: what we experience as art corresponds to iconic second-order semiosis. The characteristic features of this form of semiosis, which is one of the six basic semiotic modes, seem to correspond quite accurately to the features ascribed to art and the artistic. I would suggest, therefore, that when the iconic second-order dominates in semiosis, we are dealing with (an attempt at) art. The second-order (that is: the reflexive) level accounts for the 'contemplative' nature of art: art is not life itself, but it is a contemplative *reflection* on human life. This reflection, moreover, is iconic, that is, it is realised as a concrete event. This is the case even when, as happens in literature and sometimes in non-figurative art, the signs involved in the representation process are themselves highly abstract. In artistic semiosis, abstractions, be they literary, pictorial or otherwise, are always embedded in – and perhaps it would be more correct to say: experienced from – a concrete perspective (as they are in real life, one should notice). In other words: artistic semiosis is figurative, the signs are concrete in terms of place, time, event, and, possibly, character. Iconic (meta-)semiosis is neither conceptual nor analytic – it is neither primarily moral nor epistemological. It is not primarily oriented to action or thought, but rather toward perception. In addition, the reality represented in art, that is, the reality of human life, is two-dimensional: as I mentioned earlier, it consists of consciousness (or representation) and action. Second-order semiosis always takes both into account. It involves the double perspective of consciousness and action. Art therefore never merely concerns *what* is perceived, or valued, or thought, or done, but always also concerns *how* it is done. It is an attempt to catch, in concrete signs, the semiotic process involved in acting: in looking, listening, feeling, judging, or thinking. Any work of art should prove this point.

From a semiotic point of view, art certainly has a function. It is one of the three basic forms of self-consciousness, and other forms of self-consciousness must build upon it.[16] The semiotic perspective also enables us to

[15] For an analysis of this cultural development from a critical perspective, see Horkheimer and Adorno, *Dialektik*.

[16] A possible reason why Ernst Cassirer never succeeded in giving art its due place in his system of symbolic forms may be related to the fact that he never included the

take a fresh look at the age-old issue of the mimetic nature of art. As it provides a concrete image, iconic semiosis must necessarily be mimetic, and so is second-order iconic semiosis. It is not mimetic, however, in the banal sense of referring to a sensory reality, but as an image (in the broad sense, including all the senses) of *the reality of the semiotic process*, that is, as a faithful representation of experience, of perception, conceptualisation, and thought. Art certainly is, and always has been, an 'imitation of nature', but the nature imitated is human nature, the nature of the semiotic process, of human life. This brings me close to the pragmatist experiential aesthetics of John Dewey.[17] The difference, however, between his and my position is that experience, as I see it, can never be the *raison d'être* of art. Rather, it is the result of an active engagement with the semiotic process generated by art. Experience is, of course, a vital ingredient of life, and therefore also of its mimetic representation in art. At the same time, that is precisely what would make it a very unlikely candidate as a criterion for art. This semiotic approach of art may also remind one of Goodman's semiotic aesthetics.[18] Goodman defined aesthetic experience as 'cognitive experience, distinguished [from science and other domains] by the dominance of certain symbolic characteristics'.[19] These characteristics are syntactic density, semantic density, relative repleteness, exemplification, multiple and complex reference.[20] From the semiotic point of view outlined here, these semiotic characteristics serve to fulfil the mimetic function described above. As such, they do not define art, but they will probably be found wherever art is at work. 'Exemplification' comes nearest to what I have described as the mimetic function of art. Art, I would say, exemplifies life by mimetically representing the universal structure, as well as the historical contents of the semiotic process.

Beauty

So far we have not yet dealt with the problem of beauty. How does art, defined as iconic meta-semiosis, relate to beauty? To answer that question, a brief excursion into biological aesthetics may be helpful. If there is one single thing that research into the biology of the aesthetic has convincingly

level of reflexivity or second-order semiosis in his theory of symbolic forms. Had he done so, he would also have been able to distinguish between science and philosophy, the first- and second-order of theoretical semiosis respectively (cf. Van Heusden, 'Kunst').

[17] Dewey, *Art as Experience*.
[18] Goodman, *Languages*; idem, *Ways*; idem, *Of Mind and Other Matters*.
[19] Goodman, *Languages*, p. 262.
[20] Goodman, *Ways*, pp. 67-68.

shown, it must be this: beauty is a universal feature of human culture.[21] As humans, we search for beauty most of the time, almost everywhere, and in whatever we do. We decorate our bodies and our houses, we try to design beautiful clothes, and we shape our interactions with all sorts of beautiful rituals. We appreciate the beauty of bodies, faces, movements, sounds, gestures, objects, landscapes, gardens, buildings, language, images, ideologies, and scientific and philosophical theories. At this very general level, therefore, the universal principles listed in the introduction are certainly at work, though probably not always all together, and not all with the same force. The explanation for the ubiquity of beauty in culture given by evolutionary biology seems absolutely convincing to me: we tend to find beauty in whatever promotes adaptive fitness. Beauty is thus a general aspect of a world in which we feel at home and safe, and where our mental efforts in perception, conceptualisation, and in thought, are generally successful. One could eventually differentiate the beauty of taste, or 'sensory beauty' (taste, touch, sight, hearing, and smell) from the sense of beauty that is related to the semiotic, that is, to the solving of problems in perception, conceptualisation, and theory.[22]

The drive for beauty is, at least in part, a drive for a recognised order, for clear forms, for symmetry, for themes with variation. In the semiotic processes that constitute human culture, we witness a strong tendency toward the establishment of order (an order created, constructed, uncovered, or discovered). People tend to search for order, and to construct order out of disorder.[23] The reason may again be clear: chaos causes uncertainty, and uncertainty hampers or impedes action. Not being able to act is a dangerous situation. The suppression of uncertainty enables coherent action, becoming a skill that enhances our survival potential. No wonder the discovery of order (of form, meaning, and structure) generates a strong sense of satisfaction (as every critic of art will acknowledge). We can thus relate our sense of beauty to representation and semiosis in general. Evolutionary biology, in a sense, corroborates the old idea that what is true or good is also beautiful. When Plato discusses beauty in the *Symposium* and in the *Phaedrus*, he speaks about physical beauty of human beings, the beautiful habits of the soul, and beautiful cognitions. 'In the theory of beauty a consideration of

[21] Cf. Renschler, Herzberger and Epstein, *Beauty and the Brain, passim.*

[22] McMahon ('Perceptual Principles') refers to the two traditions in aesthetics that deal with these two 'types' of beauty, as the 'Pleasure-Principle Tradition', and the 'Pythagorean Tradition', respectively.

[23] Cf. Peckham, *Man's Rage for Chaos.*

the arts is quite absent in Plato and secondary in Plotinus and Augustine,'
says Kristeller.[24] We can now understand why.

As one of the basic semiotic functions, art obeys this general biological
principle: it should be beautiful. But, as in so many other realms of culture,
a tension can arise between the aesthetic and the semiotic. What should
prevail: beauty or truth (to life)? That, I dare say, is an age-old dilemma that
has confronted humans not only in the realm of art, but in that of science
and politics as well. In the love poem, we want the verses to rhyme, but it
should also express our feelings adequately. In art, as in most realms of
culture, we strive for perfection. Art must therefore render life in a perfect,
experiential way. But, because life is not necessarily beautiful, a tension can
arise between beauty and art; just as it arises, in a similar way, in science,
politics, and everyday life.[25]

One of the most intriguing aspects of modernity, since the eighteenth
century, has been the focus, in art, on the artistic or mimetic function,
neglecting or even refusing to pay attention to beauty. It is precisely this
aspect of modern art that has been one of the causes of the crisis in the arts,
to which we can now return.

Autonomy

In line with the hypothesis advanced above, it should be clear that the
discussion about autonomy changes completely when we turn from works
of art to semiotic functions. What does it mean to say that a semiotic
function is autonomous? It simply means that the function exists as such (it
has an identifiable and characteristic structure) and that it cannot be reduced
to any other function. It does not necessarily mean that it must always be
isolated in semiotic practice. Whereas the general semiotic function is
always present, the mimetic function is one among a number of other
semiotic functions. Apparently, when we speak about the autonomy of art,
we think about a certain form of isolation of the mimetic function from
other functions, in a certain historical period. To understand this, we have to
turn to history and the evolution of culture.

In modernity, the autonomy of both the artistic (art) and the aesthetic
(beauty) is one of the many consequences of the rise of theoretical culture.
The great invention of theoretical culture, the beginnings of which can be
located as far back as classical antiquity, is *structure*. A structure is a stable

[24] Kristeller, 'The Modern System', p. 500.

[25] Gestalt-psychologist Rudolph Arnheim (*Film as Art*) refers to the equilibrium or
balance between these two sides of the cultural coin as 'symbolic pregnance' ('sym-
bolische Prägnanz').

abstract system of relations. As it underlies sensory reality without being perceived, a structure comes into existence only through thinking. Indexical or theoretical signs, such as diagrams or models, refer to reality not on the basis of a perceptual analogy (as is the case with icons), nor on the basis of a convention (as is the case with symbols), but on the basis of structural identity. The discovery of structure enabled the advent of science (or first-order theoretical semiosis) and philosophy (or second-order theoretical semiosis), that is, enabled the dawn of modern culture.[26] Modern culture, one could say, originates and develops with the search for this reality of structure, for the 'absolute' or the 'Ding an sich'.[27] Thought requires a very sophisticated semiotic make-up. Basic to theoretical semiosis is *contiguity*: elements are conceived as related in a virtual space, and the primary intellectual move is one of separation or, as we are accustomed to calling it, *analysis*. It is structure, the 'thing as such' that grounds the autonomy, not only of art, but of all domains of culture: the individual and society, science, politics, religion, myth. Whatever has a specific and identifiable structure is in a very strong sense autonomous – its identity rests on its having a form that is independent of human perception or action. As theoretical knowledge provides a far more secure basis for action than systems of beliefs, the search for the structure of reality becomes imperative in modern culture. Art – the structure of imitation and imagination – was but one of the many structures that were investigated.[28]

On the level of second-order semiosis or mimetic reflection, we witness a movement from art as embodied meaning to art as embodied knowledge, from figurative prescription and ideology to figurative theory and philosophy.[29] In modern culture, both the artistic and the aesthetic, as identifiable structures of cultural reality, can claim a realm of their own. But, unfortunately, the term 'art' had to serve both, becoming a source of endless quarrels. Autonomous beauty became the realm of 'art for art's sake', of the aestheticism of pure form, whereas autonomous mimetic semiosis became the domain of realist art, dedicated to the uncompromising quest for the essence of life.

[26] Cf. Mithen, *The Prehistory*; *idem*, 'A Creative Explosion'; *idem*, *Creativity*.

[27] Cf. Abrams, *Doing Things with Texts*.

[28] We still stand squarely in this modern tradition. On the level of critical practice, we have moved from the *interpretation* of beauty to the *discovery* of beauty – from the work of art as *message* to the discovery of the *structure* of art (see the contribution of Rainer Grübel to this volume). The modern perspective has been incredibly fruitful in terms of textual research.

[29] I do not agree with Abrams (*Doing Things with Texts*) that the paradigm shift in the eighteenth century is one from construction to perception. It is, rather, from concept to analysis.

The movement toward autonomy did not begin in the nineteenth or in the eighteenth century.[30] In fact, it started way back in antiquity with Plato's questions about the function and specificity of art. Autonomy acquired its characteristic present-day form via a number of shock waves. In eighteenth-century Western Europe, the autonomy of structure became the basis for the institutional autonomy of many realms of culture. The institutional autonomy of art was, from this perspective, nothing but the institutional confirmation, in the context of modern culture, of the autonomy of iconic second-order semiosis. Art as an institution is the social instantiation and organisation of an immanent cultural development. The institutions serve a particular cultural evolution – in this case, that of the advent of modernity, of market capitalism, individualism, autonomy and science (technology, globalisation etc.). Art has become a commodity, subject to market forces just like everything else in this same period.[31] Mass culture is one aspect of modernism, just as, and as much as, the autonomy of art. The reconciliation of the two is one of the difficult tasks in the post-modern world.

In a culture in which the theoretical dominates, the fact that art is measured with the yardstick of knowledge further complicates the picture. The different semiotic functions are clearly distinguished and each is assigned its own domain. Art, religion, politics, myth, science, technology – they all become autonomous. Their cultural value depends, however, on the degree to which they contribute to a modern, theoretical way of thinking. Art, regarded as mere sensory knowledge, was considered to be of lesser value ('gnoseologia inferior'), distinctly inferior to science and philosophy. Artists were made conscious of the fact that they had to contribute to the general development of knowledge. To legitimate their activities, they had to come up with epistemological arguments. The cultural value of art depended on it. How did art contribute to knowledge? Leonardo da Vinci, for instance, tried to define painting as a science and emphasised its close relationship to mathematics. Artists in a modern culture also feel the need to discover the structure of their own 'thing' – the identity of art itself. Searching for this identity, art turned upon itself, in order to find out about its own essence, thus assigning legitimacy to the whole endeavour. Thus, to give but one example, Bruce Nauman declared that the question 'what art is, should be and still can be' is the point of departure for his artistic

[30] Modern culture did not, of course, emerge at one single moment in time. It developed gradually, with jerks and jolts. Classical antiquity, the Renaissance and the eighteenth century, however, are the major periods of transition in which modern culture suddenly seemed to gain ground vis-à-vis pre-modern culture.

[31] In a similar vein, Hauser (*The Social History of Art*) explains the autonomy of art in terms of rising capitalism.

research. Art is inquiry, he stated.[32] The search for the essence of art – isn't this what avant-garde art was all about?[33] Art had to prove that it was, in itself, a valuable form of knowledge. In the confrontation with the dominant realm of modern thinking, that is, with science, there were a number of options: art could either analyse an aspect of reality that seemed out of reach for science (individual emotions, experience, spirituality), or it could oppose the modern way of thinking as such, thus accepting the risk of becoming marginal.

In the eighteenth century, the development toward cultural autonomy led to a complex situation in which, at least theoretically, three forms of art can be discerned.[34] Each of them relates to a different (autonomous) concept of art. The first is the 'art of beauty', or art for art's sake; the second is the mimetic or 'realist art', and the third is the 'art about art', or avant-garde art. One could argue, however, that avant-garde art is actually a specific form of realist art, focusing on one particular aspect of life, namely, art itself ('life is / as art'!). We can therefore replace the triad of art forms by a dichotomy: the 'art of beauty' and the 'art of mimesis', where the latter would include avant-garde art as a special case. The opposition is in line with the argument about art and beauty presented above. What we witness during the nineteenth and twentieth centuries is a continuous struggle between the beautiful and the mimetic – the two functions of semiosis that were placed under the aegis of 'art' in modern culture.

Structure

In the end, of course, modern culture could not fail to discover the structures of art and beauty that would justify their autonomy. Various candidates were proposed: disinterested contemplation, genius and imagination, disruption and estrangement, popular tradition and institutional conventions. It is my hypothesis that the quintessence of art is not the structure of the object, but the structure of the semiotic process that is generated by an object in a certain context. The function of this semiotic process is mimetic: it is the representation of the semiotic process, that is, of human life. Thus, to use a canonical example, Warhol's Brillo boxes do not mimetically

[32] Nauman, *Interviews*, pp. 49 and 107.

[33] Cf. Belting, *Das Ende der Kunstgeschichte*.

[34] Apart from the three forms of art we distinguish here, one must remember that 'pre-modern' forms of art (no value-judgement is implied) continue to exist, side by side, with their modern counterparts. To the pre-modern forms of art I reckon art that revives magic, as well as art that illustrates or enunciates a religious or ideological doctrine. Although this further complicates the picture, it is not of our concern here.

represent the real Brillo boxes but, instead, they represent, through imitation of the process, life with Brillo boxes, as could have been experienced by a woman in New York in the fifties. Nor did Cézanne's paintings of the Mont Saint Victoire become art because they mimetically represented the Mont Saint Victoire. Cézanne's paintings of the mountain are a representation of how this mountain, or mountains in general, or even the world, could be represented. Beauty is not necessarily involved. Not because beauty has nothing to do with mimesis. Of course it has, but only in a very general way. The mimetic representation is no less a representation than any other and, as such, it conforms to the general semiotic rule: the search for order, symmetry, well-known content etc., according to principles like those that were outlined in the introduction. But the first task of modern art was to represent consciousness in a realistic way, deriving its strength from analysis – from dividing, separating and reducing things to their essence. The Brillo boxes, therefore, similar to so much avant-garde art, represent an abstract, modern way of being in the world (at least that of an intellectual elite) and, as such, they perfectly perform the perennial mimetic function of art.

Modernist art rigorously isolated the mimetic from the aesthetic. It also discovered that the artistic is not a quality of objects. The 'transfiguration of the commonplace' was, in a sense, 'pure' mimesis, devoid of any aesthetic aspect. Duchamp's and Warhol's extreme experiments made the important function of frames and borders all the more clear. These frames, for instance, make a text of a urinal turned upside down. This text is a second-order text, as it is about looking, about representation, about the museum, and about art. Any attempt whatsoever to engender figuratively a process of reflection upon life, such as by piling Brillo boxes one upon the other in a museum, for example, is an attempt at creating art. Whether it is successful and whether the aspect of life reflected upon, such as youth in America, for example, as well as art and its functioning in the museum, are experienced as interesting or worthwhile, is another question. But basically, that is what Modernism found out – art is not necessarily beautiful, nor is there an 'artistic structure' inherent in works of art.

Post-modernism then drew the wrong conclusion, namely, that art has no structure at all. It reduced the artistic to a set of conventions, thus marking the endpoint of modernity. If art is a mere convention, it has no structure of its own nor, therefore, can it claim autonomy. No longer can art be identified on the basis of specific structural characteristics, and the doors to entertainment and consumption stand wide open. But the fact that anything can be art does not mean that there is no such thing as art. As I have argued, art has a specific structure, though this structure is not inherent in artistic objects. It is rather the structure of a specific semiotic process engendered by the object, in a specific cultural context, for a specific au-

dience. Fundamental to artistic second-order semiosis is the imitation of the structure (and process) of semiosis: of perception, conceptualisation, and analysis. This is done by imitating the double structure of semiosis (identity plus difference) using historical material that must always be recognised, in some way, as belonging or pertaining to a known world. This is, by the way, why art is so often characterised as 'moving': what is set in motion, in a work of art more than in any other text, is our semiotic being.[35] When Danto says that no definition of art can be based upon the examination of artworks, as it must encompass the Brillo boxes, he is both right and wrong.[36] He is right, insofar as the Brillo boxes – as objects – have nothing that distinguishes them from real Brillo boxes. But he is also wrong, in the sense that artworks are not things. Culture is never 'things', but always representations, and to study an artwork (or any other fact of culture, for that matter) is to study representation processes. The boxes as things are a matter of physics and mechanics. But as representations, Warhol's Brillo boxes can be – and are – different from the real Brillo boxes. They become (for some, of course) a reflection on art, as well as on Warhol's youth, his relation with his mother, our culture of cleanliness, etc. Actually, there is an intriguing remark in the preface to Danto's *Transfiguration of the Commonplace* about the facsimiles – in plywood, which is not unimportant, as it stresses their mimetic character – of Brillo and Kellogg's cartons. The latter, he says, failed to excite the imagination, in contrast to the charismatic Brillo boxes!

Pinker is right, of course: the structure of beauty never changes, nor does the structure of art. What changes, however, are the contents of art and beauty, as well as the place occupied by both in culture. Modern art reflects in an iconic way the inquiring, autonomous consciousness of modern culture (as was so brilliantly analysed by Walter Benjamin, for instance). It represents inquiry (mimetically) and considers itself to be a form of inquiry – into the essence of life and art. Avant-garde art was the imitation of the discovery of new forms, thus contributing to the increase of knowledge and the ultimate goal: a better self-understanding. Autonomy and functionality thus combine without any contradiction.[37]

[35] Moses Mendelssohn stated something similar in 1757, in the essay 'Betrachtungen': 'Bey welchen Erscheinungen sind aber wohl alle Triebfedern der menschlichen Seele mehr in Bewegung, als bey den Wirkungen der schönen Künste?' (p. 167).

[36] Danto, *The Transfiguration*, p. vii.

[37] Cf. the contribution of Arnold Heumakers to this volume.

Crises

The alleged crisis of the arts we are living through is a double crisis – at least it seems so. Double, as it is related to two developments creating tensions within the structure of our cultural reality. The first tension is caused by the development of modernity, which took us from Modernism to Post-modernism. On an economic level, this development assumes the form of unbridled capitalism, consumerism, and blind faith in technology. In our thinking about culture, the development is characterised by the divergence of the indexical and the symbolical, of structure and meaning – meaning appears to be devoid of structure, and structure loses its meaning. The conventions of meaning have become the domain of cultural studies; structure is the object of the cognitive sciences. One of the consequences has been the crisis in our thinking about the arts: the questioning, under the influence of Post-structuralist thought, of the line separating art from entertainment, 'high' from 'low' art, and canonical from popular culture.[38]

We all know what the hegemony of theoretical semiosis has brought us: alienation, pollution, waste of energy, global warfare, genetic technology – it seems that we are living through an epoch in which the problems caused by the modern way of thinking are beginning to outweigh the solutions it once offered (science, technological progress, education, democracy, etc.). Basic notions related to modern thinking, such as progress, a linear conception of time, identity, contiguity and autonomy, are questioned. One possible reaction is, of course, a shift backwards, but what we also witness today, in my view, is an attempt to redress the balance, not on the basis of sentiment but rather on the basis of a rational analysis that (once more) uncovers its own limits, and the regional character of rationality and theoretical thinking. This process of change is related to the emergence of a non-modern, or truly post-modern (not: post-modernist) culture, and it takes us from a culture of knowledge to a culture of representation, in which the complexity of the semiotic process is acknowledged and fully put to use. This crisis is of a different nature. Within a culture of representation, theoretical knowledge is merely one of a number of possible basic 'symbolic forms' (see above) and is certainly not the privileged one.

The two developments are interrelated – they are both inherent in the end of modernity – and yet they are also very different. Whereas the former generates a typically modern tension between forms of knowledge (opposing structure to meaning, and science to ideology), the latter stresses the limits of theoretical thinking itself, not by opposing it, but by rationally analysing its limits and limitations, that is, its semiotic 'regionality'. Today,

[38] See also the contributions of René Boomkens and Peter Zima in this volume.

therefore, we are also witnessing a new kind of 'crisis', of a non-modern kind. Modernity generated crisis after crisis as a fundamental feature of its constant striving for renewal. The old had to be left behind, supplanted by some new discovery. But the contemporary crisis is not in the same way inherent in modernity. It is of a different nature, having to do with the growing insight that the modern is one possible way, among others, of dealing with the world. This insight is not externally imposed, but was reflexively generated by modern thought itself (in philosophy and semiotics, in art and literature, and in politics). Modern culture, true to its own credo, had to discover, analyse, and explain its own structure. Thus it discovered, through Warhol's Brillo boxes, for instance, the semiotic functions and their autonomy. In its search for the fundamental structure – or identity – of knowledge, modernity discovered the limits of its own way of thinking, the limits of thought itself as a semiotic form. It did not oppose theoretical knowledge. Such opposition had always been easily integrated in theoretical culture: as a 'minor' form of knowledge, or as fantastic or ideological 'non-knowledge'. Instead, modernity discovered that theoretical semiosis is one single function of a complex whole – the complex process of semiotic representation.

The crisis we witness today was caused by our reaching the limits of modern thinking, discovering and analysing the structures of the representation process. Rationality is no longer sacrosanct. Other ways of representing the world cannot be reduced to knowledge, to thinking, to structure, nor are they of a lesser value. They have their own (autonomous) function. And one of these is iconic second-order semiosis, or *mimesis*. Myth, art, and religion are no longer considered as inferior to the main – cognitive – function. The result – but we are standing only at the beginning of this development – is a different semiotic practice, in which the semiotic functions are valued in their own right and can be integrated into one complex semiotic whole. But should we really call it a crisis? It is not a genuine crisis, in the 'modern' sense of the word. It is actually more of a solution, a relief, a homecoming. The idea of a revolution (crisis), of the new, is typically modern. In its place, we now witness a search for a perspective that is not necessarily new, but one that incorporates the modern view of time and the world into a more complex and balanced view of man as the *animal symbolicum*, whose representation of the world is a combination of various modes of representation (or 'symbolic forms'). Cassirer always pleaded for the value of various symbolic forms.

For art as well as for beauty, this has again serious consequences. No longer are art and beauty relegated to their own safe domains of holidays and museums, but they are once again integrated in the general semiotic process as (autonomous) dimensions among others. We see a tendency to-

ward a reintegration of art and beauty in life, of beauty in art. This kind of reintegration is not done in the 'modern' way, as a takeover of life by art, or art by beauty, but in a post-modern way. Art (actually we should say: the artistic) now becomes an important aspect or dimension of many semiotic processes – representing the perspective of consciousness in a mimetic, concrete way in science, journalism, historiography, design, etc. And in a similar vein, beauty also gets its due place in a culture that is no longer solely directed towards progress and a quantitative increase, but rather towards an increase in quality.

The artistic is an aspect of semiosis, is a dimension or strategy of culture – both autonomous and integrated. This also implies a different (not new!) perspective on artistic development – no longer in terms of renewal through avant-garde, but in terms of changes related to the representation of a changing world. Does it mean the end of the museum? Talking in terms of 'the end' is, alas, typically modern. No, it does not mean the end of the museum and Yes it does, in a sense. It could also mean that the system of the arts (again a typically modern way of thinking) will not last. Media will merge, and our traditional classifications will disappear (as is already happening). The artistic is discovered, once again, 'outside' art: in figurative language, in fashion, in building, in design ... where it preserves its functional, semiotic autonomy, thus countering the unity of the non-artistic signs of beauty and abstraction. Culture is plural, is a lot of everything. The awareness of the artistic function is an answer to the crisis of identity of modern metaphysical, avant-garde, elite art. From art as an autonomous world we move to art as an aspect or strategy of representation. Art can still be enjoyed in isolation, but it need not be. Isolation is certainly not a prerequisite for artistic experience. The focus is once again on the world represented. This development requires an equally flexible and complex criticism – and a complex system of education.

Thus in *post-modernist* culture, art is still institutionally autonomous, but it has no autonomy of function as mimetic, or iconic second-order semiosis. It has become a commodity, a matter of money, marketing, and entertainment. Within *post-modern* culture, art loses its institutional autonomy but gains new relevance as an important aspect of a complex semiotic process in which its autonomy of function is once again acknowledged and valued.

BIBLIOGRAPHY

A.A., "'Pres Mbeki, luister asb na ons'", *Insig*, November 1999.

A.A., 'ANC-lede "neig na kultuur-diktatuur" André P. Brink besorg oor spraak-vryheid', *Die Burger*, 15 June, 1993.

A.A., 'I Qabane Labantu', *Weekly Mail*, 22 June 1990.

Abrams, M.H., *Doing Things with Texts. Essays in Criticism and Critical Theory* (New York/London, 1989).

————, 'Art as Such. The Sociology of Modern Aesthetics' and 'From Addison to Kant', both in: *Doing Things with Texts: Essays in Criticism and Critical Theory* (New York, 1989).

Accardo, A. and Corcuff, P., *La Sociologie de Bourdieu. Textes choisis et commentés* (Bordeaux, 1986).

Adorno, Th., *Ästhetische Theorie*, G. Adorno and Tielemann, R., eds., *T.A. Adorno, Gesammelte Schriften*, vol. 7 (Frankfurt am Main, 1970).

————, *Philosophie der neuen Musik* (Frankfurt am Main/Berlin/Vienna, 1972).

African National Congress, 1989. 'Position Paper on the Cultural and Academic Boycott', adopted by the National Executive Committee of the African National Congress. Lusaka, May 1989. Internet: *http://www.anc.org.za/ancdocs/pr/1989/pr0500.html*. Accessed 11 September 2003.

African National Congress, *Draft National Cultural Policy*. Department of Arts and Culture, ANC. Internet: *http://www.anc.org.za/ ancdoncs/policy/ cultural. htm*. No date [1994?]. Accessed 30 October 2003.

Alexander, V.D., *Sociology of the Arts: exploring fine and popular forms* (Malden, 2003).

Angot, Christine, *Sujet Angot* (Paris, 1998).

Armstrong, I., 'Writing for the Broken Middle, The Post-Aesthetic', *Woman: A Cultural Review* 9.1 (1998), pp. 62-96.

Arnheim, R., *Film as Art* (London, 1983).

Art and the Brain. Part I. *Journal of Consciousness Studies* 6 (1999), pp. 6-7.

Art and the Brain. Part II. *Journal of Consciousness Studies* 7 (2000), pp. 8-9.

Bakhtin, M., *Problemy tvorčestva Dostoevskogo* (Leningrad, 1929).

————, *Problemi poetiki* (Moscow, 1963).

————, *Voprosy literatury i èstetiki* (Moscow, 1975).

Barrel, H., 'A mean, insecure, fevered spirit abroad', *Mail and Guardian*, 14 April 2000.

Barth, J., *Lost in the Funhouse* (New York/London, 1968/1988).

Barthes, R., *Sade, Fourier, Loyola* (Paris, 1971).

————, *Le bruissement de la langue* (Paris, 1984).

Baudelaire, Charles, *Œuvres complètes*, vol. II (Paris, 1976).

Baudrillard, J., *La Transparence du mal. Essai sur les phénomènes extrêmes* (Paris, 1990).

Bell-Villada, G.H., *Art for Art's Sake and Literary Life. How Politics and Markets Helped Shape the Ideology & Culture of Aestheticism 1790-1990* (Lincoln/London, 1998).

Belting, H., *Das Ende der Kunstgeschichte: eine Revision nach zehn Jahren* (Munich, 2002).

Bely, A., *Ich, ein Symbolist. Eine Selbstbiographie* (Frankfurt am Main, 1987).
———, 'Počemu ja stal simvolistom ...', in: Bely, A., *Simvolizm kak miroponima-nie* (Moscow, 1994), pp. 418-493.
Bénichou, P., *L'Ecole du Désenchantement, Sainte-Beuve, Nodier, Musset, Nerval, Gautier* (Paris, 1992).
Benjamin, W., *Gesammelte Schriften* (Frankfurt am Main, 1980).
———, *Das Passagen-Werk* (Frankfurt am Main, 1983).
Berdyaev, N. *Krizis iskusstva* (Moscow, 1918).
Bergounioux, Pierre, *Miette*, (Paris, 1995).
Bernstein, R., *The New Constellation. The Ethical-Political Horizons of Modernity/ Postmodernity* (Cambridge, 1991).
Biti, V. *Literatur- und Kulturtheorie. Ein Handbuch gegenwärtiger Begriffe* (Reinbek, 2001).
Bohrer, K.H., ed., *Mythos und Moderne* (Frankfurt am Main, 1983).
Bourdieu, P. and Darbel, A., *L'Amour de l'art* (Paris, ²1969).
Bourdieu, P., *La Distinction: Critique Sociale du Jugement* (Paris, 1979).
———, *Les Règles de l'Art. Genèse et Structure du Champ Littéraire* (Paris, 1992).
———, *The Field of Cultural Production* (Cambridge, 1993).
———, *The Rules of Art: Genesis and structure of the literary field* (= *Les Règles de l'Art* (Cambridge, 1996).
Brik, O., 'T.n. "formal'nyj metod"', *Lef* 1 (1923), pp. 213-215.
Broady, D., 'French Prosopography: definitions and suggested readings', *Poetics* 30(5/6) (2002), pp. 381-385.
Brooks, C., *The Well Wrought Urn. Studies in the Structure of Poetry* (San Diego/ New York/London, 1949).
Buck-Morss, S., *The Dialectics of Seeing. Walter Benjamin and the Arcades Project* (Cambridge, Mass., 1989).
Bürger, Ch. and Bürger, P., eds., *Postmoderne: Alltag, Allegorie und Avantgarde* (Frankfurt am Main, ⁴1992).
Bürger, P., *Theorie der Avantgarde* (Frankfurt am Main, 1974).
———, 'Vorbemerkung', in: Bürger and Bürger, *Postmoderne*, pp. 7-12.
Campschreur, W. and Divendal, J., 'Preface', in: Campschreur, W. and Divendal, J., eds., *Culture in Another South Africa* (London, 1989).
Cassagne, A., *La Théorie de l'Art Pour l'Art en France chez les Derniers Romantiques et les Premiers Réalistes* (Seyssel, 1906, 1997).
Cassirer, E., *An Essay on Man. An Introduction to a Philosophy of Human Culture* (New Haven/London, 1944).
———, *The Philosophy of Symbolic Forms*, vol. 1: *Language*; vol. 2: *Mythical Thought*; vol. 3: *The Phenomenology of Knowledge*, transl. by R. Mannheim (New Haven/London, 1980).
Chamoiseau, P., *Ecrire en Pays Dominé* (Paris, 1997).
Charms, D., *Gorlo bredit britvoju. Slučai, rasskazy, dnevnikovye zapisi* (Moscow, 1991).
Chlebnikov, V., *Werke*, ed. P. Urban, vol. 1: Poesie; vol. 2: Prosa, Schriften, Briefe. (Reinbek, 1972).
Clark, T.J., *Farewell to an Idea. Episodes from a History of Modernism* (New Haven/London, 1999).
Coetzee, A. and Willemse, H., eds., *I Qabane Labantu: Poetry in the emergency.*

Poësie in die noodtoestand (Bramley, 1989).

Coetzee, A. and Polley, J., eds., *Crossing Borders: Writers meet the ANC* (Bramley, 1990).

Coetzee, A., Smith, J.F. and Willemse, H., 'Afrikaanse Letterkunde: klas en apartheid', in: Malan, C. and Jooste, G.A., eds., *Onder Andere: Die Afrikaanse letterkunde en kulturele kontekste* (Pretoria, 1990).

Cohen, R., 'Do Postmodern Genres Exist?', *Genre* 29 (1987), pp. 241-253.

Cohn, D., *The Distinction of Fiction* (Baltimore, etc., 1999).

Constant, B., *Journal Intime* (Monaco, 1945).

Danto, A., *Analytic Philosophy of History* (Cambridge, 1965).

——, *The Transfiguration of the Commonplace: a Philosophy of Art* (Cambridge, Mass., 1981).

De Azúa, F., *Historia de un idiota contada por él mismo o El contenido de la felicidad* (Barcelona, [17]1992).

De Klerk, F.W., 'Die kunste in sy verhouding tot die staat'. Speech delivered at the Kunsteberaad (Stellenbosch, 29 April 1988).

Department of Arts, Culture, Science and Technology. *White Paper on Arts, Culture and Heritage* (Pretoria, 1997).

Deppermann, 'Dostoevsky als Portalfigur der Moderne im Rahmen der ästhetischen Moderne als Makroepoche', in: Gerigk, H.-J., ed., *Dostoijevski Studie* (Tübingen, 2003), pp. 7-40.

Derrida, J., *Acts of Literature*, ed. D. Attridge (London, 1992).

Dewey, J., *Art as Experience* (New York, 1987).

Diaz, L., 'L'Autonomisation de la Littérature', *Littérature* 124 (2001), pp. 9-22.

Dilthey, W., *Das Erlebnis und die Dichtung* (Leipzig, 1905).

Dissanyake, E., *Homo Aestheticus: Where Art Comes From and Why* (New York, 1992).

——, *Art and Intimacy. How the Arts Began* (Seattle, 2000).

Djebar, A., *L'Amour, la Fantasia* (Paris, 1985).

Donald, M., *Origins of the Modern Mind* (Cambridge, Mass. 1991).

——, 'Mimesis and the Executive Suite: Missing Links in Language Evolution', in: Hurford, Studdert-Kennedy and Knight, *Approaches*, pp. 44-67.

Durkheim, E., *The Division of Labour in Society* (London/New York, 1933/1964).

Dutton, D., 'Aesthetic Universals', in: Gaut, B. and Lopes, D.M., eds., *The Routledge Companion to Aesthetics* (New York, 2001).

Duvignaud, J., *Spectacle et société. Du théâtre grec au happening, la fonction imaginaire dans les sociétés* (Paris, 1970).

Edelman, B. and Heinich, N., *L'Art en Conflits. L'Œuvre de l'Esprit Entre Droit et Sociologie* (Paris, 2002).

Egan, R.F., 'The Genesis of the Theory of "Art for Art's Sake" in Germany and England', *Smith College Studies in Modern Languages* II, 4 (1921) pp. 5-61; vol. V, 3 (1924), pp. v-ix and 1-33.

Eggers, Dave, *A Heartbreaking Work of Staggering Genius* (New York, 2000).

Eibl-Eibesfeldt, I., 'The Biological Foundation of Aesthetics', in: Rentschler, Herzberger and Epstein, *Beauty*, pp. 29-68.

Èichenbaum, B., 'Kak sdelana, šinel'' Gogolja' (1918), in: Striedter, J., ed., *Texte der russischen Formalisten*, vol. 1 (Munich, 1969), pp. 122-159.

Eliot, T.S., *The Sacred Wood. Essays on Poetry and Criticism* (London, 1920/1960).

Erlich, V., *Russian Formalism. History-Doctrine* (The Hague, 1956).

Even-Zohar, I., 'Polysystem Theory', *Poetics Today* 11.1 (1990), pp. 9-26.

———, 'The Literary System', *Poetics Today* 11.1 (1990), pp. 27-44.

Flaker, A., ed., *Glossarium der russischen Avantgarde* (Graz/Vienna, 1989).

Foster, H., ed., *The Anti-Aesthetic: Essays on Postmodern Culture* (Port Townsend, Wash., 1983).

Foucault, M., *L'ordre du discours: Leçon inaugurale au Collège du France prononcée le 2 décembre 1970* (Paris, 1971).

Frank, M., *Der kommende Gott. Vorlesungen über die neue Mythologie* (Frankfurt am Main, 1982).

Freeland, C., *But Is It Art? An Introduction to Art Theory* (Oxford, 2001).

Frith, S., *Sound Effects. Youth, Leisure and the Politics of Rock 'n' Roll* (New York, 1981).

———, 'The Good, the Bad and the Indifferent: Defending Popular Culture from the Populists', *Diacritics* 21.4 (1991), pp. 102-115.

———, *Performing Rites. Evaluating Popular Music* (Oxford/New York, 1998).

Gautier, Théophile, *Histoire du Romantisme* (Paris, 1874).

———, *Fusains et Eaux-Fortes* (Paris, 1880).

———, *Poésies Complètes*, vol. III, ed. R. Jasinski (Paris, s.d.).

———, *Mademoiselle de Maupin* (Paris, 1973).

———, *Souvenirs de Théâtre, d'Art et de Critique* (Paris, 1883).

Genette, G., 'Genre, types, modes', *Poétique* 47 (1977), pp. 389-421.

———, *Introduction à l'«architexte»* (Paris, 1979).

———, *Seuils* (Paris, 1987).

———, *L' œuvre de l'art; l'Immanence et transcendence* (Paris, 1994).

Gibson, A., *Postmodernity, Ethics, and The Novel: From Leavis to Levinas* (London, 1999).

Goodman, N., *Languages of Art* (Oxford, 1968).

———, *Ways of Worldmaking* (Indianapolis, 1978).

———, *Of Mind and Other Matters* (Cambridge, Mass., 1984).

Gossman, L., *Between History and Literature* (Cambridge/London, 1990).

Gramsci, A., *Selections from the Prison Notebooks of Antonio Gramsci*, ed. and transl. Q. Hoare and G. Nowell Smith (London, 1971).

Greber, E., *Textile Texte: poetologische Metaphorik und Literaturtheorie. Studien zur Tradition des Wortflechtens und der Kombinatorik* (Cologne, 2002).

Groys, B., *Gesamtkunstwerk Stalin* (Munich, 1988).

———, *Über das Neue. Versuch einer Kulturökonomie* (Munich, 1992).

Grübel, R. and Smirnov, I., 'Die Geschichte der russischen Kulturosophie im neunzehnten und frühen zwanzigsten Jahrhundert', in: *Wiener Slawistischer Almanach* (Munich, 1997), pp. 5-18.

Grübel, R., *Russischer Konstruktivismus. Künstlerische Konzeptionen, literarische Theorie und kultureller Kontext* (Wiesbaden, 1981).

———, 'Literaturersatz, handgreifliche Kunst oder Vor-Schrift? Diskurspragmatik und Bauformen, Axiologie und Intentionalität literarischer Deklarationen, Manifeste und Programme der russischen Moderne (1893-1934)', in: Van den Berg, H. and Grüttemeier, R., eds., *Manifeste: Intentionalität* (Amsterdam, 1998), pp. 161-192.

————, 'Zitate ohne Ende? Intertextualität und Interdiskursivität der russischen Postmoderne', in: Beekman, K. and Grüttemeier, R., eds., *Instrument Zitat. Über den literarischen und institutionellen Nutzen von Zitaten und Zitieren* (Amsterdam, 2000), pp. 239-278.

————, *Der Wandel im Autorbild der russischen Moderne* (Oldenburg, 2000).

————, *Literaturaxiologie. Zur Theorie und Geschichte des ästhetischen Wertes in russischen und anderen slavischen Literaturen* (Wiesbaden, 2001).

————, 'Chlebnikovs Zangezi als Kontrafaktur der Liturgie', in: Grübel, *Literaturaxiologie*, (Wiesbaden, 2001), pp. 615-672.

————, *An den Grenzen der Moderne. Das Denken und Schreiben Vasilij Rozanovs* (Munich, 2003).

————, 'Die Krise der Sprache und die Sprachen der Krise in der russischen Moderne', in: Boeder, W. *et al.*, eds., *Sprachliches Zeichen – Semantik – Ikonizität. Zum Gedenken Joseph P. Calbert* (Oldenburg, 2003), pp. 31-79.

Grygar, M., 'Über die Auffassung der dichterischen Sprache in der europäischen Avantgarde (Komparatistische Randbemerkungen)', in: Asholt, W. and Fähnders, W., eds., *Der Blick vom Wolkenkratzer. Avantgarde – Avantgardekritik – Avantgardeforschung* (Amsterdam, 2000), pp. 291-312.

Gumbrecht, H.U. and Pfeiffer, L., eds., *Stil. Geschichten und Funktionen eines kulturwissenschaftlichen Diskurselements* (Frankfurt am Main, 1986).

Guralnick, P., *Last Train to Memphis. The Rise of Elvis Presley* (London, 1994).

Habermas, J., *Der philosophische Diskurs der Moderne* (Frankfurt am Main, 1985).

Hambidge, J., 'Haal af die pampoenbrille en laat waai die skille', *Beeld*, 24 (1993).

Hansen-Löve, A., *Der Russische Formalismus. Methodologische Rekonstruktion seiner Entwicklung aus dem Prinzip der Verfremdung* (Vienna, 1978).

————, 'Faktur, Gemachtheit.' In: Flaker, A. and Oraić, D., eds., *Glossarium der russischen Avantgarde* (Graz/Vienna, 1989), pp. 212-219.

————, *Der Russische Symbolismus. System und Entfaltung der poetischen Motive*, vol. 1 (Vienna, 1989).

Haskins, C., 'Paradoxes of autonomy; or, why won't the problem of artistic justification go away?', *Journal of Aesthetics and Art Criticism* 58 (2000), pp. 1-23.

Hauser, A., *The Social History of Art*. With an introduction by J. Harris (London/ New York, 1999).

Hegel, G.W.F., *Vorlesungen über die Ästhetik*, vol. I/II, ed. R. Bubner (Stuttgart, 1971).

Heinich, N., 'The Sociology of Contemporary Art: Questions of Method', in: Schaeffer. J-M., ed., *Think Art. Theory and Practice in the Art of Today* (Rotterdam, 1998), pp. 314-335.

Horkheimer, M. and Adorno, Th.W., *Dialektik der Aufklärung: filosofische Fragmente* (Frankfurt am Main, 1982).

Houellebecq, Michel, *Les Particules Elémentaires* (Paris, 1998).

Hugo, Victor, *Œuvres Complètes. Critique* (Paris, 1985).

Hurford, J.R., Studdert-Kennedy, M. and Knight, C., eds., *Approaches to the Evolution of Language. Social and Cognitive Bases* (Cambridge, 1998).

Ingold, F.-Ph., *Der große Bruch. Russland im Epochenjahr 1913* (Munich, 2003).

Jakobson, R., 'The Conceptual Basis of Prague Structuralism', in: Matejka, L., ed.,

Sound, Sign and Meaning. Quinquagenary of the Prague Linguistic Circle (Ann Arbor, 1978), pp. 351-377.

Jameson, F., *Postmodernism or The Cultural Logic of Late Capitalism* (Durham, 1991/1993).

Jamme, Chr. and Schneider, H., eds., *Mythologie der Vernunft. Hegels "ältestes Systemprogramm" des deutschen Idealismus* (Frankfurt am Main, 1984).

Jencks, C., *What is Post-Modernism?* (London, 1986).

Joyce, James, *Ulysses* (London, 1960).

Kant, Immanuel, *Kritik der Urteilskraft*, ed. K. Vorländer (Hamburg, 1974).

———, *Critique of Judgement* (Indianapolis/Cambridge, 1987).

Kéchichian, P., 'La Mémoire Enfouie de Pierre Bergounioux', entretien (Le Monde, 4 February 1994).

Kneer, G. and Nassehi, A., *Niklas Luhmanns Theorie sozialer Systeme* (Munich, 1997).

Koolhaas, R., *Delirious New York. A Retroactive Manifesto for Manhattan* (Rotterdam, 1994, = 1978).

Kristeller, P.O., 'The modern system of the arts. A study in the history of aesthetics', *Journal of the History of Ideas* XII,4 (1951), pp. 496-527; XIII,1 (1952), pp. 17-46.

———, 'The Modern System of the Arts', *Renaissance Thought, II. Papers on Humanism and the Arts* (New York, 1965), pp. 163-227.

Krul, W., 'De kunst in het heden', *Feit en fictie* V, 2 (2001), pp. 8-15.

Lachmann, R., *Gedächtnis und Literatur* (Frankfurt am Main, 1990).

Lash, S., *Sociology of Postmodernism* (London/New York, 1990).

Lepenies, W., 'Goethes Geistesgegenwart', *Frankfurter Allgemeine Zeitung* (5 April, 1997).

Lévi-Strauss, Cl., *La pensée sauvage* (Paris, 1962).

Lotman, J., *Vnutri mysljaščich mirov* (Moscow, 1996).

Luesly, C., 'Police seize books allegedly quoting banned people', *The Citizen*, 27 June 1989.

Luhmann, N., 'Das Kunstwerk und die Selbstreproduktion der Kunst', in: Gumbrecht, H.U. and Pfeiffer, L., eds., *Stil. Geschichten und Funktionen eines kulturwissenschaftlichen Diskurselements* (Frankfurt am Main, 1986).

———, *Die Kunst der Gesellschaft* (Frankfurt am Main, 1995/1997).

Malan, C., 'Introduction: Race and the Writer', in: Malan, C., ed., *Race and Literature. Ras en Literatuur* (Pinetown, 1987).

Malevic, K., *Suprematizm* (Vitebsk, 1920).

———, *Artist and Theoretician* (Moscow, 1991).

Mallarmé, S., 'Crise de Vers', in: Mondor, H., ed., *Variations sur un Sujet. Œuvres Complètes* (Paris, 1979), pp. 360-368.

Mandela, N., 'Statement of the President of the African National Congress', on the occasion of the opening of the cultural development congress at the Civic Theatre, Johannesburg, 25 April, 1993.

Marcus, G., *Lipstick Traces. A Secret History of the 20th Century* (Cambridge, Mass., 1989).

———, *Invisible Republic. Bob Dylan's Basement Tapes* (New York, 1997).

Markov, V., *A History of Russian Futurism* (Berkeley/Los Angeles, 1968).

Martin, M., 'Blind vir die Kunste', *De Kat*, July 1988.

Masekela, B., 'The ANC and the Cultural Boycott', first published in *Africa Report*, July-August 1987 edition. Reprinted in Schäfer, W. and Kriger, R., eds., *From Popular Culture to the Written Artefact*. Second Conference on South African Literature, 11-13 December 1987. Evangelische Akademie Bad Boll, Federal Republic of Germany, pp. 187-193.

———, 'We are not returning empty handed', *Die Suid-Afrikaan*, August 1990.

Matejka, L., ed., *Sound, Sign and Meaning. Quinquagenary of the Prague Linguistic Circle* (Ann Arbor, 1978).

Mayakovsky, V., *Dlja golosa* (Berlin, 1923).

———, 'Vladimir Mayakovsky', in: V.M., *Polnoe sobranie sočinenij*, vol. 1, pp. 149-165.

———, 'Vojna i mir', in: V.M., *Polnoe sobranie sočinenij*, vol. 1, pp. 223-265.

———, 'Kak delat' stichi', in: V.M., *Polnoe sobranie sočinenij*, vol. 10, pp. 211-248.

———, *Polnoe sobranie sočinenij*, 12 vols. (Moscow, 1939).

McMahon, J.A., 'Perceptual principles as the basis for genuine judgments of beauty', *Art and the Brain*. Part II. *Journal of Consciousness Studies* 7, 8-9 (2000), pp. 29-35.

Meintjies, F., 'Albie Sachs and the art of protest', *Weekly Mail*, 2 March 1990.

Mendelssohn, Moses, 'Betrachtungen über die Quellen und die Verbindungen der schönen Künste und Wissenschaften' in: *Gesammelte Schriften. Schriften zur Philosophie und Ästhetik*, vol. I (1757) (Stuttgart, 1971), pp. 165-190.

Meyer, H., 'Gattung', in: Pechlivanos, M. *et al.*, eds., *Einführung in die Literaturwissenschaft* (Stuttgart/Weimar, 1995).

Michaud, Y., *La Crise de l'Art Contemporain. Utopie, Démocratie et Comédie* (Paris, 1997).

Millet, Catherine, *L'Art Contemporain* (Paris, 1997).

———, *La Vie Sexuelle de Catherine M.* (Paris, 2001).

Mironov, B.N., *Social'najaj istorija Rossii* (St Peterburg, 1999).

Mithen, S., *The Prehistory of the Mind. A Search for the Origins of Art, Religion and Science* (London, 1996).

———, 'A creative explosion? Theory of mind, language and the disembodied mind of the Upper Palaeolithic', in: Mithen, Steven, ed. (1998), pp. 165-191.

———, ed., *Creativity in Human Evolution and Prehistory* (London/New York, 1998).

Molefe, P., 'Culture IS struggle's weapon – Desk', *Weekly Mail*, 9 March 1990.

Moritz, K.Ph., *Schriften zur Aesthetik und Poetik*, ed. H.J. Schrimpf (Tübingen, 1962).

Müller, H. and Wegmann, N. 'Tools for a Genealogic Literary Historiography', *Poetics* 14 (1985), pp. 229-241.

Nabokov, V., 'On a Book Entitled Lolita', in: *Lolita* (London, 1961).

Nauman, B., *Interviews 1967-1988*, ed. by C. Hoffmann (Dresden, 1996).

Ndlangisa, S., 'Hip-hop hullabaloo', *Sunday Times*, 25 August 2002.

Novalis, *Schriften. Band I: Das dichterische Werk. Tagebücher und Briefe*, ed. R. Samuel (Munich/Vienna, 1978).

———, *Schriften. Band II: Das philosophisch-theoretische Werk*, ed. H.-J. Mähl (Munich/Vienna, 1978).

Nussbaum, M., *Love's Knowlegde: Essays on Philosophy and Literature* (Oxford, 1990).

Oraić, D., 'Die Sternensprache', in: Flaker, *Glossarium*, pp. 448-455.

———, 'Zitathaftigkeit', in: Flaker, *Glossarium*, pp. 489-511.

Peckham, M., *Man's Rage for Chaos. Biology, Behavior and the Arts* (New York, 1965).

Pine, J. and Gilmore, J., *The Experience Economy: Work is Theater and Every Business a Stage* (Boston, 1999).

Pinker, S., *The Language Instinct: How the Mind created Language* (New York, 1994).

———. *How the Mind works* (London, 1997).

———, *The Blank Slate. The Modern Denial of Human Nature* (London, 2002).

Pisarra, M., 'Some of my best friends are cultural workers: Reply to Mike van Graan', *Die Suid-Afrikaan*, February/March 1993.

Plumpe, G., *Ästhetische Kommunikation der Moderne*, 2 vols. (Opladen, 1993).

Poe, Edgar Allen, 'The Philosophy of Composition', in: Poe, Edgar Allen, *Essays and Reviews* (New York, 1984), pp. 13-25

Propp, V., *Morfologija skazki* (Leningrad, 1928).

Pyman, A., *A History of Russian Symbolism* (Cambridge, 1994).

Ramachandran, V.S. and Hirstein, W., 'The science of art. A neurological theory of aesthetic experience', *Journal of Consciousness Studies* 6, 6-7 (1999), pp. 15-51.

Rancière, J., *La Parole Muette. Essais sur les Contradictions de la Littérature* (Paris, 1998).

Rentschler, I., Herzberger, B. and Epstein, D., eds., *Beauty and the Brain. Biological Aspects of Aesthetics* (Basel, 1988).

Ricoeur, P., *Soi-même comme un Autre* (Paris, 1990).

Rigney, A., 'What's in a Name? Fictie, ervaring en autoriteit', *Tijdschrift voor Literatuurwetenschap* 3 (1998), pp. 136-146.

Sachs, A., 'Preparing ourselves for Freedom: Culture and the ANC Constitutional Guidelines', *The Drama Review* 35.1 (1991), pp. 187-193.

Sapiro, G., 'The literary field between the state and the market', *Poetics* 31 (2003), pp. 441-464.

Schelling, F.W.J., *Texte zur Philosophie der Kunst*, ed. W. Beierwaltes (Stuttgart, 1982).

Schiller, F., *Über die ästhetische Erziehung des Menschen in einer Reihe von Briefe*, ed. W. Düsing (Munich/Vienna, 1981; orig. 1795-1801).

Schlegel, A.W., *Die Kunstlehre*, ed. E. Lohner (Stuttgart, 1963).

———, *Geschichte der klassischen Literatur*, ed. E. Lohner (Stuttgart, 1964).

Schlegel, Friedrich, *Schriften zur Literatur*, ed. W. Rasch (Munich, 1972).

———, *Reise nach Frankreich*, in: *Kritische Schriften und Fragmenten, 1803-1812. Studienausgabe*, vol. III, ed. E. Behler and H. Eichner (Paderborn, 1988).

Schlögel, K., *Petersburg 1909-1921. Das Laboratorium der Moderne* (Munich, ²2002).

Schmidt, S.J., *Die Selbstorganisation des Sozialsystems Literatur im 18. Jahrhundert* (Frankfurt am Main, 1989).

Šestov, L., *Učenie dobra u grafa Tolstogo i Nicše* (Saint Petersburg, 1900).

Shiner, L.E., *The Invention of Art: a Cultural History* (Chicago, 2001).

Shusterman, R., *Pragmatist Aesthetics* (Oxford, 1992).

———, 'The end of aesthetic experience', *Journal of Aesthetics and Art Criticism* 55, 1 (1997), pp. 29-32.

Simmel, G., *Über Sociale Differenzierung. Historische und soziologische Untersuchungen* (Berlin, 1890).

Šklovsky, V., *Zoo ili pis'ma ne o lyubvi* (Leningrad, 1924).

Skoryatin, V., *Tayna gibeli Vladimira Mayakovskogo* (Moscow, 1998).

Smirnov, I., *Chdožestvenny smysl i ėvoluciya poėtičeskich sistem* (Moscow, 1979).

Spalding, J., *The Eclipse of Art. Tackling the Crisis of Art Today* (Munich, etc., 2003).

Steinberg, C., 'Albie Sachs: Our Shakespearian Fool', *The Drama Review* 35.1 (1991), pp. 194-199.

Tak, S.-M., *Das Problem der Kunstautonomie in der literaturwissenschaftlichen Theoriedebatte der BRD* (Frankfurt am Main, 1994).

Teige, K., 'Manifeste du Poétisme', in: *Prague Poésie. Front gauche* (Paris, 1972), pp. 112-126.

Thiesse, A.-M., *Ecrire la France. Le mouvement littéraire régionaliste de la Belle-Epoque à la Libération* (Paris, 1991).

Tilroe, A., *Het blinkend stof. Op zoek naar een nieuw visioen* (Amsterdam, 2002).

Tolstoy, L., *Čto takoe iskusstvo?* (Moscow, 1985).

Turner, F. and Pöppel, E., 'Metered poetry, the brain, and time', in: Renschler, Herzberger and Epstein, *Beauty*, pp. 71-90.

Tynyanov, J., 'Literaturny fakt', in: Striedter, J., ed., *Texte der russischen Formalisten*, vol. 1 (Munich, 1969), pp. 392-431.

———, 'Vopros o literaturnoi evolucii', *Na literaturnom postu* 4 (1927), pp. 42-48.

———, *Problema stichotvornogo yazyka* (Moscow, 1924).

United Nations Centre against Apartheid, 1983. 'Introduction to the First Register of Entertainers, Actors and Others Who Have Performed in *Apartheid* South Africa', *Notes and Documents, Number 20/83*, October 1983. Published by the Special Committee against *Apartheid*.

United Nations, 1968. 'Resolutions Adopted on the Reports of the Special Political Committee'. General Assembly: Twenty-third Session.

Van de Veire, F., 'I love art, you love art, we all love art, this is love. Een pamflet over de kunstwereld', *http://www.jahsonic.com/ Frank Van de Veire.html* (2003).

Van Graan, M., 'Some of my best friends are cultural workers', *Die Suid-Afrikaan*, February/March 1993.

———, 'Showdown at show time', *Mail and Guardian*, 13 June 2003.

Van Heusden, B., *Why Literature? An Inquiry into the Nature of Literary Semiosis* (Tübingen, 1997).

———, 'The emergence of difference: Some notes on the evolution of human semiosis', *Semiotica* 127-1/4 (1999), pp. 631-646.

———, 'Kunst – die vierte symbolische Form?', in: Sandkühler, H.J. and Pätzold, D., eds., *Kultur und Symbol. Ein Handbuch zur Philosophie Ernst Cassirers* (Stuttgart, 2003), pp. 191-210.

———, 'A bandwidth model of semiotic evolution' in: Bax, M., Van Heusden, B. and Wildgen, W., eds., *Semiotic Evolution and the Dynamics of Culture* (Bern, 2004), pp. 1-26.

Van Wyk Louw, N.P., 1984. '*Grense*', *Versamelde Gedigte* (Cape Town, 1984).

Verweyen, Th. and Witting, G., *Die Kontrafaktur. Vorlage und Verarbeitung in Literatur, bildender Kunst und politischem Plakat* (Constance, 1987).

Vud, P. [Wood, P.], 'Avangard i politika', *Velikaya utopia/Die große Utopie* (Moscow/Bern, 1993), pp. 284-304.

Wilcox, J., 'The beginnings of l'art pour l'art', *Journal of Aesthetics and Art Criticism* XI, 4 (1953), pp. 360-377.

Wilde, Oscar, *The Picture of Dorian Gray* (New York, 1961).

———, *The Artist as Critic. Critical Writings of Oscar Wilde*, ed. R. Ellmann (Chicago, 1969).

Willemse, H., 'Kulturele Boikot: Sensuur of Strategie?' *Die Suid-Afrikaan*, November, 1989.

Williams, R., *Keywords: a vocabulary of culture and society* (London, 1983).

Wolfson, R., ed., *Kunst in crisis* (Amsterdam/Middelburg, 2003).

Woodmansee, M., 'The interests in disinterestedness. Karl Philipp Moritz and the emergence of the theory of aesthetic autonomy in eighteenth-century Germany', *Modern language quarterly: A journal of literary history* 45.1 (1984), pp. 22-47.

Woolf, V., *Orlando. A Biography* (Oxford, 1992).

Zelinsky, K., *Poèzia kak smysl* (Moscow, 1929).

Zima, P.V., *La Négation esthétique. Le Sujet, le beau et le sublime de Mallarmé et Valéry à Adorno et Lyotard* (Paris, 2002).

Zholkovsky, A., 'Grafomanstvo kak priem: Lebyadkin, Chlebnikov, Limonov i drugie', in: Weststeijn, W., ed., *Velimir Chlebnikov (1885-1922): Myth and Reality* (Amsterdam, 1986), pp. 574-593.

———, 'Poètika Èjzenštejna: dialogičeskaya ili totalitarnaya?', in: Zholkovsky, A., ed., *Bluždayuščie sny* (Moscow, 1992), pp. 296-311.

INDEX

PRINTED ON PERMANENT PAPER • IMPRIME SUR PAPIER PERMANENT • GEDRUKT OP DUURZAAM PAPIER - ISO 9706

N.V. PEETERS S.A., WAROTSTRAAT 50, B-3020 HERENT